THE SWORD
AND THE
SKETCH BOOK

THE SWORD
— AND THE —
SKETCH BOOK

A PICTORIAL HISTORY OF
QUEEN VICTORIA'S WARS

IAN HERNON

SPELLMOUNT

For Reuben Singh Hernon Matharu and
Freya Nikki Kaur Hernon Matharu,
our grandchildren

First published 2012

by Spellmount an imprint of
The History Press
The Mill, Brimscombe Port
Stroud, Gloucestershire, GL5 2QG
www.thehistorypress.co.uk

British Library Cataloguing in Publication Data.
A catalogue record for this book is available from the British Library.

ISBN 978 0 7524 6598 2

Typesetting and origination by The History Press
Printed in Great Britain

CONTENTS

FOREWORD

Ian Hernon has written a fascinating book. I find it intensely interesting to see how the empire-building martial exploits of Queen Victoria's soldiers were illustrated to her people at home!

British imperial power reached its zenith during the 64 long years of Queen Victoria's reign. It was this period which really gave birth to the form and function of the current British Army – especially its infantry and cavalry regiments. For me it was particularly the Crimean War (1853–56) which showed the requirement for change. Until then, and during that war, the Army was exactly the same in shape and substance to Wellington's forces at the Battle of Waterloo in 1815. The Crimea exposed just how necessary was the requirement for modernisation and transformation.

In the 1870s as Secretary of State for War it was Edward Cardwell who forced a revolution on the Army by reorganising it root and branch. From his time onwards it was normal for infantry regiments to be linked directly to specific parts of the country. Regiments were both recruited and deployed in their home areas as well as taking regional titles – normally linked to counties. My own regiment, which had been called the 22nd of Foot almost from its formation in 1689, changed its name to the 22nd (Cheshire) Regiment. From then onwards the Regiment became the 'Cheshires' – until, of course, it was reorganised in recent times to become part of the 'Mercians'.

From the 1870s county regiments were reorganised into at least two battalions. One served abroad whilst the other was garrisoned at home in its recruiting area.

For good measure Cardswell also abolished flogging and indeed branding which, together with other liberalising measures, did so much to make service in Her Majesty's rank and file much more attractive and indeed of greater interest to the general public.

Cardwell's reforms reinforced the huge growth in patriotic support for the Army. Wellington's 'scum of the earth' became heroic symbols of all that was great in Great Britain. Soldiers of the Queen came to be 'our boys' doing our business abroad. Stories and illustrations of what our imperial forces did and achieved were greedily devoured by huge numbers of people. Indeed the growth in circulation of some newspapers and periodicals, such as the *Illustrated London News*, was directly encouraged by the military accounts and illustrations they contained.

From 1856 onwards exemplary soldiers who performed amazingly in combat could also be awarded the Queen's special award, the Victoria Cross. From the start VC holders were considered to be so heroic, special and unique that winners were normally lauded publicly until the end of their days. Often they became the pin-ups of the period – particularly in the areas where they lived. Towns and villages became famous simply because such and such a VC holder lived there.

For me, Victoria's soldiers are epitomised by pith helmet, red or khaki tunic, cross belts and Martini Henry rifle with bayonet fixed. Many of the illustrations Ian Hernon has picked back this up, my own personalised image of soldiering in the Victorian period.

This pictorial military history by Ian Hernon is superb and I am delighted to recommend this book to anyone who, like me, finds Queen Victoria's men of war the epitome of soldiering. They were my heroes as a boy and remain so for me to this day.

Colonel Bob Stewart DSO MP
Late the 22nd (Cheshire) Regiment
Former British United Nations Contingent Commander Bosnia 1992–93

PREFACE

Queen Victoria's long and glorious reign, from 1837 to 1901, saw vast social and technological changes and the consolidation of an Empire on which, in the patriotic boast, the sun never set. Huge fortunes were made as native peoples were 'civilised' and as the old, established Great Powers competed with each other for bigger slices of the global cake. It was a golden age of innovation, invention and exploitation, of prosperity, widening prospects and increased social mobility. According to the myth of Pax Britannica it was a period of peace. In reality it was all underpinned by war.

The carving out of empires during a time of turmoil needs military muscle, and Britain had a history of international bare knuckle bruising. Victory over Napoleon had, however, been followed by a period of stagnation in the army and the navy. Victoria's reign saw a massive modernisation in military matters. At her accession, redcoats with outdated muskets were commanded by incompetents who had bought their rank and who remained, at best, gentlemen-amateurs. At her death, soldiers were clad in khaki, were equipped with modern weaponry, and were led by ruthless professionals.

Furthermore, the technologies which drove the Industrial Revolution were harnessed by, and sometimes initiated by, the military. Railways, the telegraph, aerial observation, steam power, improved sanitation, the refinement of explosives and the invention of barbed wire and the machine gun all made warfare more efficient and also more deadly. Social changes at home also had an impact. With the widening franchise came a huge increase in literacy. That led to an insatiable appetite for reading matter, from *The Times* to penny dreadful potboilers. As the newspaper and magazine industry grew into a genuinely mass media, the public were not satisfied with simply waving off their men to war; they wanted reports from the front. Until then officers' dispatches had been published, along with their often biased and self-serving memoirs, but people wanted something more immediate, less littered with official interpretations. The professional war correspondent was born.

The new mass media had a ready-made script based on patriotic fervour. Europe may have been prone to revolution, but riots in Britain – such as those over voting reform, food shortages and religion – never reached fever pitch. Britain under Victoria was the heart of an empire which fed industry and individual wealth, created markets which in turn created jobs, and needed a great deal of flag-waving to sustain it. That in turn needed armed forces driven by the spirit of Britannia. Jan Morris wrote:

> There was hardly a moment of a day, hardly a facet of daily living, in which the face of Empire was not emphasised. From exhortatory editorials to matchbox lids, from children's fashions to parlour games, from music hall lyrics to parish church sermons, the imperial theme was relentlessly drummed. Empire was the plot of novels, the dialogue of plays, the rhythm of ballads, the inspiration of oratorios. It was as though the whole nation was being deliberately disciplined into the imperial fervour.

The telegraph and other advances speeded up the process of both patriotic dissemination and stories from the various fronts, but the development of more sophisticated printing and

THE ILLUSTRATED LONDON NEWS.

REGISTERED AT THE GENERAL POST-OFFICE FOR TRANSMISSION ABROAD.

No. 2099.—VOL. LXXV. SATURDAY, SEPTEMBER 6, 1879. WITH WHOLE SHEET SUPPLEMENT } SIXPENCE. BY POST, 6½D.

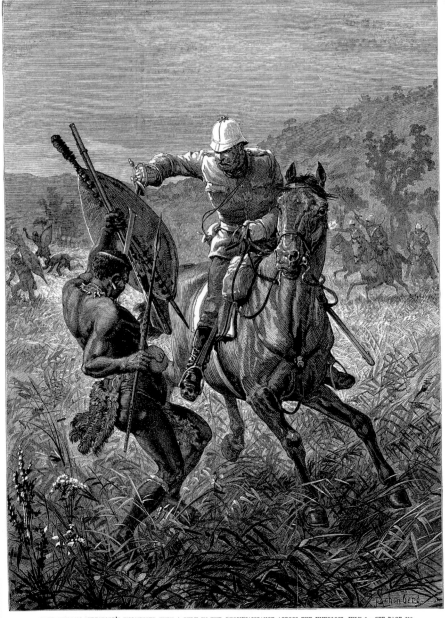

LORD WILLIAM BERESFORD'S ENCOUNTER WITH A ZULU IN THE RECONNAISSANCE ACROSS THE UMVOLOSI, JULY 3.—SEE PAGE 218.
FROM A SKETCH BY OUR SPECIAL ARTIST.

engraving processes were able to fill another demand – illustrations to support the text. For the first time, commercial artists went into battle with the troops, although initially most illustrations were interpretations of sketches sent home by officers and correspondents. The old adage that a picture paints a thousand words may not be exactly true, but they certainly helped bring battlefield prose alive. Military authorities and politicians, at first hostile to the concept of war being brought into the parlour, quickly learnt the propaganda value of illustrated tales of valour.

The purpose of this book is to show, through the illustrations themselves, how the British Army grew in tandem with the mass media of the Victorian age. Between them they created the conditions which led to victory on many fronts, and the trenches of the Somme. The pictorial history left to us shows the humanity and the humour, the courage and the stoicism, and the comradely spirit of Britons at war in far-flung places during that period. They are also sometimes a glimpse of hell, of the persecution of foreign peoples, and the suffering of soldiers on both sides.

This is not a comprehensive history of every war, battle, expedition or skirmish during the period. Some wars, such as the long Xhosa wars in South Africa, did not involve sustained military actions, and were not seen as good enough stories to warrant reporters and artists. The same is partially true of the Maori conflicts, an epic tale in which natives on the other side of the globe learnt lessons of modern warfare more quickly than the colonial forces which never properly defeated them. No disrespect is intended towards the participants; their absence here is not intended to undermine their significance, it rather reflects the lack of illustrations.

Others conflicts are missing because illustrations are either unavailable or too well known. For coverage of such campaigns as the Flagstaff War in New Zealand, the hut tax war in Sierra Leone, the Fenian invasion of Canada, the Benin massacre, the Burma wars, the bombardment

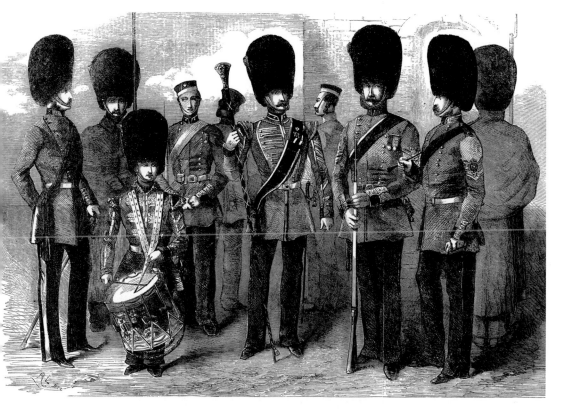

The Coldstream Guards at the time of the Crimea: major, night sentry, drummer, barrack guard, drum major, colour sergeant, drill sergeant and night sentry. (*The Illustrated London News*)

THE ILLUSTRATED LONDON NEWS

REGISTERED AT THE GENERAL POST-OFFICE FOR TRANSMISSION ABROAD.

No. 2095.—VOL. LXXV. SATURDAY, AUGUST 9, 1879. WITH TWO SUPPLEMENTS} SIXPENCE. By Post, 6½d.

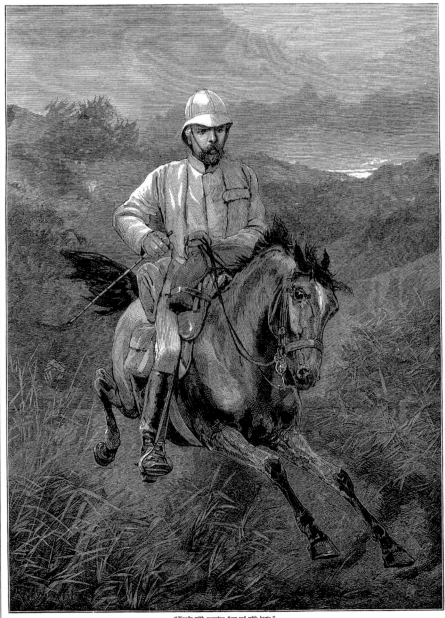

"Bloody with spurring, fiery red with haste."

THE ZULU WAR: MR. ARCHIBALD FORBES'S RIDE FROM ULUNDI.—SEE PAGE 126.

of Zanzibar, the Persian war, the Battle of Orange Walk in Belize, the siege of the Eureka Stockade in the Australian goldfields, and the Riel rebellion in Canada, the reader could do worse than looking at my previous trilogy published as *Britain's Forgotten Wars* (The History Press). Otherwise, regimental detail, logistics, casualty rates, ordnance and tales of derring-do are to be found in the impeccably researched *The Colonial Wars Source Book* by Philip J. Haythornthwaite.

In this book I have used line drawings mainly from the latter half of Victoria's reign, simply because techniques had improved to such an extent that they provided a peak of an art which was later sidelined by photography. I have also deliberately avoided including the best-known illustrations from the period and kept to a minimum portraits of generals festooned with medals, some of them deserved, some not. Instead I have focused on men and machines at war. This book is mainly about the illustrations. Some images are idealised, some may be almost fictitious, but most show the courage, stamina, sense of humour, determination and pragmatism shown by the British soldier and sailor, and sometimes by their enemies.

This book does not concern itself too deeply with the rights and wrongs of imperial expansion. The British Empire, for good or ill, was fought for with fervour and self-interest, but I have tried to avoid imposing twenty-first century judgements or morality on nineteenth-century participants. Some excesses, however, cannot be excused or overlooked, whatever century they are observed from.

I would like to thank Shaun Barrington and Miranda Jewess at The History Press, and the staff at the Kent County Archives, Maidstone. And, as ever, my family.

INTRODUCTION

'Our first drafts of history.'

THE BRITISH MEDIA

The War Correspondent

On 4 July 1879 Archibald Forbes, a former cavalryman and now special correspondent of the *Daily News*, volunteered to carry Lord Chelmsford's despatch on his victory over Cetshwayo's Zulus at Ulundi to Landsman's Drift on the Buffalo River. His 170-mile gallop in 14 hours took the news to the telegraph station to be broadcast to a grateful nation. His motives were not entirely patriotic. He also sent his exclusive report to his London newsroom, along with sketches by his colleague Melton Prior. Forbes' heroic and self-serving feat stirred a nation and generations of journalists. Engravers, armed with the sketchiest of details, got to work both on the battle itself and on how the news was broken. On Saturday 9 August, little more than a month after the action, a picture of Forbes on his epic ride appeared on the front page of *The Illustrated London News*. It described the scene: 'Bold, unwearied, dauntless horseman, bloody red with spurring, fiery red with haste.' Not for the last time, the messenger had become the story.

Forbes, 41 at the time, was a man of his age. He was born in 1838, a year after the teenage Victoria became Queen, the son of a Presbyterian minister, in Morayshire. Educated at Aberdeen University he joined the Royal Dragoons as a private but saw no action. Invalided out, he became a journalist in London, and when the Franco-Prussian War broke out he was sent to the front as a correspondent. Service followed in the Carlist War in Spain, the Serbian campaigns and the Bengal famine of 1873–74. In the 1877 Russo-Turkish conflict he was attached to the Russian Army and remained in the field until struck down with fever. In 1878 he was with the Khyber Pass force at Jalabad, marching with the troops in expeditions against the hill tribes, before moving to Burma. The British disaster at Isandlwana saw him rushing to join Chelmsford's army preparing for a second invasion of Zululand. He had military experience, a reputation for courage under fire and royal connections, having previously accompanied the Prince of Wales in his tour through India. He was truly 'embedded' and the irascible Chelmsford trusted him to report victory after shameful defeat. A rough template for the relationship between the military and the fourth estate was established.

Over 130 years later, to mark a 2011 exhibition at the Imperial War Museum, Michael Binyan wrote:

> It may indeed be vital to tell a nation what its armies are doing, why its soldiers are dying and why governments have gone to war. But it is dangerous, exhausting and frustrating. War reporting can take a huge toll on journalists caught in the thick of battle. They see friends and colleagues killed. They witness some of the most unspeakable atrocities man is capable of committing. They struggle to find the truth and struggle to get it past the censors. They come home traumatised. Yet war correspondents are the men – and increasingly women – who write our first drafts of history.

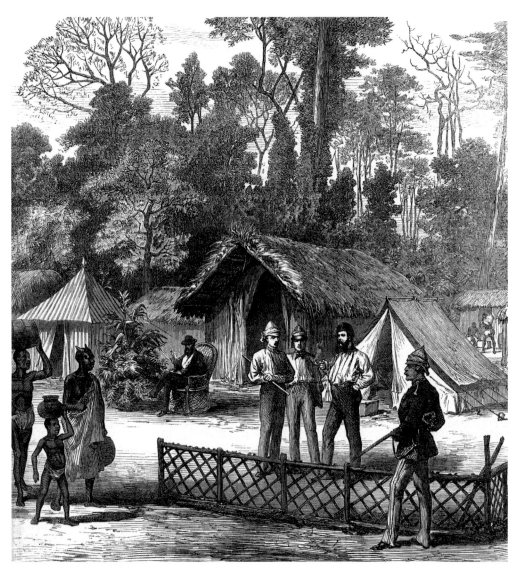

Newspaper correspondents in their quarters in the camp at Prah-Su during the First Ashanti War. Left to right: *The Times, New York Herald, The Illustrated London News, Standard.* (*The Illustrated London News*)

In the Victorian age such thoughts were only half-formed. Journalists were as venal, courageous, career-minded, hopeless, occasionally cowardly, often exhausted, cold, hot, hungry, greedy and grotesque as the commanders and men they reported on. This was an era in which empires were won and lost, nations created and destroyed, all to the tune of patriotic bands and rampant capitalism. In other words, one hell of a good story. But the way that story was told, and later illustrated, was born shortly after Victoria took the throne and ran in tandem with the realisation in military circles that a new age was dawning.

During the Napoleonic Wars, reports were sent by officers with connections eager to supplement their pay, and a ragbag of followers including missionaries, pamphleteers and ambitious glory-hunters. Wellington wrote with contempt: 'Every man who can write, and who has friend who can read, sits down to write an account of what he does not know, and his

comments on what he does not understand.' He regarded it, with some degree of truth, as tittle-tattle which could destroy reputations. Professional correspondents were kept as far away from the action as possible.

That attitude changed near the beginning of Victoria's reign with the disastrous Afghan campaign which sparked a reformist movement within army circles and coincided with a dramatic rise in literacy rates which grew during her rule from 63 to 91 per cent. The abolition of the newspaper tax also saw a surge in the circulations of newspapers and periodicals and the burgeoning influence of the press barons at court and in Parliament. Greater access for journalists was demanded and grudgingly given. But it proved a two-edged sword. William Howard Russell's reports from the Crimea wrecked reputations again, this time with complete justice, and sparked irresistible demands for reform of absurdly redundant and damaging army practices. The fact that Russell wrote with humour and a keen eye for colour made him even more dangerous. A good example is his description of an officer in the Crimea making do during supply shortages:

> It was inexpressively odd to see Captain Smith of the _ Foot, with a pair of red Russian leather boots up to his middle, a cap probably made of the tops of his holsters, and a white skin coat tastefully embroidered down the back with flowers of many-coloured silk, topped by a headdress *a la* dustman of London, stalking gravely through the mud of Balaclava, intent on the capture of a pot of jam or marmalade. This would be rather facetious and laughable were not poor Captain Smith a famished wretch with bad chilblains, approximating to frost-bites, a touch of scurvy, and of severe rheumatism.

The Edwardian historian-MP Justin McCarthy saw the Crimea as the turning point.

> The campaign had been opened under conditions differing from those of most campaigns that had gone before it. Science had added many new discoveries to the art of war. Literature had added one remarkable contribution of her own to the conditions amid which campaigns were to be carried on. She had added the 'special correspondent.' The old-fashioned historiographer of wars travelled to please sovereigns and minister to the self-conceit of conquerors. The modern special correspondent had a very different purpose. He watched the movements of armies and criticised the policy of generals in the interest of some journal, which for its part was concerned only for the information of the public. No favour that courts or monarchs could bestow was worthy of a moment's consideration in the mind of even the most selfish proprietor of a newspaper when compared with the reward which the public could give to him and to his paper for quick and accurate news and trustworthy comment.

Of Russell, McCarthy wrote:

> It was to his great credit as a man of judgement and observation that, being a civilian who had never before seen one puff of war smoke, he was able to distinguish between the confusion inseparable from all actual levying of war and the confusion that comes from distinctly bad administration ... he had the soundness of judgement to know that the confusion was that of a breaking-down system.

Russell enjoyed the fruits of his success. After the Crimea he covered the American Civil War and the Franco-Prussian War, and in 1865 he sailed with the *Great Eastern* to report on the laying of the trans-Atlantic Cable, another technological leap forward. He retired in 1882 and founded the *Army and Navy Gazette*. He was knighted in 1895 and died in 1907.

While Russell is credited with being the first modern war correspondent, there were others before him, such as Henry Crabbe Robinson of *The Times* who covered the Napoleonic Wars and Charles Lewis Gruneison of the *Morning Post* who reported on the Spanish Carlist War,

PUNCH'S FANCY PORTRAITS.—No. 52.

W. H. RUSSELL, ESQ., L.L.D.

OUR OWN CORRESPONDENT—THE MAN FOR THE TIMES.

but Russell's despatches had far more impact. A soldier who met him on the front line outside Sebastopol described him as 'a vulgar low Irishman who sings a good song, drinks anyone's brandy and water and smokes as many cigarettes as a Jolly Good Fellow. He is just the sort of chap to get information, particularly out of youngsters.' It made him unpopular with the senior officers whose incompetence he exposed and who tried to prevent their men speaking to him. Russell's prose was supported by Fenton's ground-breaking, if static, photography.

 The best correspondents were always found close to the action, sharing the privations of the front line troops rather than the fine wines at a general's table. Robert Furneaux wrote of the successors to Russell:

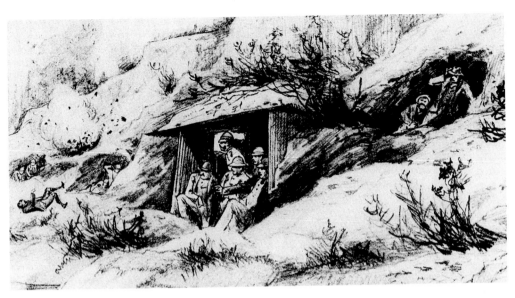

The war correspondents' shelter during the siege of Ladysmith. (*Cassell's Magazine*)

They galloped their horse and rode the trains through many campaigns in the mountains and valley of the Balkans, the frontiers of India, the plateaux of Central Asia, the veldt of Zululand and Natal, the deserts of Egypt and the Sudan ... while a new and eager newspaper-reading public clamoured for their stories.

Some, like Archibald Forbes, became the story. When the *Morning Post*'s Winston Churchill was captured by Boers, he remarked: 'This will be good for my paper.' His escape and evasion of pursuers turned him into a national hero and his articles and books on his adventure earned him £10,000 to lay the foundations of his political career.

The Artists

Then there were the war artists. British officers had for a century been taught to sketch topography as a way of communicating the lie of the land and the deployment of enemy positions. Sketching was also considered a gentleman's pastime to wile away unproductive hours in barracks and camps. They began to send their sketches for usually anonymous publication, as it was a good way of supplementing their pay. Journalists did the same, and their rough sketches were turned into minor masterpieces by the professional draughtsmen, artists and engravers sitting safely in their offices and studios. The first generation of draughtsmen included John Gilbert, Birket Foster and George Cruikshank, while the engravers included W.J. Linton, Ebenezer Llandells and George Thomas. But as the public appetite for increasingly sophisticated and realistic depictions grew, the professional war artist emerged. They are embodied, in the latter period of Victoria's reign, by Melton Prior.

Prior was born in London's Camden Town in 1845 and studied under his father William Henry, a landscape painter. In 1873 he was recruited by *The Illustrated London News* to cover the Ashanti War. This successful commission was followed by sketching assignments in Spain during the Carlist War and in Herzegovina during the Russo-Turkish War. He witnessed the Battle of Ulundi and stuffed his sketches into the pack of Archibald Forbes before the correspondent's epic ride, and he was with the group who discovered the Prince Imperial's body. In the following decades he sketched the aftermath of the British carnage at Majuba Hill during the First Boer

The artist Melton Prior in 1901. (*The Illustrated London News*)

War, covered the destruction of the Egyptian Army at Tel-el-Kebir, accompanied the relief expedition for General Gordon in the Sudan, witnessed the Battle of Abu Klea, and illustrated operations in Burma and the North-West Frontier before returning to South Africa where he was besieged at Ladysmith. His last campaigns were in Somaliland in 1903 and the Russo-Japanese War of 1904–1905. He died in London in 1910.

 Prior was hands-on during his entire career, but another artist, also featured heavily in the following pages, eventually swapped front line action for grand canvases completed from imagination and folklore in studios. Richard Caton Woodville was born in 1856, the son of a talented artist. He studied at Dusseldorf School of Painting under Prussian military artists which gave him a taste for epic panoramas. But he could write as well as he could paint and he joined *The Illustrated London News*, which in 1877 sent him to cover the Russo-Turkish War.

The artist Richard Caton Woodville. (*Random Recollections* magazine, 1914)

He impressed his editors and his coverage of the 1882 Anglo-Egyptian War won him more kudos, particularly when some of his paintings from sketches and – unusually for the time – photographs were exhibited at the Royal Academy. He stayed with *The Illustrated London News* for most of his journalistic career, but also reported for the *Strand Magazine*, the *Cornhill Magazine* and the *Tatler*. However, eventually his reputation as perhaps England's premier battlefield artist made it more profitable to stay at home and depict historic battles, including Blenheim, Badajoz, Waterloo and the Charge of the Light Brigade rather than contemporary conflicts. He was a passionate advocate of the British Army, joining the Berkshire Yeomanry in 1879. On the outbreak of war in 1914 he joined the Reserves as a captain and his Great War paintings were also displayed in the Royal Academy. In 1927 he killed himself with a revolver in his St John's Wood studios.

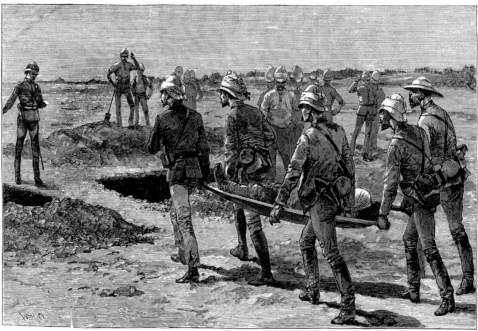

The death of John Cameron, special correspondent of the *Standard*, at the Battle of Abu Klea, and his comrades bearing his body to a desert grave. Melton Prior is the lead/left stretcher bearer. (*The Illustrated London News*)

Artists (and correspondents) were classified as non-combatants but they shared the danger, the conditions and, in many cases the weaponry of the troops themselves. The *Daily Telegraph*'s Bennet Burleigh was mentioned in dispatches for helping to steady the line at Abu Klea, firing continuously despite being hit in the neck by a spent bullet. Many others never came home. Thomas Bowlby of *The Times* was tortured to death in China, while the same publication's Frank Power was captured and killed by the Mahdi's men, and Hubert Howard was slain by a stray British shell at Omdurman.

The *Daily Mail's* George Steevens died of fever at Ladysmith, while John Cameron of the *Standard* and St Leger Herbert of the *Morning Post* were shot dead at Abu Kru.

But the pictures and prose they sent home had an astonishing impact and were used to boost both national pride and prick national consciences. Most of the artists were men of their time – white, imperialist, racist by today's standards. The slaughter of natives and the portrayal of non-white foreigners cowering under British assault can make uncomfortable viewing. The propaganda element is obvious throughout: grateful blacks provide water for the white masters and liberators; over-elaborate Afghans and Sudanese are portrayed as savage fanatics.

Some illustrations can be categorised as blatant propaganda, others sensationalised to feed the public's appetite for depictions of dramatic events. During the First Boer War the British

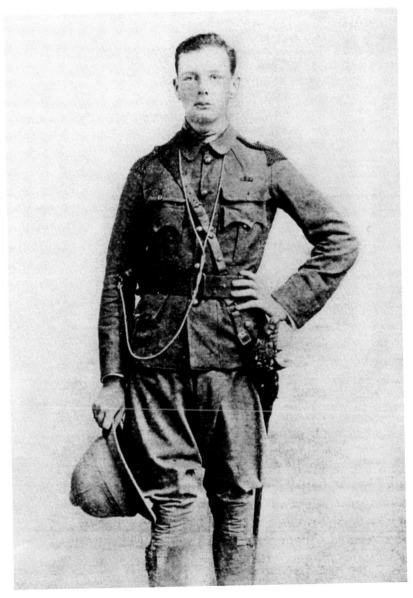

Winston Churchill in Cairo attached to the 21st Lancers, 1898.

press was full of lurid accounts of 'Boer atrocities', including shooting the British wounded, even though General Colley had telegraphed that the Boers had 'treated the wounded with courage and humanity'. But the depiction of the alleged inhumanity of the enemy became a staple of illustrated reportage. In the second, much larger, Boer conflict the Boers were shown stripping the British dead, while the burning of Boer farms was shown as just retribution against 'known rebels'. The Boers were shown setting fire to the veldt while British concentration camps were hardly ever featured. Similarly the worst atrocities of both conflicts were rarely depicted – the slaughter by the Boers of any blacks caught with a firearm, along with their families. War was portrayed as a two-dimensional struggle between good and bad. Such struggles made the nation feel better about itself; that was the nature of the mass market, and in many respects it still is.

But by and large the Victorian illustrators did not shy away from depicting the horrors of warfare. Images from the Crimea showed limbless veterans as well as glorious charges. The scorched earth policy of Kitchener may have been sanitised, but it was nevertheless exposed. The images hammered home the cost of war, as the dead, the maimed and the wounded were shown alongside the heroes. As the century progressed there was also an increasing focus on technology and the effort needed to maintain modern warfare – men struggling with mighty cannon, telegraph lines cut, trains attacked, the effect of long-range firepower and the might of the ironclads.

Most images were composites completed by professionals in newspaper and magazine offices back home. Hasty sketches made by officers at the front, the more detailed drawings of artists in the war zone, the written reports from journalists and combatants, were put together in rough approximation of the actual scene. That naturally led to dramatisations, which was exactly what the public wanted. The depiction of Ulundi, for example, from Melton Prior's sketches carried by Archibald Forbes, is shown from the Zulu perspective, an impossible position for a British

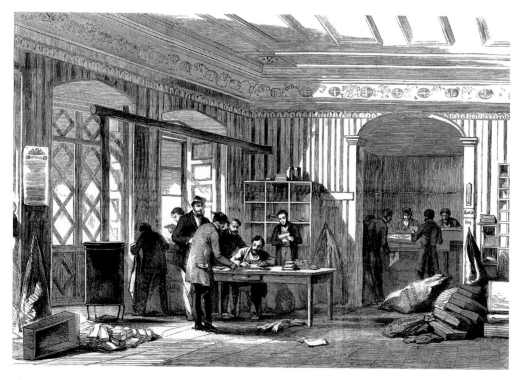

The British Army post office in Constantinople during the Crimean War. (*The Illustrated London News*)

observer. Many of the drawings from the Crimean War were relatively static, showing events behind the lines. But these have a raw honesty which, to my eyes, makes them more valuable than the panoramic battle scenes often based on popular paintings by artists far from the action. As the century progressed the public demanded ever more dramatic and gruesome portrayals. That meant artists such as Prior had to cram in many participants and events taking place over a wide area into one frame – just as Hollywood does today.

The Newspapers

Until Victoria's accession, newspapers and magazines looked dull, heavy with tiny type. Early illustrations were poorly engraved, crude and mainly portraits of the great (royalty, statesmen and aristocrats), the good (churchmen and idealised depictions of bucolic utopia) and the ugly (condemned criminals and hanged men). Even so, politician, printer and newsagent Herbert Ingram noticed that the *Weekly Chronicle* always sold more copies when it contained illustrations. Ingram, born in Boston, Lincolnshire in 1811, was unable to invest in his idea until he made a small fortune by buying the patent rights to a laxative known as Parr's Life Pills. He decided to publish a weekly publication containing illustrations in every edition. Initially he planned to focus on crime, to ape the limited success of the *Illustrated Police News*, but when he moved to London to set up shop his collaborator Henry Vizetelly convinced him that coverage of general news would be more popular.

Ingram rented an office and, with the guidance of *Punch* editor Mark Lennox, recruited artists, engravers and reporters. He appointed Frederick Naylor Bayley, formerly of the *National Omnibus*, as his editor. Ingram promised to bring to the public 'the very form and presence of events as they transpire, and whatever the broad and palpable delineations of wood engraving can achieve, will now be brought to bear upon every subject which attracts the attention of mankind.' The first edition of *The Illustrated London News* appeared on 14 May 1842. Its 16 pages included 32 wood engravings of the US Presidential elections, a steamboat accident, a train crash, a fancy dress ball at Buckingham Palace and, significantly, the ongoing Afghan war. It sold 26,000 copies at sixpence each. Ingram was a staunch Liberal and he promised also to focus his publication on the plight of the 'English poor'. The public, however, wanted drama, costumes, blood and thunder.

The next two editions saw sales dip but Ingram sent a copy with engravings of the inauguration of the Archbishop of Canterbury to every Church of England clergyman across the country, a tactic which won him many new subscribers amongst their congregations. By the end of its first year the ILN's circulation hit 60,000.

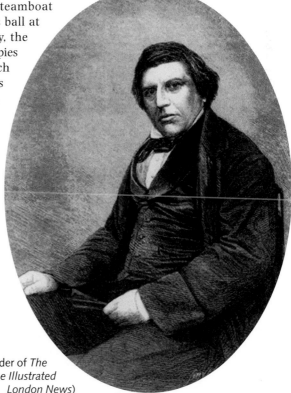

Herbert Ingram, founder of *The Illustrated London News*. (*The Illustrated London News*)

In 1852 Ingram published another scoop, printing Joseph Paxton's designs for the Crystal Palace before even Prince Albert had seen them, and circulation rocketed to 130,000. In 1852 a special edition on the funeral of the Duke of Wellington sold 150,000 and during the Crimean War Roger Fenton's photographic record saw sales of 300,000 copies a week, an astonishing circulation for the time.

By then Ingram was dead, killed on 8 September 1860 in a paddle-steamer accident on Lake Michigan. But his entrepreneurial skills, showmanship and nose for what the public wanted had created an industry and seen off all his rivals. Through his periodical the public saw things they could only dream of disbelievingly before: a street scene in Tangier, gold-mining in Colorado, the mountains of the Hindu Kush and New Zealand, and their own menfolk battling against the elements and the enemy on almost every continent. He is seen as the father of pictorial journalism.

The new illustrated periodicals relied for their revenue on the explosion in consumerism during Victoria's reign. All the combustibles, fripperies and exotica which were deemed, if not essential, then desirable to a Victorian household were to be found within their pages. One *Illustrated London News* page, dated 27 September 1884, contained advertisements for the following: furniture stock from the London Louvre; window-blinds; Beetham's rose leaf toilet powder;

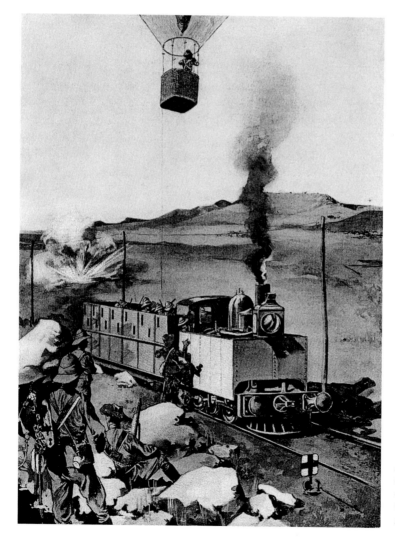

Armoured train and observation balloon outside Ladysmith. (*Cassell's History of the Boer War*)

A Boer telegraph wire-cutter is shot down. (*Cassell's History of the Boer War*)

velveteens; children's double-knee stockings; Eno's fruit salt recommended by a naval veteran of the Zulu war; the Coventry Chair tricycle; Beghin's genuine French-made boots and shoes; Hudson's extract of salt; and the sea view at the St Mildred's Hotel, Westgate-on-Sea.

Apart from newspapers, publishers produced hugely popular instant histories of wars, often while they were still being fought, in weekly or monthly instalments which relied heavily on drawn and painted illustrations. These were then collected and published in book form. One such was Harmsworth's *With the Flag to Pretoria* which ran from 1901. Another, which I have plundered in this volume, was *Cassell's Illustrated History of the Boer War*.

Cassell's Family Magazine had been published since the 1850s but was reborn as *Cassell's Magazine* in 1897 as a 'pulp' version of the *Strand Magazine*. Under the editorship of Max Pemberton until 1905 it attracted such writers as Robert Louis Stevenson, J.M. Barrie, H. Rider Haggard and Arthur Conan Doyle to its sensationalist stable. Its illustrators, who sadly remain anonymous, combined realistic depictions of a soldier's life in the Boer theatre of operation, battle scenes suspiciously close to the action, 'humorous' incidents and gung-ho propaganda. These images still have the power to grip and fire the imagination over what it must have been like to be a soldier of the Queen.

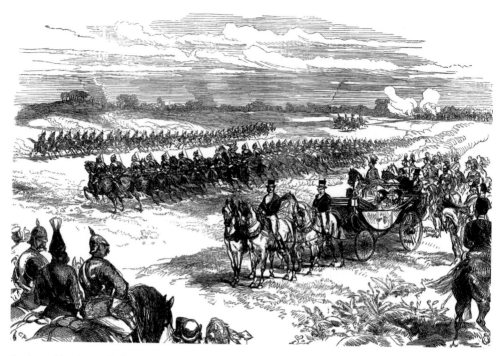

Review of the troops before Queen Victoria at Chobham, June 1874. (*The Illustrated London News*)

Technological Advances

By the last fifteen years of Victoria's reign the pace of technological advances in print and communications had speeded up. The linotype printing press was introduced in 1886, to be quickly followed by three-colour printing, and photographic techniques allowed better quality pictures to be printed in huge numbers through the new rotary presses. In 1892 the first automatic telephone switchboard was up and running, and three years later Marconi invented wireless telegraphy and moving cinematographic pictures began to emerge. Cars were beginning to appear on the roads and it would not be long before powered flight became possible. Some military commanders were slow to see the possibilities; during the Boer War some still preferred to trust heliograph signals which needed sunlight and could be seen by the enemy, rather than exploit the new-fangled electric telegraphy. But the British press embraced change and increasingly photographs became the standby of such publications as *The Illustrated London News*.

The art of line drawings and painted works, however, was not dead. Studio photographs of generals and general views of the aftermath of battle were no substitute for the often ersatz immediacy of the likes of Prior and Woodville.

THE BRITISH ARMY

The Soldiers

The men of Victoria's army were famously described by the Duke of Wellington as:

> The scum of the earth – the mere scum of the earth. It is only wonderful that we should be able to make so much of them afterwards. The English soldiers are all fellows who have enlisted for drink – that is the plain fact. People talk of them enlisting from their fine military feeling – all stuff – no such thing. Some of our men enlist from having bastard children – some for minor offences … you can hardly conceive such a set brought together.

Yet he could also say with pride: 'There are no men in Europe who can fight like my infantry ... my army and I know one another exactly ... Bravery is the characteristic of the British Army in all quarters of the world.'

Around 60 years later, in his general orders for the 1873 Ashanti Expedition, General Sir Garnet Wolseley wrote:

> English soldiers and sailors are accustomed to fight against immense odds in all parts of the world; it is scarcely necessary to remind them that when in our battles across the Pra [River] they find themselves surrounded on all sides by hordes of howling enemies, they must rely on their own British courage and discipline, and upon the courage of their comrades.

Such men waded through malarial swamps, hacked through jungles and clambered over mountain crags, fighting for one another rather than their country. They also grumbled and dodged duties, drank, stole and fought each other; they often abused natives and occasionally slaughtered the defenceless. But without them no Empire would have been won, whatever the genius of generals and strategists, whatever the ambitions of monarchs and politicians. 'But for this a price must be paid,' wrote Sir Arthur Conan Doyle,

> ... and the price is a grievous one. As the beast of old must have one young human life as a tribute every year, so to our Empire we throw them day to day the pick and flower of our youth. The engine is worldwide and strong, but the only fuel that will drive it is the lives of British men.

The horrors of warfare haunted the ordinary soldier and often sleep gave no respite. William Forbes-Mitchell described the aftermath of the carnage during the Indian Mutiny:

> The horrible scenes through which the men had passed during the day had told the terrible effect on their nervous systems, and the struggles – eye to eye, foot to foot, and steel to steel – with death in the Secunderabagh, were fought over again by most of the men in their sleep, oaths and shouts of defiance often curiously intermingled with prayers.

Food was a constant cause of complaint. Russell wrote:

> Meat is bad and dear. The beef being very like coarse mahogany; the mutton is rather better, but very lean. Milk is an article of the highest luxury and only seen at the tables of the great; and the only attempt at butter is rancid lard packed in strong-smelling camel's-hair.

Faith in God was used to stiffen army morale according to Lawrence James:

> Sermons given by Anglican chaplains to troops in the 1842 Afghan campaign concentrated on the familiar themes of moral regeneration. Soldiers were asked to trust in Jesus as they would their commander and to fight depravity as they would the Pathans. If the

Field Marshal, the Duke of Wellington.
(Sir Thomas Lawrence)

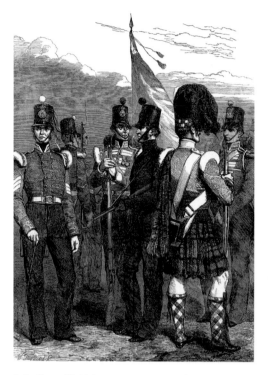

Selection of British troops serving in the Crimea. Left to right: recruiting sergeant, 33rd Duke of Wellington's Regiment; 3rd Buffs marching order; 9th Regiment marching order, Rifle Brigade, 93rd Highlanders; 55th Regiment. (W. Thomas)

Royal Marines in the Crimea. Left to right: Colour Sergeant (artillery); private; drummer. (George Thomas)

preachers touched on preparation for death and salvation, it was in terms of redemption through the repudiation of the soldier's favourite sins. 'Flee fornication', 'Swear not at all' and 'Be not drunk with wine wherein is excess' were texts recalled by one listener.

Soldiers' attitudes reflected the inherent racism of the time, but officers and men respected a gallant, brave and effective foe even if they and their comrades suffered as a result. An unnamed officer-correspondent, writing in *The Illustrated London News* during the Second Sikh War, described the foe during the Battle of Ramnaggur:

> Nothing could exceed the accuracy of the enemy's fire; their range was beautifully taken for certain points, showing that they must have discovered them previous to our advance; and our artillery officers say they never saw anything finer than the way their Horse Artillery were brought up to the edge of the river, and formed up. No nation could exceed them in the rapidity of their fire. No men could act more bravely than the Sikhs. They faced us the moment we came on them, firing all the time, and, when we did come on them, some opened out and immediately after closed round us, while others threw themselves on their faces or turned their backs, protected by a shield from the strike of the Dragoon sabre, and the moment that was given, turned around, hamstrung the horse, and shot the rider, while their individual acts of bravery were the admiration of all.

Such respect disappeared, however, if the British soldier was encouraged to seek revenge on a non-white enemy even suspected of outrages against white women and children, as was demonstrated to horrible effect during the Indian Mutiny. Such encouragement came from their

British Guards serving in the Crimea. Left to right:
1st Grenadiers marching order; Coldstreams night
sentinel; Coldstreams drummer; Royal Fusiliers
barrack guard. (W. Thomas)

officers. Lieutenant Kendal Coghill wrote home in the early stages of the Mutiny: 'We burnt every village and hanged all the villagers who had treated our fugitives badly until every tree was covered with scoundrels hanging from every branch.' The massacre of British women and children at Cawnpore created a bloodlust amongst even the most civilised British officers, and the desire for vengeance was passed on to the rank and file. Lieutenant Arthur Lang of the Bengal Engineers wrote:

Every man [rebel] across the river whom I meet shall suffer for my visit to Cawnpore. I will never again, as I used to at Delhi, let off men who I catch in houses or elsewhere. I thought when I had killed twelve men outright and wounded or knocked over as many more at the Battle of Agra, that I had done enough. I think now I shall never stop, if I get the chance again.

Mutiny aside, the British soldier's treatment of a fallen enemy was always patchy, and depended on the circumstances. Subadar Sita Ram, serving with the Bengal Native Infantry at the Battle of Sobraon, recalled seeing an English soldier preparing to bayonet a wounded Sikh:

To my surprise, the man begged for mercy, a thing no Sikh had ever been known to do during the war. The soldier then pulled off the man's turban and jacket, and after this I saw him kick the prostrate man and then run him through several times with his bayonet. Several other soldiers kicked the body with great contempt and ran their bayonets through it. I was told later that this was a deserter from some European regiment who had been fighting with the Sikhs against his comrades.

Looting was endemic in the British Army, often condoned as retribution, and regarded as the legitimate spoils of war. The sacking of the Old Summer Palace at the end of the Second Opium War was sanctioned by senior British staff. But the wanton destruction and thievery in other theatres appalled some observers. William Howard Russell, after witnessing the fall of Lucknow during the Indian Mutiny, wrote in his diary:

These men were wild with fury and lust for gold – literally drunk with plunder. Some come out with china vases or mirrors, dash them to pieces on the ground, and return to seek more valuable booty. Others are busy gouging out the precious stones from the stems of pipes, from saddle-cloths or the hilts of swords. Some swathe their bodies in stuffs crusted with precious metals and gems; others carry off useless lumber. One fellow, having burst open a leaden-looking lid, which was in reality solid silver, drew out an armlet of emeralds and diamonds and pearls so large that I really believe that they were not real stones and that they formed part of a chandelier chain.

British infantry in barracks. (*The Illustrated London News*)

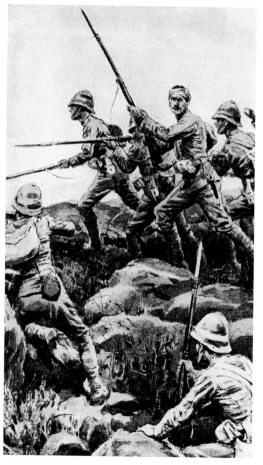

British troops take Leeuw Kop during the Second Boer War. (*Cassell's History of the Boer War*

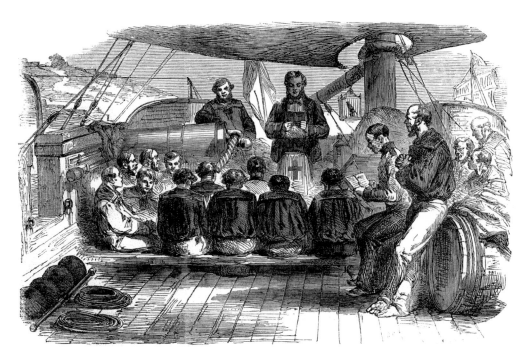

The crew of a gunboat at prayers on the Canton River during the First Opium War. (*The Illustrated London News*)

The execution of a Ghazi, 'or Mohammedan fanatic', at the Peshawar Gate, Jellalabad, during the Second Afghan War. (*The Illustrated London News*)

The soldier offered them to the journalist for 100 rupees.

Drunkenness was a constant problem in British regiments. In one year alone the men of the Madras European Battalion committed 357 such offences, not counting those dealt with quietly by officers on the spot. Young officers, unused to the military drinking culture, were not exempt to punishment but were dealt with less harshly than the rank and file. These men were generally uneducated; at the beginning of Victoria's reign the most fertile recruiting ground was amongst the rural poor. But as the century progressed, more men came from the cities that had expanded during the Industrial Revolution. The army offered these men an escape from poverty, as well as the security of a regiment which they rarely left, save feet first.

Death and Disease

Tens of thousands of letters were sent home informing loved ones of grievous loss. One, quoted by Russell after the Battle of Alma, read in part:

> I am heart-sick at the loss of so many dear and valued friends ... God alone can comfort us in these overwhelming calamities, and to His almighty will let us humbly bow. Your dear boy died instantly, without pain, and lies buried in a deep grave along with his brave comrades, close to the spot where he so nobly died. P.S. – Harry Torrens and Bulwar buried him. His wound was in the centre of his breast. He lay on his back, and his body had been untouched and respected. God bless him and save him. His face was calm, with almost a smile upon his face.

We will never know whether the writer was being truthful or was just intent on sparing the bereaved family further anguish. Most soldiers died horribly; the nature of Britain's wars (the weaponry and adversaries) meant that a dead comrade was more likely to be found with shattered limbs, disembowelled, or with severed genitalia, rather than a clean bullet to the heart. And too often the corpses were hurriedly disposed of in shallow graves.

Russell described the scene at a makeshift British hospital outside Sevastopol after a skirmish:

In this garden could be seen men with every description of wound, from the sabre-cut to the grape and canister shot. One poor fellow's leg was taken off while we were there, nor can one easily forget the shocking scenes, the result of such a day's fighting. The surgeons of the Greys were working away with their sleeves turned up, arms bloody, faces the same, looking more like butchers than surgeons, so hard they worked all day.

'Horrors of war – the news of the battle.'
(*The Illustrated London News*)

Although Russell's reports are credited with changing attitudes to the treatment of the British sick and injured, that of *The Times*' Constantinople correspondent, Thomas Chenery, actually had more impact.

> It is with feelings of surprise and anger that the public will learn that no sufficient medical preparations have been made for the proper care of the wounded. Not only are there not sufficient surgeons – that, it might be urged unavoidable – not only are there no dressers and nurses – that might be a defect of a system for which no-one is to blame – but what will be said when it is known that there is not even linen to make bandages for the wounded?

In home barracks a man could expect to be hospitalised once every thirteen months, but overseas the rates rocketed. Diseases such as malaria and dysentery ravaged British soldiers, and in some campaigns killed ten men for every one who died in action. Incompetence and corruption added to the hardships of the ordinary soldier. That was not surprising in malarial zones, but was unforgivable on European soil, even during a Russian winter. The Welch Fusiliers lost 754 men during the Crimean War, 530 of whom died of disease. Such mortality rates caused an outcry at home, and Florence Nightingale's campaign, continued long after she left the military hospital at Scutari, helped to raise awareness of hygiene, uncontaminated food and water and the treatment of the wounded. General Wolsely was one commander who recognised the lessons learnt – he took 70 doctors for the 2400 men on the Ashanti Expedition. But throughout Victoria's reign disease was the soldier's most dangerous foe.

Medical advances in the middle of the nineteenth century, such as the introduction of chloroform as a general anaesthetic, slowly transformed battlefield surgery, but only in the face of bull-headed prejudice. John Hall, senior army medical officer in the Crimea, instructed his surgeons not to use chloroform when operating on gunshot wounds. He told them: 'The smart of the knife is a powerful stimulant and it is much better to hear a man bawl lustily, than to see him slip silently into his grave.' His reported comments caused public outrage and he was forced to rescind his order. But the hacksaw and the cauterising iron remained the most common tools in army hospitals, and infections continued to take a heavy toll until the widespread use of antiseptics much later in the century. It was an aspect of war which soldiers rarely described in letters home. When they did write of their injuries, it was often with remarkable sang froid, as when Harry Lumsden described being wounded when preparing to attack the Sikhs at Sobraon in 1846:

> I was shot through the foot by some desperate rascal but I was so excited at the time that I scarcely knew that I had been hit ... an officer of the 10th Foot, seeing that I was wounded, [gave] me a glass of brandy, which refreshed me very much, and enabled me to do my duty until the action was over. My foot was so swollen that I was obliged to get one of the men to cut the boot and stocking off. When I got home I was obliged to have the wound opened from end to end, and all sorts of queer little bones came out, I shall now be able to put on a much more fashionable boot. If you hear of an old boy wishing a cure for corns, just recommend them to have a musket shot sent through them.

The Commanders

Aside from disease, another major killer was – at least during the first part of the Victorian era – the poor quality of British officers. While there were some great fighting generals and middle-rankers, they were the exception; for every General Napier there were ten Raglans. Justin McCarthy wrote scathingly: 'A battle in the Crimea with which generalship had anything particular to do has certainly not come under the notice of this writer.' He quoted one general saying: 'I have no orders to give; I have but to point at the enemy.'

> This seems to have been the general principle on which the commanders conducted the campaign. There were the enemy's forces – let the men go at them any way they could ... The soldier won his battle always. No general could prevent him from doing that.

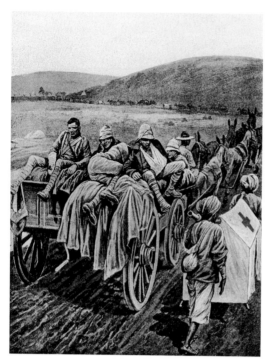

Bringing the wounded from Elandslaagte to Ladysmith. (*Cassell's History of the Boer War*)

During the early years of Victoria's reign, the widespread hopelessness of the officer class was due to the long-established practice of allowing the rich to purchase commissions and promotions regardless of ability. Untrained aristocrats had absolute power over their men, both on the battlefield and in barracks, and few were up to the job. Their courage was rarely questioned – although acts of cowardice were not unknown – but their main weaknesses were ignorance of the arts of war, including tactics and logistics, and contempt for their own men. Their failures were recognised, and not just by the men under their command. Lieutenant-General Sir Archdale Wilson wrote home during the attack on Delhi:

I have not a Queen's Officer under me worth a pin, or one who can preserve any sort of discipline ... In fact the men are so badly officered that they will and can do nothing. I do not suppose that any Commanding Officer had such wretched tools to work with, as I have. The only good officers I had are killed or wounded, and *such* a set left, no head, no control over their men...

One colonel during the same campaign was variously described as 'a perfect fool', 'a funk stick' and 'just a lot of blether.' That, admittedly, was aimed at an officer of the British East India Company, an army staffed by the elderly and infirm because of the slow rates of promotion, but it was also true of the regular army. The lack of good commissioned officers meant that NCOs – sergeants in particular – became the backbone of Victoria's army.

Weaponry

The Industrial Revolution provided the technologies which transformed British imperial warfare. In 1830 soldiers were still using Napoleonic-era muskets. By 1851 they were rearmed with the Minie rifle, accurate to 800 yards and capable of cutting down enemy cavalry charges before they reached British lines. By 1866 the breech-loading Snider rifle was introduced, allowing soldiers to load and fire while lying behind cover for the first time. Each decade brought improved versions: the Martin-Henry during the 1870s and the Lee Metford by the end of the 1880s. By 1891 smokeless powder was introduced, vital for those firing from hidden places.

In 1884 the American Hiram Maxim began manufacturing a battlefield weapon of mass destruction. His machine gun was capable of firing 600 bullets a minute, using energy captured from each successive shell. The British Army enthusiastically adopted the weapon not just for use against massed ranks of troops, but also to cow and kill natives in the Empire's more unruly lands. It was to show 'savages' that industrial might would crush anyone who dared challenge Britain's authority. A contemporary ditty ran: 'Whatever happens, we have got, The Maxim gun, and they have not.'

The development of field artillery was steady throughout the century, with the light six-pounder the mainstay on many battlefields. It was reliable, easily mobile and had a range of 1200 yards. The

'Replenishing the Larder.' (*Cassell's History of the Boer War*)

'A patrol set fire to the house of a notorious rebel.' (*Cassell's History of the Boer War*)

breakthrough was the development of shrapnel packed in hollow shells with a time fuse designed to explode over the heads of a massed enemy. During the Sikh Wars a witness recorded how it was used to mow down warriors at a river crossing: 'Never was it more clearly demonstrated that shrapnel, when directed with precision, is one of the most formidable and effective inventions of modern times.'

The Victoria Cross

For the first decades of the Victorian era official recognition for heroism was rare, particularly for other ranks. Rewards came in the form of promotion, mentions in dispatches, pensions, some security post-service and pride in regimental colours rather than medals. Prince Albert recognised that and persuaded Victoria to offer rewards 'for valour.' In January 1856, as the Crimean War was ending, she instituted the Victoria Cross with the order 'Our will and pleasure is that the qualification shall be conspicuous bravery or devotion to the country in the presence of the enemy.' On 26 June that year she presented it to 62 veterans of the Crimea.

The fourth man to receive it – although arguably the first to win it – was 20-year-old midshipman Charles David Lucas. Almost exactly two years earlier the Armagh teenager, already a veteran of Burma, was in command of a six-gun battery on HMS *Hecla* bombarding Russian batteries off Bomarsund in the Baltic. Russian batteries fired back with 24lb shells, one of which landed, its fuse spitting flame, on the deck. As his comrades took cover, Lucas seized the shell and threw it over the side where it exploded a second or two later. Many decades later, as a retired Rear Admiral, Lucas said of the incident: 'I didn't stop to think much. You can't cast about for an elaborate plan of action when fate puts a pistol to your head.' Lucas died in 1914, just as another greater conflict changed the nature of warfare forever.

Lucas' VC inspired fierce debate, as his action did not strictly qualify him for the award: he had not been 'in the presence of the enemy'. Such was also the case when five men of the South Wales Borderers were given the medal; they were part of expedition sent to investigate reports that shipwrecked sailors had been butchered by natives on the Andaman Islands. Two boats full of soldiers were rowed towards the shore but got into difficulties. Another boat of volunteers led by Assistant-Surgeon Campbell Mellis Douglas went to their rescue, and managed to save at least seventeen men. But they never saw the enemy, breaching the Queen's order, and while they kept their medals, the Victoria Cross was never awarded against unless the candidate had indeed been 'in the presence of the enemy.'

The Green Hill battery under fire before Sevastopol. (*The Illustrated London News*)

As well as personal heroism, the men of the British Army were capable of the shared heroism of well-drilled, disciplined soldiers. At the Battle of Sobroan, a Sikh soldier, Hookum Singh, watched in awe as the British infantry marched towards his rampart.

Nearer and nearer they came, as steadily as if they were on their own parade ground, and in perfect silence. A creeping feeling came over me; this silence seemed so unnatural. We Sikhs are, as you know, brave, but when we attack we begin firing our muskets and shouting our famous war-cry, but these men, saying never a word, advanced in perfect silence. They appeared to me as demons, evil spirits, bent on our destruction, and I could hardly refrain from firing. At last the order came … and our whole battery as if from one gun fired into the advancing mass. The smoke was so great that for a moment I could not see the effect of our fire, but fully expected that we had destroyed the demons, so, what was my astonishment, when the smoke cleared away, to see them still advancing in perfect silence, but their numbers reduced to about one half. Loading my cannon, I fired again and again, making a gap or lane in their ranks each time; but on they came, in that awful silence, till they were within a short distance of our guns, when their colonel ordered them to halt and take breath, which they did under heavy fire. Then, with a shout, such as only angry demons could give and which is still ringing in my ears, they made a rush for our guns, led by their colonel. In ten minutes it was all over; they leapt into the deep ditch or moat to our front, soon filling it, and then swarming up the opposite side on the shoulders of their comrades, dashed for the guns, which were still defended by a strong body of our infantry, who fought bravely. But who could withstand such fierce demons, with those awful bayonets, which they preferred to their guns – for not a shot did they fire the whole time – then, with a ringing cheer, which was heard for miles, they announced their victory.

Travel and Transport

Fighting for the common soldier was generally only the culmination of any campaign. For the most part, after rigorous training in home barracks, the soldier who had probably never have been outside his town or county of birth, had to endure long sea voyages, often packed into cramped, unsanitary and lumbering transport ships. Seasickness was a shared misery, followed by more serious disease which meant that many never reached their destination, or were too sick to fight when they arrived. Shipwrecks were all too common. One of the most famous of the Victorian era, and one which showed the discipline and self-sacrifice of soldiers, was the loss of the *Birkenhead* off the coast of South Africa in February 1851. She was a modern, iron steamship, packed with troops and army families on their way to India, which struck a submerged rock. The soldiers stood in ranks on the open decks as the order 'women and children first' was observed. One of the few survivors, Captain Wright of the 91st, wrote:

The order and regularity that prevailed on board, from the time the ship struck until she totally disappeared, far exceeded anything I thought could be exceeded by the best discipline; and it is to be the more wondered at, seeing that most of the Soldiers were but a short time in the Service. Everyone did as he was directed, and there was not a murmur or a cry among them until the ship made her final plunge. I could not name any individual officer who did more than another. All received their orders and carried them out as if the men were embarking instead of going to the bottom; there was only this difference, that I never saw any embarkation conducted with so little noise or confusion.

Of the 693 on board, 454 perished, most of them soldiers.

Once on solid ground, most soldiers spent their days marching. The Welch Fusiliers' Official History said of the campaign against the Boers as the century closed:

Averaging nearly 17 miles a day, over apparently endless prairies, in blazing sun and bitter cold, swept now by hot and choking dust storms, now be rushes of icy hail, fording

rivers and floundering through sand, with scanty food and shelterless bivouacs, their toil unenlightened by anything but hope. Marching is the true rigour of campaigning. Of fighting, the welcome relief, they had too little to lighten the dullness of their task.

Cumbersome baggage trains, using mules, horses and, in some theatres, elephants, slowed down fighting columns and were easy targets. Winston Churchill, writing in 1898 shortly after the Tirah Campaign on the North-West Frontier, said:

> People talk of moving columns hither and thither, as if they were mobile groups of men who had only to march about the country and fight the enemy wherever found; and a very few understand that an army is a ponderous mass which drags painfully after it a long chain of advanced depots, rest camps and communications. In these valleys, where wheeled traffic is impossible, the difficulties and cost of moving supplies are enormous.

The baggage and camp followers would generally dwarf the fighting columns, thanks largely to what was considered the minimum accoutrements for officers, the cost of which they bore themselves. Lieutenant Walter Campbell, on arrival in India, was told he would need a tent with up to four bullocks to carry it, a portable campcot, mattress, table, chair and basin carried by two 'coolies', two horses with a keeper and grass-cutter for each steed, two servants, two baskets stocked with tea, sugar, brandy, coffee and wax candles carried on each end of a pole by a carrier, hog-spears, a stock of cheroots, gun, rifle, ammunition and telescope, a tent carpet and other 'little luxuries'. Columns were already weighed down with cannon, ammunition trucks and wagons full of supplies for the ordinary soldiers, and needed vast amounts of fodder for the animals hauling them through inhospitable country.

But the sheer scale and complexity of an army on the march in foreign theatres could be impressive. Ensign William Hodson, in the run-up to the 1845 Battle of Mudki, wrote:

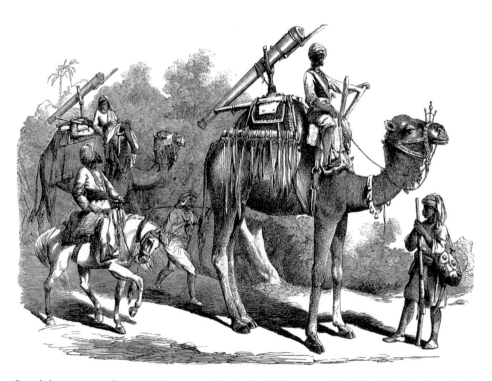

Camels bearing *jingalls* (mountain cannon) during the Afghan wars. (*The Illustrated London News*)

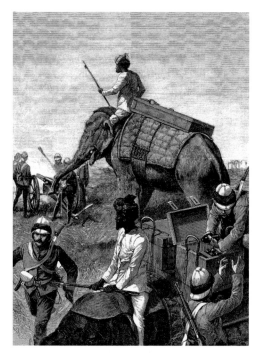

An elephant battery in action in Burma. (*The Illustrated London News*)

I wonder every day at the ease and magnitude of the arrangements and the varied and interesting picture continually before our eyes. Soon after 4am the bugle sounds the reveille and the whole mass is astir at once. The smoke of the evening fires has by this time blown away and everything stands out clear and defined in the bright moonlight. The sepoys bring the straw from their tents and make fires to warm their black faces on all sides and the groups of swarthy redcoats stooping over the blaze with a white background of canvas and the dark clear sky behind all produces a most picturesque effect as one turns out into the cold. The multitude of camels, horses and elephants, in all imaginable groups and positions – the groans and cries of the former as they stoop and kneel for their burdens, the neighing of hundreds of horses, mingling with the shouts of the innumerable servants and their masters' calls, the bleating of the sheep and goats, and, louder than all, the shrill screams of the Hindoo women, almost bedevil one's senses as one treads one's way through the canvas streets and squares to the place where the regiment assembles outside the camp.

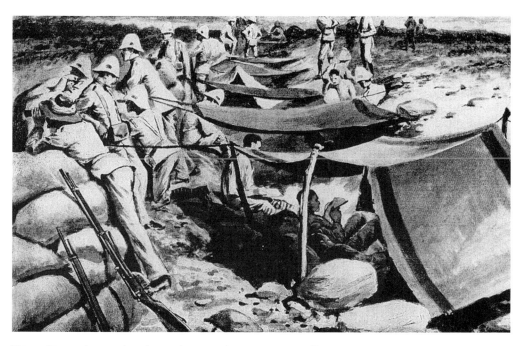

Bivouacking in the trenches during the Second Boer War. (*Cassell's History of the Boer War*)

Bandmaster and musicians of the Madras Army, 1845. (*The Illustrated London News*)

Railways, first used by the military in the Crimea, helped speed men and supplies to the front in less inhospitable terrain, but their construction was always an arduous task. General Sir Robert Napier built one for the first stretch of his campaign to capture the Magdala stronghold in the Abyssinian mountains. It helped him bring his force to battle with few casualties *en route*, an unheard-of triumph for the time.

The Modern British Army

The army of the British East India Company was disbanded in 1858 after the Indian Mutiny, but when Victoria first sat on the throne there were around 37,000 men serving in what Richard Holmes described as 'perhaps the most striking example of the flag following trade.' It was made up of British regiments alongside British-led native regiments such as the Bengal Fusiliers. The native regiments were swelled after the Gurkha and Sikh wars by former enemies who respected the martial prowess of the imperial forces, and who needed to work to send money home to their families. Europeans and Indians rubbed along quite well, holding each other in relatively high esteem, until the Mutiny sowed the seeds of mutual suspicion. In the early decades Britons married local women and brought up mixed-race children – until an influx of white memsahibs and missionaries changed all that.

The Company soldiers impressed Ensign Hodson, who wrote:

> The stern, determined-looking British footmen, side by side with their tall and swarthy brethren from the Ganges and Jumna – the Hindu, the Musselman, and the white man, all obeying the same word, and acknowledging the same common tie; next to these a large brigade of guns, with a mixture of all colours and creeds; then more

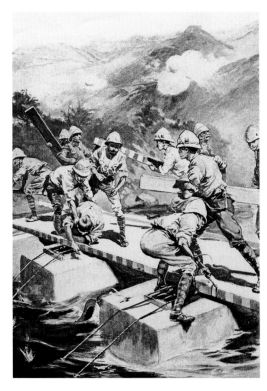

Pontoon bridge-building during the Second Boer War. (*Cassell's History of the Boer War*)

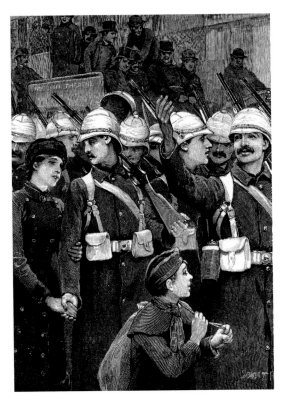

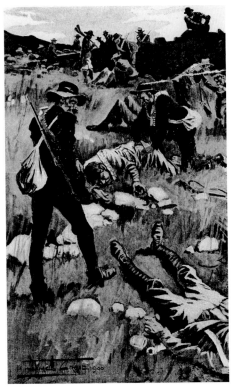

Return of the Guards from the Sudan. (*The Illustrated London News*)

'After the retreat – Boers robbing the dead.' (*Cassell's History of the Boer War*)

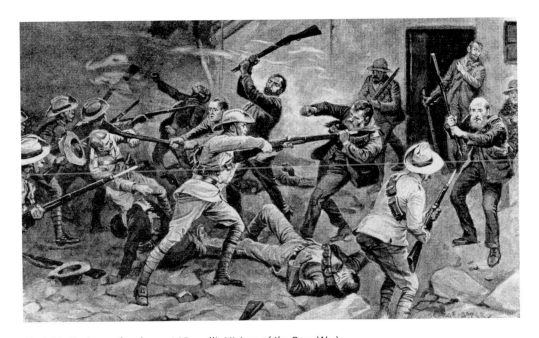

'A night attack on a farmhouse.' (*Cassell's History of the Boer War*)

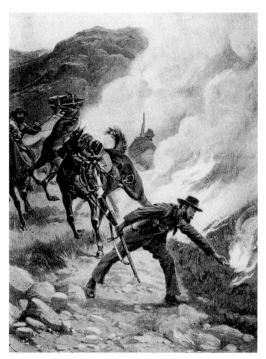

'The Dutchmen had covered their retreat by setting fire to the grass.' (*Cassell's History of the Boer War*)

The Duke of Cambridge, who took over command of British forces in the Crimea. (*The Illustrated London News*)

regiments of foot, the whole closed up by the regiments of native cavalry; the quiet looking and English dressed troopers strangely contrasting with the wild Irregulars in all the fanciful and un-uniformity of their costume; yet these last are the men I fancy for service.

A little over a decade later, during the Mutiny, Hodson would murder such men in great numbers.

After the Mutiny the regular British Army became a truly global business. When Victoria took the throne in 1837 it stood at around 100,000 men, mainly infantry. By 1859 it stood at 237,000. Of the 130 infantry battalions, around 50 were in India, 37 in the Colonies and 44 at home. Added to these were artillerymen, pioneers, road and rail-builders, muleteers, munitions-handlers, the whole array of a modern army. Such a vast undertaking needed a thorough overhaul – the failures in the Crimea and during the Indian Mutiny proved that unequivocally – and in 1868 Secretary of War Edward Cardwell introduced long-awaited reforms. He introduced short-term enlistment which resulted in a younger and fitter army. He built up the Reserves and abolished flogging. Most importantly, he scrapped the purchasing of commissions. Cardwell's reforms were the basis of a truly professional army to match the increased efficiency of firepower and communications. Naturally the ordinary British fighting man, as portrayed in the following pages, continued to grumble about pay and food, to take his pleasures where he could find them, to get into trouble at home and abroad, and to fight like fury.

THE AFGHAN WARS

'Several saddles were emptied.'

When Victoria was crowned, trouble was brewing in Afghanistan. Paranoia about Russia's expansionist plans towards British-ruled India would lead to a disastrous invasion – based on inaccurate intelligence – of one of the most inhospitable regions on earth and a series of costly wars. To some minds they are still going on.

Fears over the Russian threat led the British to send an envoy to Kabul to form an alliance with the Afghan emir, Dost Mohammad, who wanted in return help in retaking Peshawar, lost to the Sikhs in 1834. The British refused and the Emir opened negotiations with Russia. Those negotiations broke down in 1838, the year of Victoria's accession, and Persian troops backed by the Russians attacked the Afghan city of Herat in a bid to annexe it. The Governor-General of India, Lord Aukland, saw an opportunity to dislodge Dost Mohammad and lessen Russian influence. His plan was to drive back the Herat besiegers, depose Dost Mohammad and install the pro-British

A camp bazaar in Meerunzaie, western Afghanistan. (W. Carpenter)

Shuja Shah Durrani, a former ruler, as emir. He argued that the British would merely be supporting the legitimate government of Afghanistan against 'foreign interference'.

The army of India was formed to do the job – two divisions of British Army and British East India Company troops. Around 21,000 British and Indian soldiers marched from the Punjab in December 1838. By late March 1839 the force – under Lieutenant-General Sir John Keane – had crossed the Bolan Pass and was approaching Kabul. It crossed mountains and deserts and took Kandahar in April, and in July it mounted a surprise attack which captured the seemingly-impregnable stronghold of Ghazi. An Afghan had betrayed the city, helping the British blow up the city gate, and the besiegers marched in after a brief battle. British casualties were 17 dead and 165 wounded; the Afghans lost 600 dead and 1600 captured. Dost Mohammad fled to Bukhara and Shuja was enthroned in Kabul.

Most of the British force returned to India, leaving around 8000 behind to prop up Shuja's rule. But it soon became clear that the Aghans deeply resented the occupying troops and that more would be needed to maintain Shuja's grip on power. When British soldiers were permitted to send for their families, the Afghans sensed that they were facing permanent occupation. Furthermore, in a tactical blunder, the British encampment was shifted from a fortress to a

An Afghan *sungha* (rifle pit). (*The Illustrated London News*)

A sowar of the 10th
Bengal Lancers and
a private of the 9th
Regiment of Foot.
(*The Illustrated
London News*)

cantonment on low, swampy land to the northeast of Kabul, while its stores and supplies were kept 300 yards distant.

Disaffected Afghan tribes rallied to Dos Mohammad's son, Mohammad Akbar Khan, who was poised across the border, and in November 1841 a senior British officer and his aides were murdered by a Kabul mob. The British made no reprisals, which only encouraged the growing revolt. Within days the Afghans had stormed the barely-defended supply depot. The British representative in Kabul, William Hay Macnaughton, opened negotiations with Akbar Khan while at the same time offering a large reward for his assassination. Akbar Khan heard of the plot and at a meeting on 23 December Mcnaughton and three officers were killed and their bodies dragged through the streets of Kabul to be displayed in the bazaar.

The British military commander, Major-General William Elphinstone, found himself besieged in the fetid cantonment. On New Year's Day 1842 he reached a deal with Akbar Khan to allow the British to withdraw with their dependants and be given safe passage to the border. Five days later the exodus began. Around 16,000 marched or rode out of camp – 4500 military personnel made up of one British battalion, the 44th Regiment of Foot, and Indian units, plus almost

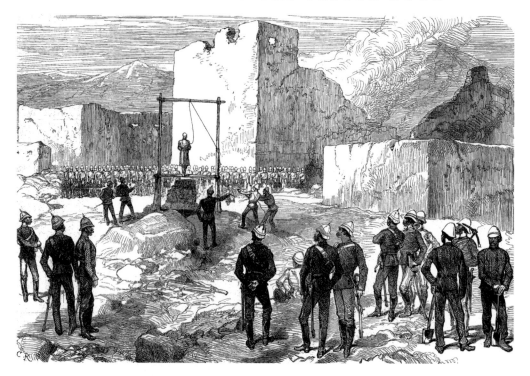

Execution of the Kotwal of Kabul, outside the Residency. (*The Illustrated London News*)

12,000 civilians and camp followers. All were demoralised by poor leadership, cold, hungry and very scared. They had a right to be, as the killing began as soon as they reached the Kabul River and turned into a long-distance massacre.

The evacuating force was harassed for 30 miles along the river bank and attacked by Ghilzai tribesmen as they struggled through snowbound gorges. Stragglers were picked off easily, and many were butchered as they slumped in cold-induced comas after nightfall. The Gandamak Pass became an abattoir. Surgeon William Brydon recalled:

> We had not gone far in the dark before I found myself surrounded, and at this moment my *Khidmutgar* [butler] rushed up to me, saying he was wounded, had lost his pony, and begged me to take him up. I had not time to do so before I was pulled off my horse and knocked down by a blow on the head from an Afghan knife, which must have killed me had I not a portion of *Blackwoods Magazine* in my forage cap. As it was a piece of bone about the size of a wafer was cut from my skull. and I was nearly stunned, but managed to rise upon my knees, and seeing That a second blow was coming I met it with the edge of my sword, and I suppose cut off some of the assailant's fingers, as the knife fell to the ground. He bolted one way, and I the other, minus my horse, cap and one of my shoes. The *Khitmutgar* was dead; those who had been with me I never saw again. I rejoined our troops, scrambled over a barricade of trees made across the Pass, where the confusion was awful, and I got a severe blow to my shoulder from a fellow who rushed down the hill...

According to Major-General William Elphinstone:

> The pressure of non-combatants and cattle rendered vain all attempts to restore order. The horse artillery had unfortunately got some spirits and many of them dashing with their swords at all who opposed progress. Towards the end of the pass the firing increased and

the line of march presented the appearance of a rout. The rear-guard, H.M.44th and 54th, suffered very severely, and were at length obliged to find their way up to the main body as best they could. As we reached the bivouac, snow fell and continued during the night. Nothing could be done for the wounded, and we had to pass another night on the snow, without tents, food or firewood.

Over 500 soldiers and 2500 camp followers died in the pass. They were luckier than most.

The carnage continued for a week. The 44th was wiped out apart from one officer, an NCO and seven men who were taken prisoner. Elphinstone was captured while trying to negotiate and died in captivity. Of the 16,000 who set out, only 40 reached the British garrison in Jalalabad. The only Briton to get there was the surgeon William Brydon. Lady Butler's famous painting of Brydon approaching sanctuary became a metaphor for Afghanistan as a graveyard for foreign armies. It also gave, in British eyes at least, the Afghans a reputation for treachery and broken promises.

The besieged Jalalabad garrison and other forces in Kandahar and Ghazni held out until the spring when a British relief force arrived from India. Akbar Khan was heavily defeated near

Attack on a baggage train near Koruh, by marauders of the Mangal tribe. (*The Illustrated London News*)

Jalalabad and the British aimed to take savage reprisals. But Lord Auckland had suffered a stroke and been replaced and there was a change of government in London. His replacement, Lord Ellenborough, was ordered to bring the war to a speedy conclusion.

In the meantime two British columns had taken and destroyed Ghazni and inflicted another crushing defeat of Akbar Khan. The two forces combined and retook Kabul in September. The following month the captured British prisoners were released and Kabul's main bazaar was demolished in revenge for the massacre of Elphinstone's column. The British withdrew through the Khyber Pass. Military historian Philip Haythornthwaite wrote:

'The 10th Bengal Lancers in the Jugdulluk Pass.' (*The Illustrated London News*)

The war was announced as having had a successful outcome, but in reality it was the reverse: the diminution of the Russian threat had not been the result of military action but of diplomatic activity in London and St Petersburg, and the defeat of Elphinstone had dispelled the air of invulnerability which had surrounded British arms in the subcontinent, which was to have a considerable effect.

Dost Mohammad returned to rule in Kabul, dying 21 years later. The Russians, through annexation of neighbouring provinces, moved closer to Afghanistan.

Tensions within Afghanistan and with her neighbours, and between Britain and Russia continued for decades and finally provoked a second invasion 36 years after the first. In summer 1878 Russia sent a diplomatic mission to Kabul despite efforts by Emir Sher Ali Khan, to keep them out. The British demanded that he accept a British mission as well. Sher Ali refused and the British envoys were turned back as they approached the eastern entrance to the Khyber Pass.

Britain sent 40,000 troops divided into three columns – Lieutenant-General Sir Donald Stewart's Kandahar Field Force, Major-General Frederick Roberts' Kurram Field Force and Lieutenant-General Sir Sam Browne's Peshawar Valley Field Force – which drove deep into Afghan territory. Stewart was unopposed and in January 1879 his column reached Kandahar. The other columns were opposed by both the Afghan armies and the warlike tribes whose territory they traversed. Roberts found his route blocked at the Peiwar Kotal but he outflanked the defenders. Browne stormed the Ali Musjid fort unsuccessfully but the Afghans, fearing a flanking manoeuvre, evacuated during the night. Most blundered into the British brigade and were captured.

Most fights, however, were small-scale melees. A contemporary account described one such at Deh Surrock:

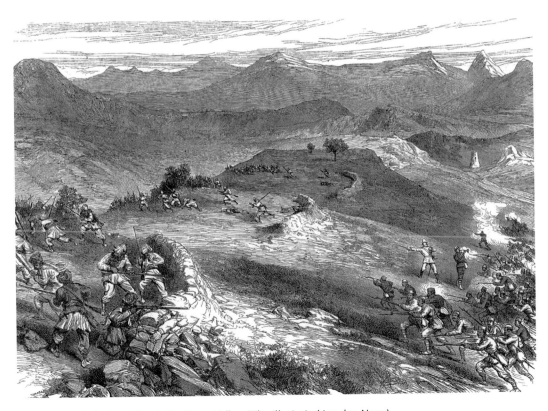

Storming of Afridi sunghas in the Bazar Valley. (*The Illustrated London News*)

On came the Afghans with savage yells, but they had been caught in a trap, the cavalry came charging down on their flank; no sooner did the enemy see the cavalry bearing down on them than they turned their attention to them, and when barely 200 yards, they poured a ragged volley into the ranks of the advancing horsemen, and several saddles were emptied; having delivered their fire, the Shinwarries (the pluckiest of all Afghan tribes) formed up in small groups, mostly of four men back to back, and faced their foes like men; the first shock of the charge over, the cavalry reformed, and wheeling round, charged once more; after this the scene was for some time a confused mass of riderless horses, dead Afghans and troopers, and here and there individual combats and hand-to-hand fights, this went on for some ten or fifteen minutes...

Artillery passing through the Kabul Gate in Jellalbad. (*The Illustrated London News*)

A reconnoitring party. (*The Illustrated London News*)

Sher Ali appealed to Russia for help but was rebuffed. Panic-stricken and ill from travelling, he died in February 1879. Faced with a superior British force occupying most of the country, his son Mohammad Yaqub Khan, signed a peace treaty to prevent total occupation. He gave up control of foreign affairs to Britain, agreed to British consuls in Kabul and elsewhere, and ceded Quetta and other frontier areas to Britain in return for an annual subsidy and the withdrawal of British forces.

The British duly left but in September an uprising in Kabul saw the murder of the consul Sir Louis Cavagnaria and his staff. Major-General Sir Frederick Roberts led the Kabul Field Force back into Afghanistan. He defeated the Afghans at Char Asiab on 6 October 1879, and re-occupied Kabul. An attempted Afghan siege of the Sherpur cantonment ended in heavy defeat when a massive assault involving up to 100,000 men was beaten off with disciplined firepower for the loss of just three defenders. Yaqub Khan was forced to abdicate in favour of his cousin, Abdur Rahman Khan.

The governor of Herat, Ayub Khan, then rose in revolt and defeated a British detachment under Brigadier-General George Burrows at Maiwand in July 1880. Burrows' 2600 men were exposed and greatly outnumbered and were almost annihilated. The 66th Regiment of Foot made a gallant last stand and the survivors struggled to Kandahar, which was again besieged. Roberts led his main force – 10,000 men stripped of most cumbersome baggage – from Kabul. For three weeks they marched over scorching deserts and rugged mountains, their artillery carried by mules, with no support. After 300 miles they reached Kandahar on 31 August and decisively defeated Ayub Khan at Kandahar the following day. Their arduous march won them the rare honour of a campaign medal, the Kabul to Kandahar Star, for a manoeuvre rather than for combat.

Captain R.R. Lauder of the 72nd described the firestorm which greeted the last mass charge of the Aghans on the cantonment at Kandahar shortly before dawn:

> From the mouths of a score of cannon there played a lurid light, their hoarse thunder making the very earth tremble; while, from thousands of rifles, a stream of bullets poured incessantly into the darkness. This prolonged roar of musketry, the fearful sound of the Afghans' voices, rolling backwards and forwards in mighty waves, was the most appalling noise I have ever heard. Then a bright star shell flew into the sky, bursting over the heads of the enemy, and coming slowly down with a glare, like electric lights, disclosing the dense masses struggling on, over ghastly heaps of wounded and dead. In the clear greenish light, they appeared to sink in writhing masses to the earth. It was a truly terrible scene.

Adbur Rahman confirmed the previous treaty with the British and Roberts withdrew, having achieved his objectives. Roberts, however, was realistic about the long-term effects of his campaigning. He wrote: 'I feel sure that I am right when I say that the less the Afghans see of us, the less they will dislike us.' Secretary of State Lord Harrington was blunter when he said:

> As the result of two successful campaigns, of the employment of an enormous force, and of the expenditure of large sums of money, all that has yet been accomplished has been the disintegration of the State, the assumption of fresh and unwanted liabilities, and a condition of anarchy throughout the remainder of the country.

His pessimism was not entirely warranted, as the Emir proved to be an effective ruler until his death in 1901. During that time relations with Britain and the Raj remained cordial, largely because Britain kept out of Afghan internal affairs. He was succeeded by his son Habibulla who followed his father's pragmatic approach of unifying tribes while keeping dissidents firmly in check. His assassination in 1919 sparked a third war with Britain, but that conflict belongs in another book.

THE OPIUM WARS

'Permanent disgrace.'

The Opium Wars with China are impossible to justify to modern sensibilities, lost Britain the respect of civilised people and undermined British self-esteem built on perceived moral superiority. Near-contemporary historian-MP Justin McCarthy stormed that the wars were fought on the principle of Britain's right to 'force a peculiar trade on a foreign people.' But they also serve to underline the neglected fact that the soldiers of the Queen fought, more often than not, in the interests of trade and commerce rather than national glory and conquest. The trade in this case was addictive narcotics.

THE FIRST OPIUM WAR

It may have been inevitable, however, that sooner or later two empires would collide – Britain's with its rampant commercialism and dominance as a global power and the inward-looking, closed culture of China's Quing dynasty. Diplomatic and trade disputes had rumbled for a century as Chinese emperors struggled to keep foreigners out of their vast country and limit their influence on the Chinese population. Foreigners were officially constrained to port cantons but they were ingenious in evading these restrictions. The British East India Company relied heavily on trading opium for tea, but tariffs were applied to Chinese advantage. The Company responded by smuggling more opium to the increasingly addicted Chinese population. The Emperor banned the trade altogether with an imperial declaration which said: 'Opium has a harm. Opium is a poison, undermining our good customs and morality.' The ban was flouted by the British, as well as European and American traders.

In 1834 Lord Napier, a 47-year-old sea captain with a ferocious temper, was sent to Canton to smooth over resentment between the traders and the Chinese. He did neither, losing patience with Chinese imperial protocols. Furious at being referred to as 'barbarian' he told London in a dispatch that he could extend the trade to the whole of China with a force smaller than would be needed to take a 'paltry' West Indian island. The crisis deepened and in 1839 Imperial Commissioner Lin Zexu, one of the richest men in China, was sent to enforce the anti-opium laws.

Lin demanded a permanent halt to all opium shipments and when the British refused he blockaded the traders in their factories amid the docks of Canton. At the end of March 1839, Charles Elliot, the British Superintendent of Trade, finally agreed to hand over roughly 1400 tons of raw opium. He duly did so, but only after departing from his official brief by promising the merchants that the British Crown would compensate them. The opium was dissolved in salt and lime and dumped in the sea.

Lin addressed a letter to Queen Victoria urging her to prevent further trade in opium and telling her 'we mean to cut this harmful drug forever.' It is doubtful whether she ever received it, but her government was heading for war. Opium was legal in Britain and therefore, to British eyes, their merchants were engaging in a legal trade. When the traders refused to sign a bond undertaking to abandon the trade, the British government felt they were honour-bound to support them. There

was also the question of the massive indemnity which Napier had promised. It seemed easier to go to war than to pay it.

A British Indian army under Major-General Sir Hugh Gough was sent by sea, arriving off Macao in June 1840. There were 16 English warships carrying 540 guns, 4 armed steamers and 28 transport ships carrying 4000 men armed with the latest muskets. The warships, and in particular the steam ship *Nemesis* which could run against wind and tides, devastated Chinese war fleets and coastal towns. On shore the outdated Chinese flintlocks were no match for disciplined British firepower. On paper the Chinese had a million men. In reality they were cannon fodder carrying spears, poleaxes and swords, some of them still wearing chain armour. One officer wrote of 'the poor Chinese – with their painted pasteboard boats – must submit to be poisoned, or must be massacred by the thousand, for supporting their own laws in their own land.' But another officer, Captain Granville Locke wrote that if drilled under British officers the Chinese levies could well have matched sepoys. 'The matchlock man carries the charges for his piece in bamboo tubes,' Locke said,

> contained in a cotton belt fastened about his waist. He loads without a ramrod, by striking the butt against the ground after inserting the ball; the consequence is that he can charge and fire faster than one of us with a common musket. The best marksmen are stationed in front and supplied by people whose only duty is to load for them.

The first British objective was Canton. Outside the port city 700 British and Indian troops attacked up to 10,000 Chinese militiamen at the Hill of the Five-Storeyed Pagoda but found that the weather was their greatest enemy – their rain-soaked firearms were initially useless. An officer of the 37th Madras Native Infantry wrote:

> At his time not a musket would go off, and little resistance could be offered against the enemy's long spears. The men, after remaining in this position for a short time, were enabled to advance to a more defensible [position], where they were soon surrounded by thousands of the enemy, who, had they possessed the slightest determination, could have at once annihilated them. The rain ceasing to fall for a time, enabled a few of the men to discharge their muskets. The enemy was not removed above 15 yards and every shot told.

The British withdrew in good order with no losses and Elliott warned the Cantonese authorities of dire repercussions if the militia was not withdrawn. They obeyed.

After retaking Canton the British sailed up the Yangtze River. The hardest of several battles was fought at Chinkiang. Gough recorded:

> I have seldom witnessed a more animated combined attack: the Chinese cheering until we got close to them, now poured in a very heavy but ill-directed fire, and displayed in various instances of individual bravery that merited a better fate; but nothing could withstand the steady but rapid advance of the gallant little force that assailed them; field-work after field-work was cleared, and the colours of the 49th were displayed on the principle redoubt.

Major-General Sir Hugh Gough, commander of British forces in China, 1840. (*The Illustrated London News*)

'Chinese rebels.' (*The Illustrated London News*)

After the capture of the garrison town, the British were repelled by the carnage inside its walls, including women and children being thrown into wells to prevent them being taken by the 'foreign devils'. Gough described it as a 'frightful scene of destruction' and removed his troops from the city.

Moving onwards the allied force captured the imperial tax barges, a setback which robbed the imperial court of most of its revenue. In 1842 the Emperor sued for peace. In the Treaty of Nanking the following year China was forced to pay a massive indemnity to Britain, almost £5.75 million in 'China money' which was carried in five enormous wagons to The Mint in London, escorted by a detachment of the 60th Regiment. Victoria herself received exquisite jewellery and fine silks as presents from the humbled Beijing court. In addition Hong Kong was ceded to Britain. In a supplementary treaty China gave British, French and American subjects extraterritorial privileges in designated trade, or 'treaty' ports.

The military action was attacked by the newly-elected MP William Ewart Gladstone, who said: 'a war more unjust in its origin, a war more calculated to cover this country in permanent disgrace, I do not know.' But generally in Britain it had been a popular war, especially when the riches came home.

THE SECOND OPIUM WAR

Despite the Treaty of Nanking, the Chinese tried to keep out as many foreign merchants as possible and stamp out the opium trade. The new Imperial Commissioner at Canton, Yeh Ming-ch'en, hated foreigners and targeted Chinese merchants who traded with the British in treaty ports. To protect their commercial allies from victimisation and seizures of property, the British granted their ships British registration. In October 1856 the Chinese authorities in Canton confiscated the vessel *Arrow* whose Chinese crew had been engaged in piracy. The ship was flying the British flag and the British consul demanded the release of the crew and an apology. The

first was acceded to, but not the second. The British governor in Hong Kong, Sir John Bowring, retaliated by sending warships to bombard Canton.

That could have been the end of it, but in London Prime Minister Lord Palmerstone was eager to force the Chinese, through military might if needed, to accept full-scale trade. The China issue figured prominently in the March 1857 general election which he won handsomely, and he determined to take action. The French supported British action because of the failure of the Chinese to arrest the murderers of a missionary, and because of disputes over French trading rights in Canton.

A strong Anglo-French force under Admiral Sir Michael Seymour destroyed 40 war junks at Escape Creek in June 1857 and around another 80 at Fatshan Creek just days later. Sir Henry Keppell described the latter action:

> My boat was badly hulled below the waterline, a round-shot passed through both sides, smashing the magazine, but fortunately not exploding it, and wounding the two stroke-oarsmen. However, we plugged the hole with a bluejacket's frock, and finding our launch in a sinking state, we ran alongside her and took out her crew and her gun. Our boat was now so deeply loaded we could scarcely keep her afloat. The Chinamen continued to pepper us as long as we were within range, one shot breaking all the oars on one side of the barge. Having rested alongside the gun-boats till the tide rose, we again shoved off and resumed the attack. There was no hitch this time: we passed the bar all right, and with a cheer dashed at the junks. My old boat could hardly keep up, so deep was she in the water, and leaking like a basket, but we staggered on, firing our 12-pounder brass howitzer into the brown of them. The Chinamen knew now that the game was up, and firing their last broadside as we closed on them, they deserted the junks and escaped across the paddy-fields.

The Indian Mutiny delayed the deployment of ground forces until December, when they occupied Canton. Commissioner Yeh was captured by British bluejackets (Royal Marines) and deported to Calcutta, where he died 15 months later. The port was taken with the loss of just 13 British and two French lives. The force went on to capture the massive earthen Taku forts near Tientsin in May 1858.

The gunboat *Starling* engaging a battery at Fatshan Creek on the Canton. (*The Illustrated London News*)

Action between a large Chinese row-galley and a small cutter of HMS *Amethyst* on the Canton. (*The Illustrated London News*)

Negotiations in June theoretically brought peace, with the Chinese agreeing to open up more treaty ports and legalise opium imports. But the peace was shattered when the Chinese refused to allow foreign diplomats into Beijing.

On 25 June 1859 Admiral Sir James Hope bombarded forts guarding the mouth of the Hai River below Tientsin. But landing parties were repulsed by efficient fire from the garrisons. An eyewitness wrote:

Just as the first boat touched the shore, bang went a gun from the fort, immediately followed by a perfect hurricane of shot, shell, gingal balls and rockets, from all the batteries, which mowed down our men by tens as they landed. Nevertheless out of the boats they all leaped with undiminished ardour (many into water so deep that they had to swim to the shore), and dashed forward through the mud, while the ships threw in as heavy a covering fire as they possibly could. The enemy's fire, however, continued to be deadly, and the mud proved so deep – in most places up to men's knees at least, often up to their waists – that out of the men who landed, barely 100 reached the first of the three deep and wide ditches, after some 500 yards of wading, and out of that number scarcely 20 had been able to keep their rifles or their ammunition dry.

'The late engagement with Chinese junks at Fatshan Creek.' (*The Illustrated London News*)

Hope's force faced slaughter until Commodore Josiah Tattnall of the US Asiatic Squadron cruising nearby declared that 'blood is thicker than water' and covered the British withdrawal. British losses were 81 dead, 345 wounded and three gunboats sunk.

Another Anglo-French force gathered at Hong Kong in May 1860 consisting of 11,000 British under General Sir James Grant and 7000 French under Lieutenant-General Cousin-Montauban. Overall command was given to James Bruce, the Earl of Elgin. Landings were unopposed at Pei-Tang and the Taku forts were again captured in August. Thomas Bowlby of *The Times* recorded the taking of the Taku forts:

> The fire of the enemy continued incessant. Cold shot, hand grenades, stinkpots and vases of lime were showered on the crowd of besiegers. The ladders placed against the walls were pulled into the fort, or thrown over, and in vain did man after man attempt to swarm through the embrasures. If the defence was desperate, nothing could exceed the gallantry of the assailants. Between English and French there was nothing to choose. A Frenchman climbed to the top of the parapet, where for some time he stood alone. One rifle after another was handed up to him, which he fired against the enemy. But his courage was unavailing, and he fell back, speared through the eye. Another, pickaxe in hand, attempted to cut away the top of the wall. He was shot, and Lieutenant Burslem of the 67th, caught hold of his pick and continued the work. Lieutenant Rogers attempted to force his way through an embrasure, but was driven back. He ran to another, but it was too high for him. Lieutenant Lenon came to his assistance, forced the point of his sword into the wall, and placing one foot on the sword, Lieutenant Rogers leaped through...

Burslem, Rogers and Lenon were amongst seven to win the Victoria Cross in the action.

The forces moved upriver from Tientsin towards Beijing, defeating the Chinese in two battles. As the allies approached the capital a delegation was sent under Sir Harry Smith Parkes to negotiate, but they were seized, imprisoned and tortured. Half of them died as a direct result of their mistreatment, some of them because the cords binding their hands were too tight, causing their hands to swell and putrefy. They included 42-year-old journalist Thomas Bowlby. The son

'Attack on the Banterer's boat in Sai-Lau Creek, Canton River.' (*The Illustrated London News*)

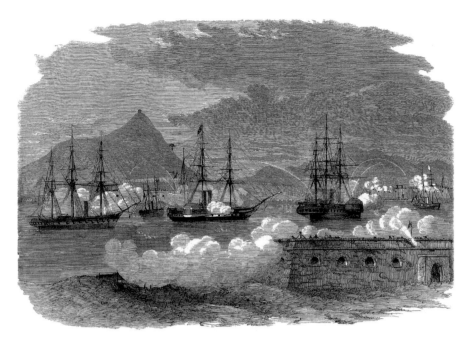

Taiping rebels open fire on the gunboat *Lee* at Nankin. (*The Illustrated London News*)

of an artillery officer, Bowlby had previously reported on revolution in Berlin, and had been on the SS *Malabar* with Lord Elgin in May when the steamship sank in Galle harbour during a severe storm. When he finally reached China his informative and comprehensive reports were popular with readers. He left a widow and five children.

> The survivors were belatedly released, but the subjects seized in defiance of honour and the laws of nations, only 13 have been restored alive, all of whom carry on their persons evidence more or less distinctly marked of the indignities and ill treatment from which they have suffered, and 13 have been barbarously murdered ... Until this foul deed shall have been expiated, peace between Great Britain and the existing dynasty of China is impossible.

Six miles from the imperial city the allies met the main Tartar Army at Pal-le-chiao. The French stormed across a narrow bridge to destroy Chinese emplacements guarding the high road, while the King's Dragoon Guards charged the enemy cavalry, inflicting heavy losses. Chinese infantry advanced to within 200 yards of British artillery as they were being unlimbered, but they were repelled by canister shells. On the left flank, supported by the 1st Sikhs, Fane's Horse, thirsty for revenge, attacked another body of Chinese cavalry across recently-cut maize and millet stubble which gouged the legs and bellies of the horses. Grant described the subsequent action:

> The enemy, though defeated on the spot, yet still remained in front, in clouds of horsemen who, though constantly retiring from the advance of any party of our cavalry, however small, never allowed more than 1000 yards between us, and showed a steady and threatening front. At this time I had with me the cavalry, the 4th Infantry Brigade, and three Armstrong guns; the rest of the artillery, with the 2nd Brigade, having been left in the centre ... With the Armstrong guns we fired occasional single shots on their thickest masses.

The 99th Regiment took and burnt the camp of the imperial princes. The Chinese Army fled towards Beijing, leaving 43 cannon and piles of their dead. Allied losses were just two dead and 29 wounded, most of them only slightly.

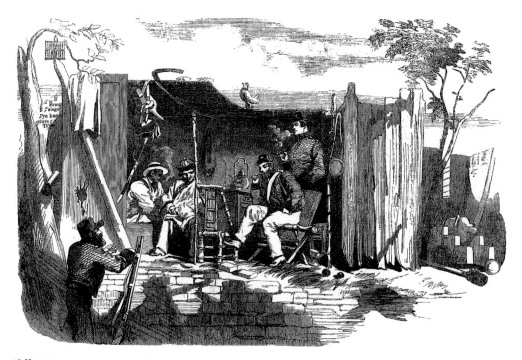

'Officers' quarters, provisional battalion Royal Marines, on the walls of Canton.' (*The Illustrated London News*)

The Naval Brigade landing at Canton. (*The Illustrated London News*)

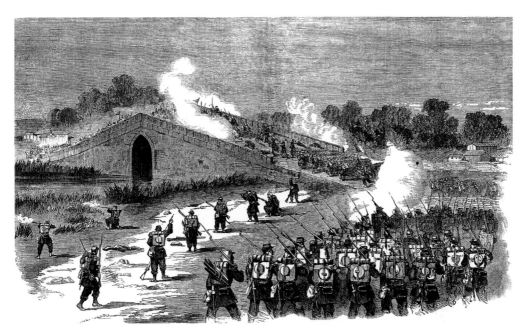

The French attacking the bridge at Pa-le-chiao on the approach to Peking. (*The Illustrated London News*)

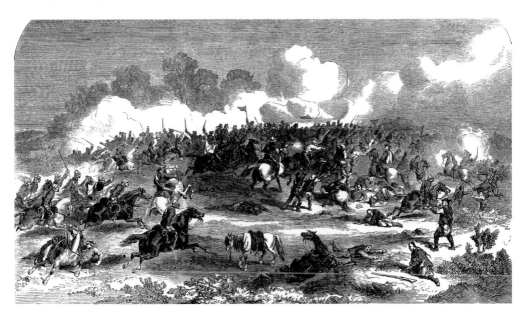

The King's Dragoon Guards closing with Chinese cavalry at Pa-le-chiao. (*The Illustrated London News*)

Elgin's force reached the walls of Beijing on 26 September and prepared for the final assault. In the meantime allied troops sacked and looted the Emperor's former Summer Palace, stripping it of treasures before destroying the rest. A 27-year-old Royal Engineers captain, Charles George Gordon, was in charge of demolishing the palace complex which had been laid out in the style of Versailles. He wrote to his mother:

A brass gun taken from the Chinese, placed on the north terrace of Windsor Castle. (*The Illustrated London News*)

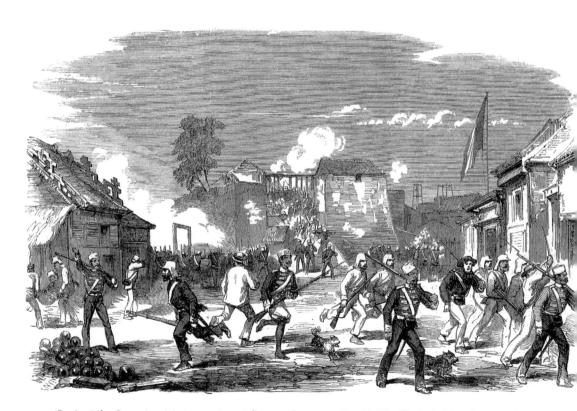

'Panic at the Commissariat stores – "great firing and no execution."' (*The Illustrated London News*)

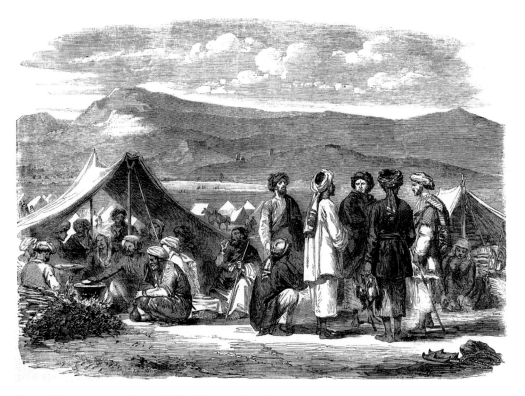

'Demolishing houses in Canton.' (*The Illustrated London News*)

We went out and, after pillaging it, burnt the whole place, destroying in a Valhalla-like manner most valuable property ... You can scarcely imagine the beauty and magnificence of the places we burnt. It made one's heart sore to burn them, in fact, these places were so large and we were pressed for time. It was wretchedly demoralising work for an army. Everybody was wild for plunder.

The Chinese again sued for peace and agreed to all allied demands. They included ten new treaty ports, the regulation of the opium trade, diplomatic envoys at the imperial court, freedom of travel for Western missionaries, the cessation of Kowloon to the British, and an indemnity of three million ounces of silver for Britain and two million for France.

The victory was seen as a triumph for Palmerston. Other foreign powers licked their lips at the prospect of open trade and new markets in a humbled China. Russia forced Beijing to give up its maritime provinces, allowing it to found the seaport of Vladivostok.

Lin Zexu – the Imperial Commissioner who had tried so hard to halt the opium trade – was made a scapegoat by the Emperor, but is now a hero in modern China.

The Sikh Wars

'The finest material in the world for an army.'

The Sikhs, like the Gurkhas before them, fought two particularly brutal wars against the British Raj. But when the guns stopped firing there was so much mutual respect for martial prowess that they became an integral part of the British Army.

THE FIRST SIKH WAR

The death in 1839 of Maharajah Ranjit Singh – who had expanded the Sikh kingdom through a policy of friendship with the British – plunged the Punjab into chaos and fratricidal in-fighting. His successor Kharak Singh lasted only a few months and died in prison, having probably been poisoned. His son and brief successor Kanwar Nau Nihal Singh also died when an archway suspiciously crushed him on his way back from his father's cremation. Two factions plotted and fought for power, the Hindu Dogras and the Sikh Sindhanwalias, the latter having its strongest advocates in the Sikh Army (the Khalsa).

The Khalsa was much more than an army. It was a political, social and religious force which considered itself the embodiment of the Sikh nation and the only true holder of its faith and integrity. One British observer described it as a 'dangerous military democracy'. Ranjit Singh had built it into a superbly armed and drilled force of 29,000 regular infantry and cavalry with 192 guns staffed with French, Italian, British, German, American and Russian instructors. It was supplied with the latest British muskets which were copied in the foundries of the capital, Lahore. British observers were particularly impressed by the superbly-drilled Lancers and the heavy dragoons clad in chain mail. Captain William Osborne regarded them as

> the finest material in the world for forming an army ... I never saw such a beautiful line with any troops ... The commanding officer beats and abuses the major, the major beats the captains, the captains the subalterns, and so on till there is nothing left for the private to beat but the drummer boys, who catch it accordingly.

But such discipline could not eradicate the Sikh lust for booty on and off the battlefield. Ranjit had understood the defect and said:

> The system of the British is [so] good that even if the enemy throw gold coins in the course of their flight, the soldiers would not even look at them. On the other hand, if the Khalsa soldiers saw mere corn, they would break their ranks, dash towards that and spoil the whole plan of operations.

By 1844 the Khalsa had expanded to over 80,000 men. They constantly clashed with or mutinied against the central court or durbar and the new Maharajah Sher Singh refused to meet their pay demands despite financing a notoriously degenerate and profligate court. He was

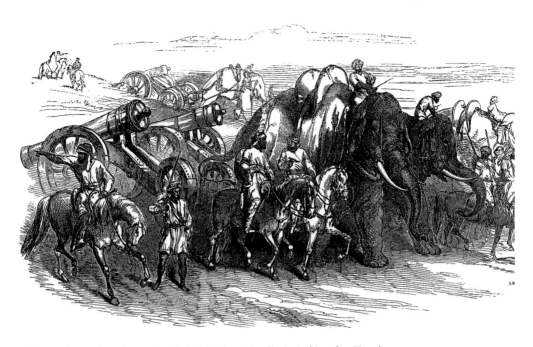

Khalsa heavy artillery during the First Sikh War. (*The Illustrated London News*)

murdered by his cousin, a senior Khalsa officer. The Dogras ensured that Marahani Jindan Kaur, Ranjit's youngest widow, became regent until her infant son Duleep Singh came of age. Jindan was 50, a clever, brave, politically savvy and ruthless woman who, according to her detractors, had a string of lovers and was permanently drunk. Her Vizier was killed when he tried to flee the capital with much of the gold in the Treasury, and Jindan Kaur's brother became Vizier. He in turn was killed at a Khalsa parade, and she appointed her lover, Lal Singh, in his place, and vowed revenge on the Khalsa.

Meanwhile the British East India Company had been increasing its strength on the borders with the Punjab, and in 1844 annexed Sindh to the south. Successive British India Governor-Generals Lord Ellenborough and Sir Henry Hardinge believed that the Khalsa posed a serious threat to the Raj. They were encouraged in that view by frontier political agent Major George Broadfoot who stressed disorder in the Punjab and advocated British expansion into the fabulously rich kingdom.

Military build-ups on both sides of the border resulted in the breaking of diplomatic relations. An East India Company division under Sir Hugh Gough, commander-in-chief of the Bengal Army, marched towards Ferozepur. Governor-General Hardinge went with it but placed himself below Gough in the chain of command. That delicate relationship, mixing military and civil responsibilities, was not to last. The Company division was made up of roughly one British unit to four Bengal infantry or cavalry units, and light guns from the elite Bengal Horse Artillery. Gough, the ultimate fighting general, drove his parched men by rapid marches through dust clouds.

In response the Khalsa crossed the Sutlej River which marked the boundary of the Punjab, ostensibly to take back a disputed village. The British saw this as a hostile action and declared war. One Khalsa army under the talented general Tej Singh advanced towards Ferozepur but did not attack the British already there. A second army under Lal Singh met Gough's advancing force at Mudki on 18 December 1845. The battle was confused, but the general consensus was that the British had won. Gough reported that the Sikhs

were driven from position after position with great slaughter and the loss of seventeen pieces of artillery; our infantry using the never-failing weapon, the bayonet, whenever the enemy stood. Night only saved them from worse disaster, for this stout conflict was maintained during an hour and a half of dim starlight, amid a cloud of dust from the sandy plain, which yet more obscured every object.

The following day the British approached the strongly-entrenched Sikh positions at Ferozeshah. Gough planned to attack at once, but Hardinge, despite his earlier promise to take a back seat, overruled him and insisted on waiting for reinforcements. When they arrived two days later the attack was launched shortly before nightfall. The Sikh artillery cut swathes through their attackers and, as the night was lit up by explosive fire, the infantry on both sides fought desperate hand-to-hand actions. Lieutenant John Cummings wrote:

> We advanced against a hailstorm of roundshot, shells, grape and musketry. The slaughter was terrible. Yet our fellows pressed nobly on with the charge, and with the bayonet alone rushed over the entrenchments and captured the guns in front of us. The Sikhs flinched not an inch, but fought till they died to a man at their guns.

Lal Singh, inexplicably to his soldiers, kept the Khalsa's elite irregular cavalry out of the action. Gough's infantry fought their way into the Sikh positions and dug in. It was a fearful night and Gough, sensing defeat, burnt official documents. But at dawn the British and Bengal units rallied and drove the Sikhs from the village. Lal Singh made no effort to rally his troops. At a crucial point Tej Singh's army arrived and Gough's exhausted force seemed doomed. But Tej withdrew, later claiming that he feared a flanking move by the British cavalry. Operations were suspended as all sides rested and restocked their dwindling supplies. The British suffered 2315 casualties over the two days, a seventh of Gough's entire force. Governor-General Hardinge said tartly: 'Another such victory and we are undone.'

General Sale wounded at the Battle of Mudki. (*The Illustrated London News*)

The death of Major Broadbent at Ferozeshah. (*The Illustrated London News*)

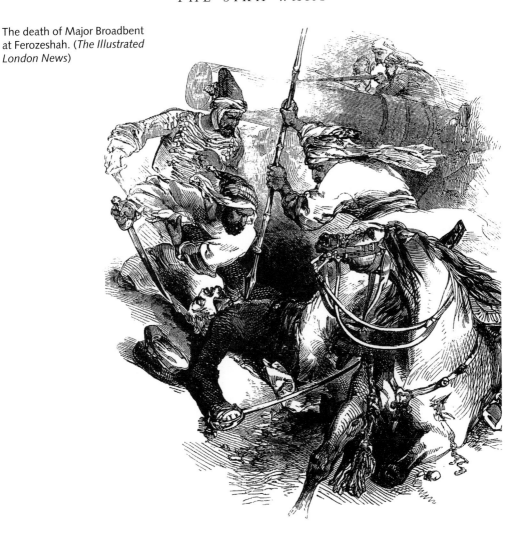

Hostilities resumed when a Sikh force crossed the Sutlej near Aliwal, aiming to sever Gough's communications and supply lines. A column under Sir Harry Smith rushed forward under constant attack from the Sikh cavalry. At the Battle of Aliwal on 28 January 1846, Smith decisively won a textbook action. The battle featured a magnificent cavalry charge by the 16th Lancers led by the six-foot tall Major Rowland Smyth, who commenced the action with three cheers for the Queen. Sergeant William Gould described what followed:

There was a tremendous burst of cheering in reply, and down we swept upon the guns. Very soon they were in our possession. A more exciting job followed. We had to charge a square of infantry. At them we went, the bullets flying around like hailstorm. Right in front of us was a big sergeant, Harry Newsome. He was mounted on a grey charger, and with a shout of 'Hullo, boys, here goes for death or a commission,' forced his horse right over the front rank of kneeling men, bristling with bayonets. As Newsome dashed forward, he leaned over and grasped one of the enemy's standards, but fell from his horse pierced by 19 bayonet wounds. Into the gap made by Newsome we dashed, but they made fearful havoc among us. When we got to the other side of the square our troop had lost both lieutenants, the cornet, troop sergeant-major and two sergeants. I was the only sergeant left.

Brigadier Charles Cureton, commander of the cavalry at the Battle of Aliwal. (*The Illustrated London News*)

Despite such losses, the pell-mell actions forced the Sikhs back and Smith wrote in his despatch:

> The battle was won, our troops advancing with the most perfect order. The enemy, completely hemmed in, were flying from our fire. Our eight-inch howitzers soon began to play upon their votes ...

The battle, however, cost Smith the most highly-regarded cavalry officer in India, Brigadier Robert Cureton. He died trying to stop an unwise rush by a junior officer overcome with excitement.

Smith's column rejoined Gough's main army, which had been heavily reinforced, and attacked the 20,000-strong Sikh bridgehead at Sobraon on 10 February 1846. It was a classic, ruthless onslaught in which Gough used every weapon available to him. Bombardier Bancroft wrote that the infantry and artillery worked in unison:

> The former marched steadily on in line, with its colours flying in the centre, and halting only to close in and connect where necessary; the latter taking up their respective positions at a gallop, until all were within three hundred yards of the Sikh batteries; but

notwithstanding the regularity, the soldier-like coolness, and the scientific character of the assault ... so terrible was the roar of musketry, the fire of the heavy cannons, and of those pestilential little guns called 'zumboorucks' and so fast fell our dead and wounded beneath them all that it seemed impossible that the trenches could ever be won. But very soon the whole of our centre and right could see our gallant soldiers swarming in scarlet masses over the banks, breastworks and fascines, driving the Sikhs before them within the area of their own defences over which the yellow and red colours of the 10th and 53rd were flying; and no less gallant was the bearing of the 43rd and 59th Native Infantry, who were brigaded with them and swept in with them 'shoulder to shoulder.'

Tej Singh deserted across the Sutlej at the start of the action, but his force was not so fortunate. Despite stubborn Sikh resistance, Gough's men broke through their perimeter while the bridge behind Sikh lines was destroyed, partly by British artillery and partly under the orders of the fleeing Tej Singh. The defenders were cut off, but none surrendered. They were slaughtered instead, many in the swollen waters of the Sutlej which ran red. The Governor-General's son, Arthur Hardinge, wrote: 'The river seemed alive with a struggling mass of men. The artillery, now brought down to the water's edge, completed the slaughter. Few escaped; none, it may be said, surrendered.'

Gough much later wrote: 'Policy precluded me publicly recording my sentiments on the splendid gallantry or the acts of heroism displayed by the Sikh army. I could have wept to have witnessed the fearful slaughter of so devoted a body of men.' Such sentiments could not, however, disguise his brutal efficiency at the scene. He had done his job well, and the remaining might of the Khalsa was destroyed.

It is accepted amongst Sikh historians that the Khalsa was betrayed by both of their generals, Lal Singh and Tej Singh, on the orders of the Maharani whose vow of vengeance for the murder of her brother had been made good. The 9 March 1846 Treaty of Lahore saw her surrender the valuable Jullundur Doab regions to the British, while the Durbar was ordered to pay an indemnity of 15 million rupees. Because it could not raise that sum quickly, Kashmir and the frontier hill territories were ceded to Britain. But Jindan Kaur remained Regent and her child Duleep remained the would-be Maharajah.

Her grip on power, however, was short-lived. The Lahore Durbar voted for a continued British presence until Duleep was sixteen. Under another treaty a week before Christmas 1846 the British gave the Maharani a pension of 150,000 rupees and replaced her with a British resident and a council of regency. The East India Company effectively ruled the Punjab.

THE SECOND SIKH WAR

Following the slaughter of many of their comrades, survivors of the Khalsa were retained by the British to curb the rebellious instincts of several Sikh provinces which were tempted to forge an alliance with Afghanistan's ambitious ruler, Dost Mohhammed. The British did not want to commit more men and expense than were strictly necessary and Governor-General Hardinge actually reduced the Bombay Army by 50,000 to help recoup some of the costs of the war. The Khalsa generals rankled at having to take orders from junior British officers and civil servants.

In 1848 Sir Frederick Currie was appointed political agent in Lahore. He was a stiff pen-pusher who refused to believe reports that Sirdar Chattar Singh, the Sikh governor of Hazara, was plotting rebellion. More evidence of his bull-headedness came when Currie imposed a Sikh governor, Sirdar Khan Singh, on the city of Multan, replacing Viceroy Dewan Mulraj. British political agent Lieutenant Patrick Vans Agnew and a small escort was sent to supervise the handover. Vans Agnew's party was attacked by irregular troops and then butchered by a mob. Mulraj handed Vans Agnew's head to Khan Singh and told him to take it back to Lahore. News of the killings spread fast and many Sikh soldiers deserted their regiments to join the revolt.

A hastily-raised irregular Pathun force, together with some loyal Sikh units under Lieutenant Herbert Edwardes defeated Mulraj's army at the Battle of Kineyri on 18 June 1848. He pursued them back to the city but was unable to attack the strong fortifications.

Currie asked for a large British force to invest Multan, but was denied by General Sir Hugh Gough, commander of the Bengal Army, who argued that he must wait until November and the end of the monsoon season. Currie instead sent a smaller force under Major-General William Whish to begin the siege of Multan. It joined Edwardes in mid-August.

Other British agents were doing their best to stop further revolt, or contain it when in occurred. Cavalry under Captain John Nicholson seized the vital fort of Attock commanding the Indus River before the Sikh garrison had decided whether to rebel or not. Nicholson then joined other units to capture the Margalla Hills and isolate the rebellious Hazara province. But the biggest shock to the British came when Sirdar Sher Singh, commander of the main Sikh Army and a son of Ranjit, defected to Mulkraj with 5000 men and 10 cannon.

In November large contingents of the Bombay Army finally joined Whish outside Multan, while Sir Hugh Gough led the main British East India Company force against Sher Singh's army which defended the line of the Chenab River. On 22 November the Sikhs forced back a cavalry attack on their bridgehead on the eastern bank in the Battle of Ramnaggur. An officer in the Bengal Horse Artillery wrote home:

> The Sikhs had placed their guns in masked batteries; and, as you might suppose, the sudden discharge took our people by surprise; nevertheless they went on, seeing a great number of the enemy beyond the nullah. The ground was very heavy and sandy: a large portion of our cavalry got into a quicksand, and the horses, being somewhat exhausted by the march over heavy ground, were not able to extricate themselves as soon as they might have done. The enemy's infantry were, in the meantime, behind large sand hillocks, and steadily firing into our men.

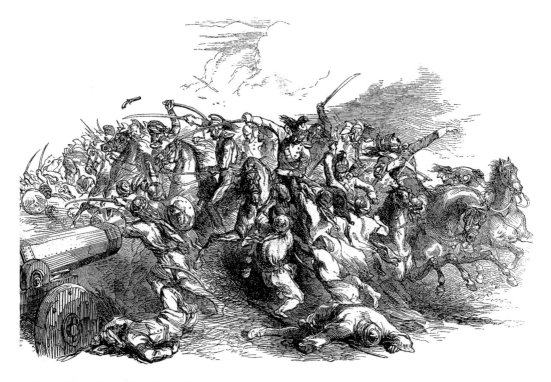

The death of General Cureton at Ramnagar during the Second Sikh War. (*The Illustrated London News*)

The partial victory raised Sikh morale. Gough, however, outflanked the defenders and crossed the Chenab in December. But a decisive British victory was lost when the cavalry waited for infantry reinforcements, allowing the Sikhs to make an orderly withdrawal.

At the beginning of 1849 Afghanistan's Dost Mohammed offered support to the Sikh rebels. When 3500 of his horsemen approached the Attock fort the Muslim garrison led by Nicholson defected. That allowed Hazara governor Chattar Singh to move out of his province and march towards Sher Singh's main rebel army. Gough was ordered to destroy Sher Singh's army before the reinforcements arrived. What followed was one of the costliest battles of the Raj.

Sher Singh had cunningly hid his army near the Jhelum River and Gough's advance guard stumbled across it on 13 January. Although it was mid-afternoon Gough refused to countenance a halt to his advance, much less a retreat. The Battle of Chillianwala was fought at close quarters in thick, thorny scrub between around 12,000 men under Gough and over 30,000 Sikhs.

The 24th Foot, a battle-hardened regiment with a reputation for both courage and ill luck, led the advance; 31 officers and 1065 men burst through the foliage across a wide open space commanded by 20 Sikh guns. Roundshot and grape mowed them down in swathes. They were under orders to use only their bayonets and doggedly charged on. Lieutenant Andrew Macpherson wrote:

> One charge of grapeshot took away an entire section and for a moment I was unhurt. On we went, the goal is almost won, the ground clears, the pace quickens ... the bayonets come down for the charge. My men's pieces were loaded but not a shot was fired, with a wild, choking hurrah we stormed the guns and the battery is won.

The fight was one of blades, brute strength, ramming rods in a stabbing, slashing, cursing melee. The Queen's colours were lost in the confusion, but the 24th broke the Sikh line and spiked the guns, before being forced by flanking fire to reverse their steps. It was a magnificent charge, all who saw it agreed, but the cost was even higher than that of the better known Light Brigade action at Balaclava. The 24th lost nearly half its men, with 515 casualties including 238 dead. Of its 31 officers, 13 were killed and 10 wounded.

Elsewhere on the battlefield the British and Indian units were either distinguishing or disgracing themselves. Lieutenant D.A. Sandford of the 2nd Bengal Europeans described another infantry charge on the right: 'The men bounded forwards like angry bulldogs, pouring in a murderous fire. The enemy's bullets whizzed above our heads; the very air seemed teeming with them; man after man was struck down, and rolled in the dust.' When Sandford's unit was surrounded, the horse artillery blasted an escape route for them through the Sikh ranks.

> Every gun was turned on them, the men working as coolly as on parade, and a salvo was poured in that sent horse and man head over heels, in heaps. The fire was fearful; the atmosphere seemed alive with balls. I can only compare it to a storm of hail. They sang above my head and ears so thick that I felt that if I put out my hand it would be taken off.

On the left a cavalry charge led by Brigadier White captured guns, ammunition and an elephant. But such successes were almost squandered by the performance of cavalry under the elderly, almost blind Brigadier Pope. The men under his command – the 14th Light Dragoons, the 9th Lancers and two regiments of native cavalry – had little confidence in him. When they were ordered to attack a large body of Sikh horsemen, Pope got the orders confused and sent them charging in the opposite direction through the British artillery lines. The Sikh cavalry took advantage of the confusion and followed them. They cut down 73 gunners and carried away several guns and the regimental colours. The Sikhs gave no quarter, nor expected any in return.

The battle dragged on inconclusively until nightfall. Both sides were mauled and three days of heavy rain allowed a halt in hostilities while they recovered. Both sides withdrew. As the Sikhs were allowed to meet up with Chattar Singh, the battle was a strategic British defeat. Gough was heavily criticised by administrators deeply shocked by the scale of losses: 104 missing and 66

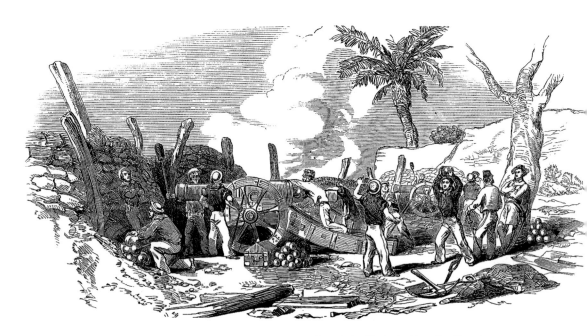

A battery manned by Royal Navy sailors besieging Multan. (*The Illustrated London News*)

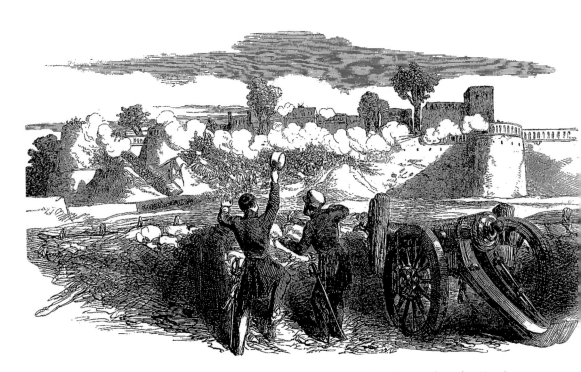

The 1st Bombay European Fusiliers storming a breach at Multan. (*The Illustrated London News*)

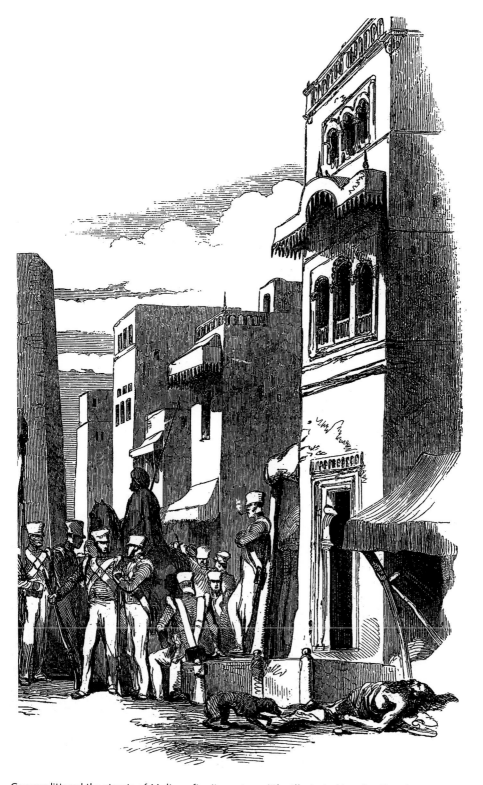

Corpses littered the streets of Multan after its capture. (*The Illustrated London News*)

officers and 1585 men wounded, 26 European officers and 731 men killed. The Queen herself said that 'the news from India is very distressing.' The *Annual Register* recorded:

> The news was received in England with a burst of sorrow and, we must add, indignation. Want of due caution on the part of the General was patent on the face of the accounts of the engagement, and it was felt that it ought not to have been hazarded, nor so great a waste of life so wantonly incurred.

Gough was officially replaced by General Charles James Napier but the orders did not arrive until the war was over.

By now General Whish had completed his siegeworks around Multan and his batteries pounded the walled city and its population of 80,000. Corporal John Ryder wrote in his diary: 'Salvo after salvo went thundering into the town, both shot and shell, and must have committed awful destruction ... killing men, women and children. We got more guns into play during the night, and approached much nearer to the walls.' The walls were breached and Mulraj's main magazine was detonated by fire, creating an explosion which was likened to an earthquake and which killed up to 800 people. The *Illustrated London News* correspondent sent his report to Bombay:

> The principal magazine of the fort blew up with a terrific explosion – nearly 800,000 lbs of powder are reported to have been stored in it – blowing a vast column of dust a thousand feet up into the air. The destruction it caused around was tremendous. A conflagration immediately commenced spreading through the town ... On the next two days, the cannonade continued; shells were thrown sometimes every minute, sometimes at intervals of ten minutes, and fearful salvos were from time to time discharged from the heavy batteries.

Sikh cavalry surrender their arms at Rawalpindi, 11 March 1849. (*The Illustrated London News*)

After such a battering, Mulraj surrendered the city on 22 January. An officer of the 32nd, 'J.D.', reported to the ILN:

> I wish never again to see a sacked city, with its heaps of slain, and of wounded, and dying lying all around, and its crowds of poor old men, and women and children, crowding together in fear in the corners of the streets. In two or three days, however, encouraged by our gentleness, the inhabitants began to return ... and the busy hum of traffic sounds as it did before; and it is only when you stray into the more unfrequented streets and dark courts, and kick your boot against a dead body, that you are reminded.

Mulraj was imprisoned for life. Whish was now able to reinforce Gough with both men and large cannon which the rebel Khalsa force lacked.

Sher Singh tried to outflank Gough by crossing the Chenab, but heavy rains had swollen the river and those who struggled across were defeated by British irregular cavalry. On 13 February Gough attacked the Khalsa and Hazara army at the Battle of Gujrat. He first bombarded the hastily-dug enemy entrenchments for three hours, and then sent forward his cavalry and horse artillery. The Sikhs broke and a bloody chase ensued which lasted four hours. Gough's report stated:

> The retreat of the Sikh army thus hotly pressed, soon became a perfect flight, all arms dispersing over the country, rapidly pursued by our troops for a distance of 12 miles, their track strewn with the wounded, their arms and military equipment, which they threw away to conceal that they were soldiers.

Little if any quarter was given.

Sher Singh and Chattar Singh surrendered near Rawalpindi on 12 March 1849 and 20,000 of their men laid down their arms. Dost Mohammed's Afghan cavalry rushed for home.

On 30 March the 10-year-old Mahrajah Duleep Singh signed away all claims to the Punjab and his kingdom was annexed by Britain. Duleep was given a pension of £50,000 a year and came to England with his guardian, a Bengal Army surgeon. The Raj under Viscount Dalhousie continued to expand and the remnants of the Khalsa, respectful of their former enemies in battle, joined the army of the Raj, as did their sons.

Amongst the spoils of the Second Sikh War was the fabulous Koh-in-Noor diamond, the 'Fountain of Light'. It was presented to Queen Victoria as a token of Sikh submission and remains in the Crown Jewels.

THE CRIMEAN WAR

'One could not walk for the bodies.'

The Crimean conflict is widely reckoned to have been the first truly modern war, harnessing the new technologies of killing and the tactics needed to counter them, and engendering a wider understanding of the horrors involved through a new and burgeoning mass media. By the end of it a million British, French, Ottoman and other allies would have been pitted against 720,000 Russians and their allies. It saw the first clash of ironclads at sea and the development of trench warfare on land. For the first time the telegraph speeded up military communications, while railways speeded munitions and supplies to the front. The conditions suffered by fighting men were highlighted by William Russell's influential and vivid despatches and the equally effective pioneering photographs of Roger Fenton. For the first time the incompetence of commanders were shown all too clearly, and the pioneering work of Florence Nightingale and Mary Seacole revolutionised nursing practices and pricked consciences in every strata of society.

Lord Gough, Marshal Pelissier and staff inspecting the troops in the Crimea. (R. Landells, *The Illustrated London News*)

Yet it began with an unseemly spat amongst rival priests and monks over who should control the Christian holy places in the Holy Land and, in particular, the keys to the Church of the Holy Nativity. The dispute was between the Ottoman Empire, France and Russia, but territorial ambitions saw the real conflict emerge between the Turks and the Russians under Tsar Nicholas I. The British Charge d'Affairs in Constantinople, Hugh Rose, fanned the flames as he gathered intelligence on Russian troop movements along the river Danube. The British Prime Minister Lord Aberdeen sided with the Turks, but Nicholas wrongly believed that the European powers would not object too strongly to his annexation of neighbouring Ottoman provinces. When he sent troops into the Danubian principalities Britain sent a fleet to join a French fleet already in the Dardanelles. The aim was to prop up the shaky Ottomans as a bulwark against Russian expansion towards India. This show of force, and last-ditch diplomatic efforts, failed; the Russians did not withdraw, and the Ottoman Sultan formally declared war on 23 October 1853.

The Turks had some success on the Danubian front and in the Caucasus, but at the Battle of Sinope a few weeks later the Russians annihilated the Ottoman fleet anchored off northern Anatolia. After the Russians again ignored a troop withdrawal ultimatum, Britain and France declared war on the side of the Turks on 28 March 1854. Nicholas, after Austria failed to support him, did indeed withdraw his forces from Danubia, removing the initial cause for conflict, but Britain and France decided this was now the time to curb the Tsar's territorial ambitions once and for all. In Britain the increasingly influential printed media whipped the public into nationalistic fervour with loud demands for tough measures to tame the Russian bear. Paranoia, rather than coherent national interest, proved unstoppable. Britain and France formally declared war on 23 October 1854.

The Danube theatre saw some intense fighting involving British and French expeditionary forces, but it was around the Black Sea that most of the war's focus was directed. At the beginning it was mainly a naval war, with the Russian fleet strangling Turkish coastal traffic between Constantinople and the Caucasus ports. At the end of March the British frigate HMS

'First landing of the Royal Horse Artillery in the Bosphorous.' (*The Illustrated London News*)

The supply depot at Balaclava. (*The Illustrated London News*)

Furious was fired on outside Odessa and in response she bombarded the city. By June British forces were transported to Varna to support the Turks in Danubia, and in September the Allied armies totalling 56,000 men were transported to the Crimea peninsula and laid siege to the naval port of Sevastopol. The Russian fleet refused to engage in action, but instead scuttled their vessels to block access to the port, after first stripping them of their guns. The Russian military commander, Prince Menshikov, evacuated his field force with their guns from the city, but left behind a strong garrison.

The Allied expeditionary force landed at Eupatoria, north of Sevastopol, with no opposition and quickly established a bridgehead. The British and French crossed the river Alma and faced strong Russian positions on the ridge above. Allied losses in the subsequent battle approached 3000, while the Russians lost at least four times that number. Sergeant Luke O'Connor of the Welch Fusiliers laconically described a charge at the Russian guns: 'Getting near the Redoubt, about 30 yards, Lieutenant Anstruther was shot dead and I was badly wounded in the breast with two ribs broken. I jumped up and took the Colour from Corporal Luby, rushed to the Redoubt and planted it there.' The Russians retreated in blind panic. Raglan intended to pursue and destroy them but the French had left their knapsacks at the other side of the river and were determined to retrieve them. Raglan decided that he could not risk further action without back-up and a precious opportunity was lost. The Russian Army regrouped in the interior.

A corporal of the 42nd, quoted by journalist William Russell, said:

I felt what I never felt but once in my life before, and that was when a boy at school, and fighting with another – I felt possessed of a nerve and resolution which I never believed was in me, though I winced a little when I saw a cannon-ball or shell coming direct in my way, and seeing some of my comrades cut in two by it. The bullets were so thick, it would make you think you were in a shower of hailstones. After we had taken the heights we sort of half fell out and were half-permitted. As I was looking at the awful carnage, I came

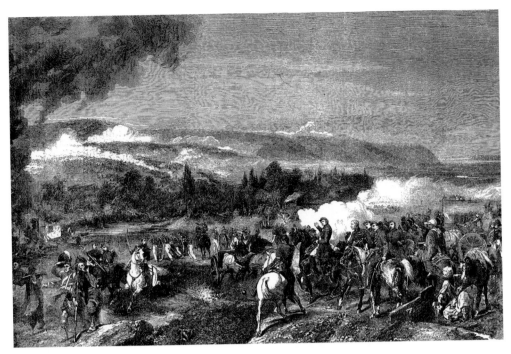

The Battle of the Alma, in a woodcut from a painting by Horace Vernet. (*The Illustrated London News*)

across a poor Pole: he was shot in the belly, and was in great agony. I went down on my knees, the tear stood in my eye, and I cried like a child. I clapped him and gave him a drink of water, which was all I could do for him.

An officer of the 95th described a narrow escape:

While in line, and standing up, we could plainly see the shot, nine, twelve, and twenty-four pounders bouncing along the ground towards us, and over our heads; one of the latter I saw almost when it left the gun; it came apparently very slow, right for me, so slow that one would imagine it could be stopped by the hand, and about a few feet horizontally from the ground. I made sure that my last moment was at hand, when, by instinct, I bent myself double, and, at that moment, whiz, I heard the shot pass and felt the wind of it on my head. A short prayer of thanks to Him who had thus so miraculously preserved me, burst from my lips.

Russell himself graphically described the battlefield:

One could not walk for the bodies. The most frightful mutilations the human body can suffer – the groans of the wounded – the packs, helmets, arms, clothes, scattered over the ground – all formed a scene that one could never forget. There, writhing in their gore – racked with the agony of every imaginable wound – famishing with thirst – chilled with the cold night air – the combatants lay indiscriminately, no attempt being made to relieve their sufferings until the next day.

The victory at Alma was a missed opportunity and showed an ominous failure of leadership by both the British and French commanders. Justin McCarthy wrote:

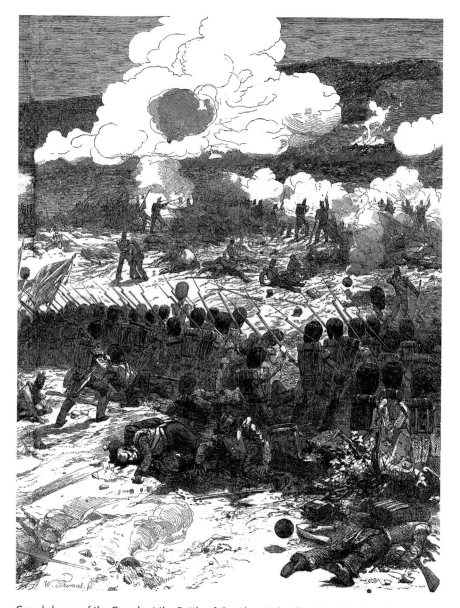

Grand charge of the Guards at the Battle of the Alma. (*The Illustrated London News*)

It was rather a pell-mell sort of fight in which headlong courage and the indomitable obsti-
nacy of the English and French troops carried all before them at last. It was a heroic scramble.
There was little coherence of action between the allied forces. But there was happily an
almost total absence of generalship on the part of the Russians. The soldiers of the Czar
fought stoutly and stubbornly as they have always done, but they could not stand up to the
vehemence of the English and French ... The Russians should have been pursued. They them-
selves fully expected pursuit. The Russians were unable at first to believe their good fortune.
It seemed to them for a long time impossible that any commanders in the world could have
failed, under conditions so tempting, to follow a flying and disordered enemy.

A Russian attack on the supply base at Balaclava was beaten off in October in an engagement best
known for heroic misadventure rather than glory. The British Commander-in-Chief, Lord Raglan,

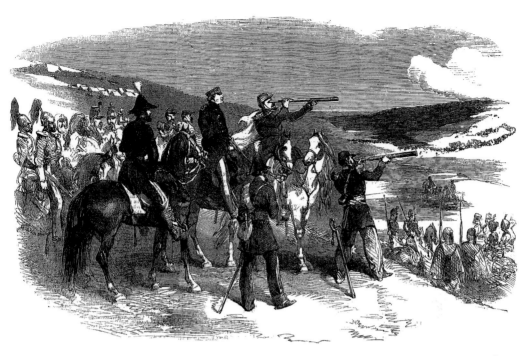

'Lord Raglan and General Canrobert visiting the French outposts opposite Sebastapol.' (*The Illustrated London News*)

had taken men away from the Sevastopol siege line to counter any Russian moves on his supplies seven miles away. Spies had warned of an enemy advance, but he was still taken by surprise. On the evening of the 24th 25,000 Russian men and 78 guns under Count Liprandi were deployed against Raglan's 16,000 troops. A Turkish stand on a redoubt gave the British an extra hour to prepare to defend the Causeway Heights which separated two valleys which provided a direct route to Balaclava. The 93rd Highlanders under Sir Colin Campbell, described by Russell as 'a thin red streak topped with a line of steel,' halted the Russian advance with volley after volley of their muzzle-loading Minie rifles, each capable of firing twice a minute. The Russians turned to storm the Causeway Heights but their column was broken by the extraordinary charge of the Heavy Brigade. Russell's eyewitness account thrilled *Times* readers at home:

> Turning a little to their left, so as to meet the Russian right, the Greys rush on with a cheer that thrills to every heart – the wild shout of the Enniskilleners rises high and clear through the air at the same instant. As lightening flashed through a cloud, the Greys and Enniskilleners pierced through the dark masses of the Russians. The shock was but for a moment. There was a clash of steel and a light play of sword-blades in the air, and then the Greys and the red-coats disappear in the midst of the shaking and quivering columns. In another moment we see them emerging and dashing on with diminished numbers, and in broken order, against the second line, which is advancing towards them as fast as it can to retrieve the fortune of the charge. It was a terrible moment. 'God help them! they are lost!' was the exclamation of more than one man, and the thought of many. With unabated fire the noble hearts dashed at their enemy. It was a fight of heroes. The first line of the Russians, which had been smashed utterly by our charge, and had fled off at one flank and towards the centre, were coming back to swallow up our handful of men. By sheer steel and courage, Enniskillener and Scot were winning their desperate way through the enemy's squadrons, and already gray horses and red coats had appeared right at the rear of the second mass, when, with irresistible force, like one bolt from a bow, the 1st Royals, the 4th Dragoon

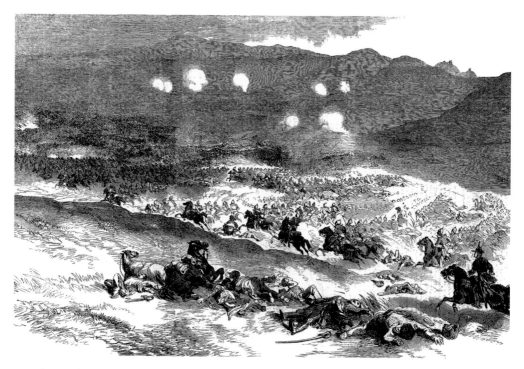

First charge of the Heavy Brigade at Balaclava, 25 October 1854. (*The Illustrated London News*)

Guards, and the 5th Dragoon Guards rushed at the remnants of the first lines of the enemy, went through it as though it was made of pasteboard, and, dashing on the second body of Russians as they were still disordered by the terrible assault of the Greys and their companions, put them to utter rout. The Russian horse in less than ten minutes after it met our dragoons was flying with all its speed before a force certainly not half its strength. A cheer burst from every lip.

Despite this victorious charge, the Russians took control of redoubts at the eastern end of the Heights. Lord Lucan was ordered to lead his Light Brigade down the second valley to sweep them away. But Lucan's orders from Raglan were confusing, unclear, even contradictory, and Lucan led his men down the wrong valley into the jaws of the Russian cannon. By the end of the day he had lost 113 men killed and 134 wounded out of 673. The Charge of the Light Brigade was immortalised by Tennyson, but it was not an unmitigated disaster. Such casualty rates were not that unusual for the time and the Light Brigade managed to drive off a much larger body of Russian cavalry, Cossacks were slaughtered before the batteries, and Cardigan's second line overwhelmed the artillerymen. The Heights were cleared.

The Charge also highlighted the courage of the common soldier. One of them, Private John Pope of the 17th Lancers, a veteran of the Sikh Wars, cantered into legend. A contemporary account reads:

Passing through the enemy gun ... our hero came into contact with a Russian officer; he made for him, and the officer wheeled his horse around for the purpose of making a bolt; he therefore took a favourable distance on the officer's left (both at the time being at a gallop, when he delivered cuts six, which instantly dismounted the officer, whose head was nearly severed from his body. At the same time, his horse halted, and on dismounting, to his grief, he found that his horse had received a bullet in the near shoulder.

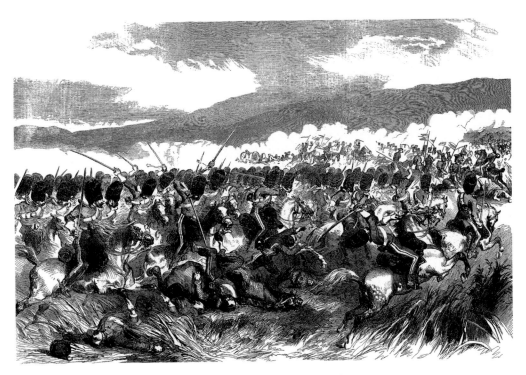

Charge of the Scots Greys at Balaclava. (*The Illustrated London News*)

Pope took the dead officer's sword and cut his way through the Russians, killing or disabling at least seven of them. Both man and horse made it back to the lines.

A Russian attempt to lift the siege of Sevastopol was defeated at Inkerman on 5 November. Menshilov divided his 42,000-strong field army into two columns to attack the Allies' right flank east of the city, the 2700-strong British Second Division. But the attackers were further divided by deployments around ravines and as the Russians advanced through thick fog they were caught in a bottleneck. The Second Division opened fire with their Enfields, while the Russian fire was enfeebled by their reliance on smoothbore muskets. Bayonet charges threw back the first column to engage. The second Russian column was also halted by the stubborn defence of just 3000 men at the Sandbag Battery. Their courage encouraged fellow Britons and some French units to charge a much superior force, and British cannon added to the carnage. The Russians fell back, but again there was no attempt to pursue them.

Inkerman was known at the time as a 'soldiers' battle' because of the by then typical lack of direction from on high. McCarthy wrote:

> Strategy, it was said everywhere, there was none. The attack was made under cover of a dark and drizzling mist. The battle was fought for a while almost entirely in the dark. There was hardly any attempt to direct the allies by any principle of scientific warfare. The soldiers fought stubbornly in a series of hand-to-hand fights, and we are entitled to say that the better men won.

An officer's private letter, quoted by Russell, contained allegations of atrocities by the enemy:

> I can not mention without horror the atrocious conduct of the Russian soldiers to our wounded as were passed to them in the repeated changes of ground during this engagement. Nearly every officer and soldier was bayoneted on the ground, and some even

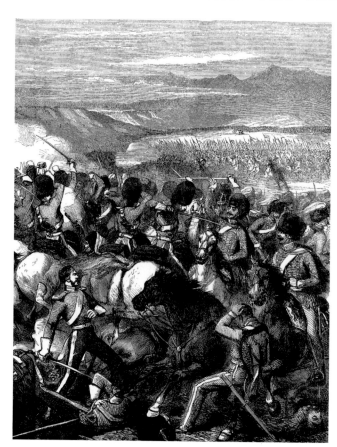

The Scots Greys in action at Balaclava. (*The Illustrated London News*)

The Charge of the Light Brigade at Balaclava. (*The Illustrated London News*)

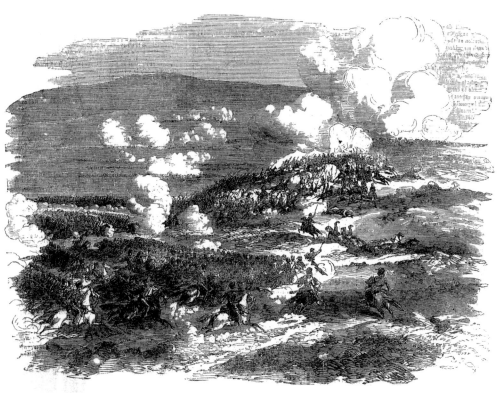

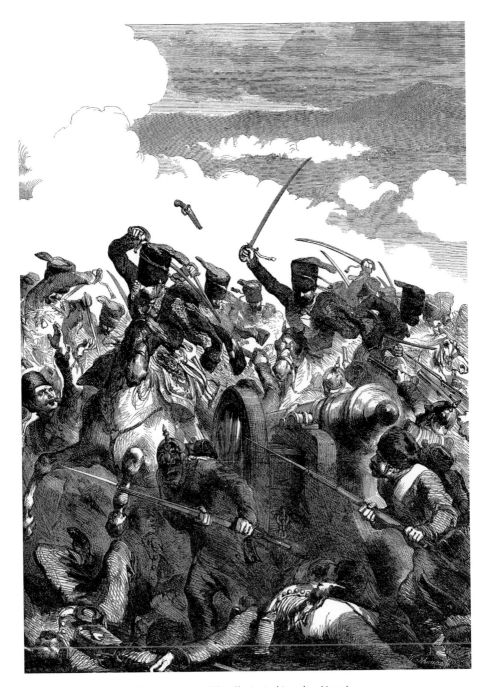

The Light Brigade at the Russian guns. (*The Illustrated London News*)

mutilated to a great extent. Captain Sir R.L. Newman, of the Grenadier Guards, who was wounded in the leg, received so many bayonet thrusts that he was scarcely recognisable ... Lieutenant-Colonel Carpenter, of the 41st, was being conveyed wounded from the field by four of his men, when the Russians surrounded him; the men left him to his fate, when one Russian bayoneted him in the back, another clubbed his musket and struck him on the head with the intention of dashing his brains out, but by great good fortune the blow

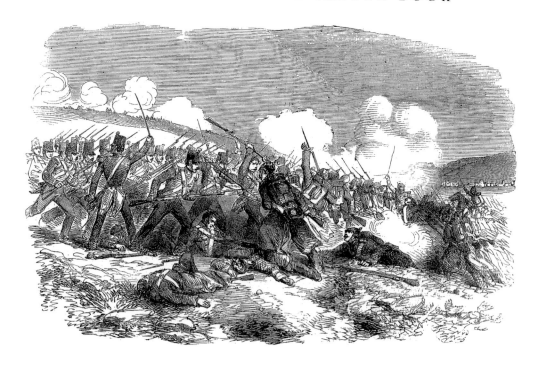

'The Battle of Inkerman – Repulse of the Russians.' (*The Illustrated London News*)

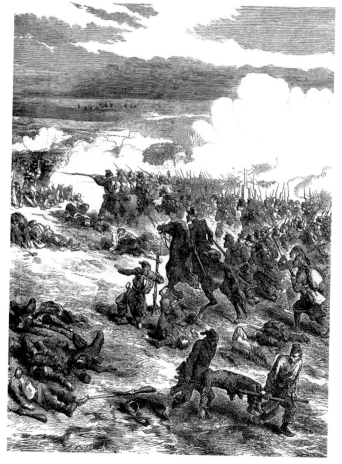

Charge of the English and French troops at Inkerman. (*The Illustrated London News*)

only rendered him insensible, in which state he was found, and it is hoped that he will yet recover. Captain Crosse of the 88th was wounded in the leg and surrounded by six Russians, who came to dispatch him. Drawing his revolver, he shot three of them dead upon the spot, wounded the fourth, and the other two took to their heels.

Supply failures on both sides, together with the harsh onset of winter, caused a halt to land movements. By then the Allies had completely encircled Sevastopol with trenches and batteries. Massive bombardments greatly damaged but failed to breach the city's defences. It was a stalemate.

The lack of adequate supplies was a constant cause of suffering beyond the battlefield. Major Daniel Lysons wrote of his camp:

> The food is very bad and insufficient. A lump of bad beef without any fat, boiled in water, and a bit of sour bread are not sufficient to keep men in good condition. We can get no vegetables whatsoever, and the people of the village here will not sell us anything.

Cholera, dysentery and wound infections took a far greater toll than any battle. Russell reported the miseries of the siege for ordinary British soldiers:

> Our army are much exhausted by the effect of excessive labour and watching and by the wet and storm to which they have been incessantly exposed. It is now pouring rain, the skies are as black as ink, the wind is howling over the ragged tents, in which the water is sometimes a foot deep; the trenches are turned into dykes; the men have not either warm or water-proof clothing and are out for twelve hours at a time in the trenches; they are plunged into the inevitable miseries of a winter campaign – and not a soul seems to care for their comfort, or even their lives. These are hard truths, but the people of England must hear them. They must know that the wretched beggar who wanders about the streets of London in the rain, leads the life of a prince compared with the British soldiers who are fighting out here for their country, and who, we are complacently assured by the home authorities, are the best-appointed army in Europe.

Transporting frostbitten soldiers to Balaclava hospital. (*The Illustrated London News*)

Wives and female camp-followers suffered alongside their men. Colonel George Bell of the Royal Scots wrote during the siege that his troops:

> go down to the trenches wet, die the same night, and are buried in their wet blankets the next morning. Nine of my good men lay stretched and dead this morning outside one tent, rolled up in their blankets. Look into this tent and observe the household. You see it all in rags about the skirting, and the floor is a thick paste baked nearly dry by the head of the fevered patients. That bundle of dirty, wet blanket rolled up contains a living creature, once a comely useful soldier's wife, now waiting for death to release her from such misery.

In February 1855 the Russians attacked the base at Eupatoria where the Turks had built up their forces and were threatening supply lines. The Russians were repulsed with heavy losses.

Outside Sevastopol the Allies switched their main thrusts to the right sector against the fortifications of Malakoff Hill. In March there was heavy fighting over a small hill, Mamelon, to its front, but the defences could not be broken. In April the Allies launched another ferocious bombardment. Artillery batteries duelled across no man's land, but the Allied commanders failed to follow up with an infantry advance. In June a third bombardment was followed by a successful attack which took the Mamelon but failed to take Malakoff. Captain Hugh Hibbert of the 7th Fusiliers wrote of the attack on the Great Redoubt:

> We had some hundred yards to advance across an open plain with guns loaded with grape and canister shot blazing away into us. As I advanced I thought every second would be my last. I could hardly see for the dust that the grape shot made in ploughing up the ground all around us – before – behind – and on each side – shells bursting over my head and fellows rolling over right and left. I seemed to bear a charmed life because nothing would hit me! When we got to the abbatis which was at least fifty yards from the Redan the fire was so heavy that no mortals could stand it and there was nothing for it but to retreat as fast as possible. In fact we were regularly beaten back and I saw those rascally Russians taking off their caps and jeering at us.

Inside the garrison, however, Russian military commander Admiral Nakhimov suffered a fatal bullet wound to the head.

In August the Russians again attacked Balaclava but they were routed in the ensuing Battle of Tchernaya. On 5 September another bombardment softened up resistance to a final assault on the Malakoff which was captured by the French. The British attacked the Redan but Russian resistance remained stiff and the attackers were isolated on the parapet. Captain Nathanial Steevens of the 88th wrote:

> At last our ammunition became entirely exhausted, and our position became therefore untenable. The enemy, perceiving this, made a sudden rush upon the salient, which caused those in front to fall back, and never shall I forget the frightful

'Scene in the military hospital at Maslar.' (*The Illustrated London News*)

Carrying the wounded. (*The Illustrated London News*)

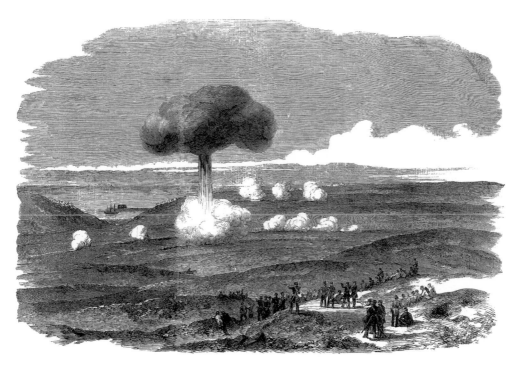

'The siege of Sebastapol – explosion of a powder magazine in the English trenches.' (*The Illustrated London News*)

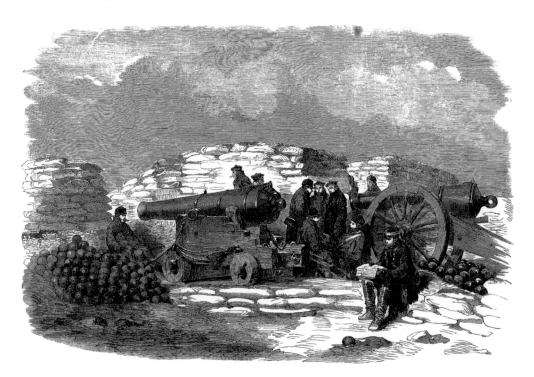

'No 2 Sailors' (Green Hill) battery before Sebastapol.' (*The Illustrated London News*)

Burial of the dead in front of the Malakoff Redoubt. (*The Illustrated London News*)

Destruction of the dock at Sebastapol. (J.A. Crowe, *The Illustrated London News*)

scene that consequently ensued: the whole of us, *en masse*, were precipitated into the ditch upon the top of bayonets, ladders, and poor wounded fellows, who writhed in their agony under the crushing weight of us all; and the shouts and cries were fearful. The Russians now stood upon the parapet, which we had just left, and pelted us with hand-grenades, stones, etc.; under a heavy shower of these missiles I found myself in the ditch, jammed under a ladder, a firelock between my legs with the bayonet through my trousers, while I was trodden upon by numerous feet. With no little difficulty I managed to extricate myself ... and clamber up the side of the ditch; and then what a gauntlet there was to run!

Burial parties later interred 250 British and 150 Russians in the ditch where they fell. The officer in charge of the interments wrote: '*Never* had to perform such a disgusting duty. The bodies were so mangled, and some of the Ruskies had been dead for days.'

Despite such horrific setbacks, the Russian defences collapsed and the city fell on the 9th after a year-long siege. Fires raged in the rubble, igniting batteries and munitions stocks. Russell described the scene:

The rush of black smoke, of gray and white vapour, the masses of stone, beams of timber, and masonry, into the air, was appalling, and then followed the roar of a great bombardment; it was a magazine of shells ... exploding like some gigantic pyrotechnic display in the sky.

The garrison survivors, however, had escaped in good order to join the undefeated Russian Army; the war was not won. But both sides were exhausted and military operations were once again stopped for the winter.

'The land transport camp before Sebastapol – Shoeing a refactory mule.' (J.A. Crowe, *The Illustrated London News*)

Captured Russian guns and a church bell.

Scots Guard saving a French wife from the Russians. (Woodcut from a painting by Sovrieul in an exhibition of pictures of the French School)

The Crimea had not been the only theatre of action during the siege. In May 1855 an Anglo-French fleet sailed into the Azov Sea to disrupt supplies to the besieged city. They destroyed the coastal batteries at Kamishevaya Bay and then attacked the port of Taganrog which had stockpiled huge volumes of food. The Russian commanders refused to give up despite a ferocious bombardment. British and French troops were landed but beaten back by Don Cossacks. The Cossacks then captured the gunboat HMS *Jasper* when it was grounded due to a local fisherman repositioning marker buoys. The Allied fleet left without gaining much glory.

In the Caucasus the Russians faced an insurrection under the mountain leader Shamil. Russian and Ottoman forces clashed at Fort Nicholas, Alexandropol and Akhatzikh. The Russians besieged the town of Kars which finally surrendered in November 1855.

Throughout the eastern hostilities another, now barely remembered, segment of the war was fought in the Baltic. Allied naval commanders Sir Charles Napier and Alexandre Parseval-Deschenes assembled the largest fleet seen since the Napoleonic Wars to take on the Russian Baltic Fleet. The outnumbered Russians, however, stayed close to their fortifications. The Allies considered the massive Sveaborg fortress near Helsinki too hard a nut to crack and instead raided easier targets along the Finnish coast while imposing a blockade to halt trade and supplies to the Russian capital of St Petersburg. The burning of tar warehouses and ships prompted British MP Thomas Gibson to ask the Admiralty to explain 'a system which carried on a great war by plundering and destroying the property of defenceless villagers.' In 1855 the Allied

Private John Penn of the
17th Lancers.

fleet attacked Sveaborg and its dockyards with 1000 guns which together fired over 20,000 shells. Despite the intensity of fire, the Russian 120-gunner *Rossiya* successfully defended the entrance to the harbour. Russian resistance was also boosted by the first-ever deployment of naval 'torpedo' mining of sea approaches, a system devised by Immanuel Nobel, father of the more famous Alfred.

Efforts to end a war which had left everyone drained began in 1856 with Tsar Nicholas's son Alexander II at the Congress of Paris. The new Tsar and the Ottoman Sultanate agreed not to place any naval or military arsenals anywhere on the Black Sea coastline, a major blow to Russian expansionist dreams. The Great Powers also agreed to respect the international and territorial integrity of the Ottoman Empire. That could not stop the process of rot which saw that empire

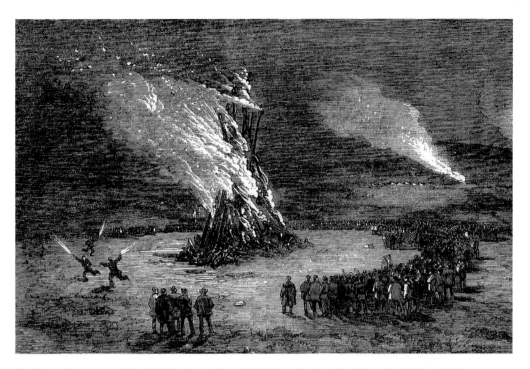

'Bonfire in the camp of the 90th Regiment, the night before leaving the Crimea for England.' (*The Illustrated London News*)

The Crimean troops defiling at the foot of the column in the Place Vendome, Paris. (*The Illustrated London News*)

'Return of the Guards – the welcome in Parliament Street.' (*The Illustrated London News*)

contract and disappear over the next 60 years. Meanwhile imperial Russia grew stronger until revolution brought down the royal family.

The Crimean War cost Britain 2755 men killed in action, 2019 dead from wounds and a massive 16,323 who perished from disease, out of a total of approximately 250,000. Total French casualties were estimated at 100,000, 70,000 from disease, while Ottoman casualties topped 175,000. The Russians and their allies lost 143,000 men, 89,000 from disease. The main killer on all sides was bacterial rather than ballistic.

THE INDIAN MUTINY

'A war of downright butchery.'

The Indian Mutiny, or the Great Rebellion, or the First War of Independence, grew out of Britain's desire to expand in the subcontinent without incurring huge expense. Its roots were complex, its motivations political, territorial and avaricious. It forced the abolition of the British East India Company, the reorganisation of British forces, and the creation of the Raj as it was known for almost 90 years. It also provided the seed of an independent India.

The Company had ruled by force of arms, bribery and commerce since the 1779 Battle of Plassey. But when the Earl of Dalhousie became Governor-General in 1848 he pursued a policy of annexing any Indian state whose ruler died without leaving a clear heir. He claimed the purest of motives but naturally caused resentment amongst the princes and aristocracy and insecurity amongst the civilian population. He pressed on, however, annexing Nagpur, Jhansi and Oudh. Much of the Bengal Army came from these provinces and soldiers of high caste feared that their customs and social order would be replaced by foreign standards. That, Philip Haythornthwaite wrote, 'caused the greatest discontent among that part of society most necessary for the preservation of order, the army.'

The armies of British India were made up of around 330,000 Hindu and Muslim sepoys, plus Gurkhas and Sikhs, roughly five times the number of British troops in the subcontinent. The Bengal Army was largely high caste, while the Madras and Bombay Armies were more caste-neutral. It was in the Bengal Army that the fiercest resentment took root. A change in their rules of service removed their exemption from serving overseas, denied them pensions and reduced their pay to below that of the two other Indian armies. They were also poorly led by elderly or incompetent British officers because Company promotions were slow and many men did not reach the rank of major or colonel until they were 'a terror to everyone but the enemy.' Meanwhile, the Company and Dalhousie embarked on a reduction in the number of white British troops to cut costs. The ratio compared to Indian troops fell to just over 12 per cent.

The potential for resentment turning into mutiny simmered below the surface until 1856; the final spark was provided by the issue of ammunition for the new Enfield rifles. The tallow used to pre-grease the paper cartridges – which sepoys had to bite open – were made of tallow. No-one knew the exact composition, but if the tallow was from pork it would be offensive to Muslims, and if from beef would offend Hindus. In August 1856 they were issued at Fort Williams, Calcutta, and the rumour spread that the cartridges were indeed greased with animal fat. A high caste sepoy was taunted to that effect by a low-caste labourer at Dum Dum. Drill was immediately modified so that sepoys could tear, rather than bite, the cartridges with their hands, but that only convinced many sepoys that the rumours were true and that their fears were justified.

On 29 March 1857 a sepoy of the 34th Bengal Native Infantry, 29-year-old Mangal Pande, tried to incite his comrades at the Barrackpore parade ground. Apparently crazed by *bhang*, or hemp, he tried to shoot the regimental adjutant but hit his horse instead. Pande was court-martialled and hanged on 8 April. Two weeks later the regiment's Jemadar, who had refused to apprehend Pande, was also hanged. The 24th was disbanded and the men were stripped of their uniforms. The ex-sepoys returned to their homes seething at the disgrace and vowing vengeance.

Within days the 3rd Bengal Cavalry refused to take the greased cartridges and were sentenced to ten years of hard labour. The local Meerut garrison rose up, released the prisoners and murdered their white officers, while civilians looted and burnt British properties. Around 50 white men, women and children were killed. Some sepoys of the 11th Bengal Native Infantry escorted some British officers and their families from the scene, but the revolt quickly spread.

At this stage the revolt could have been contained as there were over 2000 British troops with six cannon in the cantonment, and 2357 sepoys, not all of them rebels. But the 70-year-old Major-General Hewitt, who was ill, and other Company officers were indecisive. Their troops rallied but were given no orders to engage the rebels and had to simply guard Company property and armouries through a tense night. The following morning, 11 May, they found Meerut deserted as the rebel sepoys had marched towards Delhi.

When they reached the city, the rebel army, swelled by sepoys from other regiments, massacred every European they could find. Three battalions of Bengal Native Infantry held back from joining the insurrection at first, but when nine British Ordnance officers opened fire on their own guard and then blew up the arsenal, they joined the revolt; they captured another arsenal two miles outside the city containing 3000 barrels of gunpowder. In the meantime European refugees had gathered at the Flagstaff Tower north of the city and telegraph operators stationed there wired the news to other British stations across India. When it became clear that help was not coming immediately they set out in carriages and on foot to Kamal. Some were helped by local villagers, others were robbed and killed. The next day, 13 May, the Mughal king of Delhi, Bahadur Shah Zafar, accepted the allegiance of the rebel sepoys and approved the revolt. His palace guard and servants killed up to 50 European prisoners under a peepul tree.

The news of the Delhi massacres and the King's approval spread rapidly, provoking more sepoy and native civilian uprisings. The exodus of British administrators with their families and servants to places of safety spread panic and further encouraged the rebellion. At Agra 6000 such non-combatants gathered at the fort within days, although it was 160 miles from Delhi. The British military response was disjointed; in some areas commanders trusted their sepoys, in others they attempted to disarm them. Equally, there was little unity amongst the rebels. Some

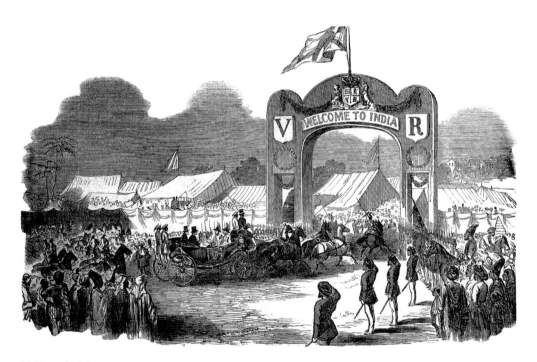

'Native entertainment to European troops at Bombay.' (*The Illustrated London News*)

sepoys wanted Maratha rulers to be enthroned rather than Bahadur Shah Zafar. Some Muslims called for a jihad, or holy war. Sunni Muslims did not want to be ruled by Shi'ites, and vice versa.

Amidst such confusion, loyalty to regiment, religion and region held sway. The Sikhs and Pathans solidly supported the British, as did some Muslims under the Aga Khan. The Bengal

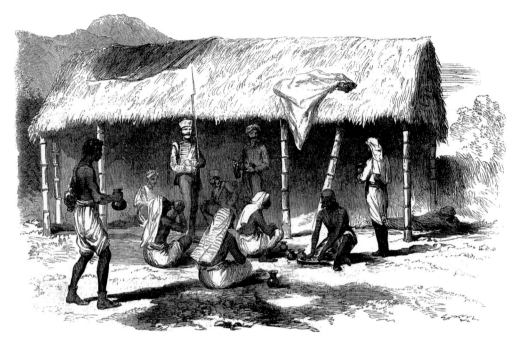

'The 70th Bengal Native Infantry messing.' (*The Illustrated London News*)

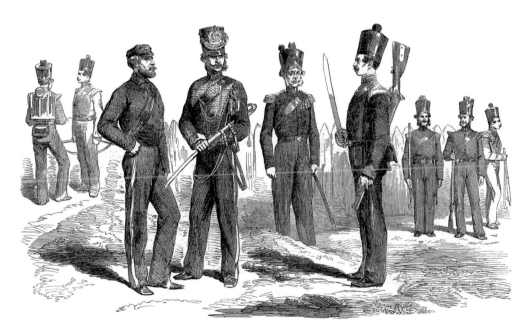

Rifle Company 38th Regiment Madras Native Infantry, sketched at Hong Kong. (*The Illustrated London News*)

East Indian Railway water tank at Barwarie, defended against the mutineers for 32 hours. (*The Illustrated London News*)

Rissaldar Meer Heidayut Ali, 4th Regiment, Bengal Irregular Horse, from a sketch by Major-General Carmichael.

Army was split, with 80,000 troops remaining loyal to the British. They included Rissaldar Meer Heidayut Ali of the Bengal Irregulars who was one of the few Indians publicly feted in Britain for protecting European families. Within the Bombay Army there were three mutinies but it largely remained loyal, while the Madras Army had no mutinies. Most of southern India was untouched, but the north experienced savage mayhem.

Badahur Shah Zafar was proclaimed Emperor of all India and thousands of sepoys and peasants flocked to his banner. The sepoys pushed the British back and captured important towns in Haryana, Bihar and other provinces. One natural leader emerged, Bakht Khan, but largely the sepoys were handicapped by a lack of centralised command and control structures, and the incompetent generalship of Indian princes.

The British were slow to respond, having to transport extra troops from the Crimea through Persia, and divert forces bound for China. Those forces already in India also took time to organise into field forces, but eventually two sluggish columns left Meerut and Simla for Delhi. Two months after the mutiny began they were still short of the city. But at Badli-ke-Serai the two merged columns, including two Gurkha units, met the main rebel army and drove them back. The Company commanders established a base on the ridge to the north of Delhi on 1 July and began to build siegeworks.

For much of the siege of Delhi it might have appeared that it was the British who were besieged. No full encirclement was achieved, allowing the city to be constantly re-supplied and reinforced. The British were generally outnumbered and suffered from disease, exhaustion, poor supplies and constant sorties by the rebels. But Punjabi reinforcements arrived under Brigadier John Nicholson on 14 August and they were joined by a heavy siege train. From 7 September the large guns pounded the city, breaching its walls in several places. The British attacked through the shattered Kashmiri Gate, suffering heavy casualties but gaining a foothold within the city.

Lieutenant Kendal Coghill wrote to his father:

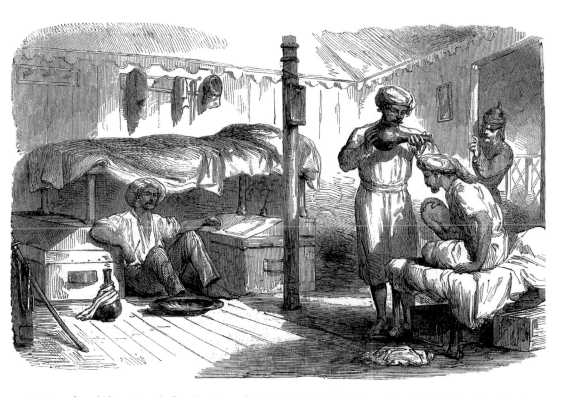

Interior of a subaltern's tent before the siege of Delhi. (Captain G.F. Atkinson, *The Illustrated London News*)

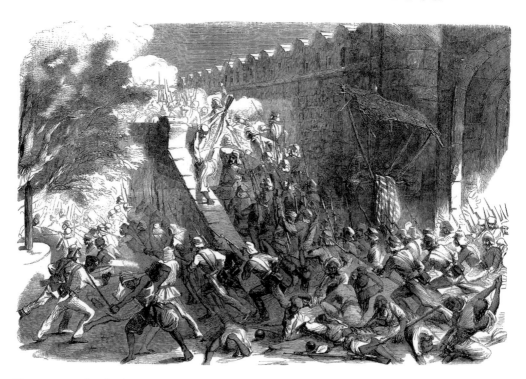

The storming of Delhi. (*The Illustrated London News*)

I took a bit of a pistol bullet in my mouth and with a devil's yell rushed from under cover, knowing that the quicker the rush the nearer the enemy and the earlier the revenge. The musketry and jingals poured in like rain and men kept falling on either side of me, but I thought my life charmed and they could not touch me. The groans and execrations were pitiable in the extreme. They rolled and writhed in agony. I felt like a drunken man. I just remember putting my sword back and seizing the ladders and throwing them down the ditch ... The brutes fought till we regularly cut and hacked our way through them with sword and bayonet. Unfortunately the first thing my sword stuck in was the body of a colour sergeant of mine who was shot and fell on it. But the next moment it was skivvering through a Pandy and then another. All order and formation was over and we cut and hacked wherever we could. I never thought of drawing my pistol, but poked, thrust and hacked until my arm was tired.

The British fought street by street for a week. Lieutenant-General Sir Archdale Wilson wrote to his wife:

This street fighting is frightful work; and Pandy is as good a soldier as that as our men ... We have to gain our way inch by inch, and of the forces we have, unfortunately there is a large portion besides the [native] troops upon whom I can place no confidence ... An attempt was made this morning [18 September] to take the Lahore Gate, but failed from the refusal of the European soldiers to follow their officers. One rush and it could have been done easily but they would not make it. The fact is our men have a great dislike of street fighting. They do not see their enemy, and find their comrades falling ... and get in a panic and will not advance. We and always have been too weak for the work to be performed. Both mind and body are giving way ... I am knocked up ... cannot sleep ... and unequal to any exertion.

Eventually the British forces captured the Red Fort, allowing them to set artillery in the main mosque and bombard the homes of the Muslim nobility. By then Bahadur Shar Zafar had fled. The British had retaken the city.

The army looted and ransacked defences and homes and took their revenge for the massacres of Europeans. A correspondent for the *Bombay Telegraph* reported:

All the city's people found within the walls when our troops entered were bayoneted on the spot, and the number was considerable, as you may suppose, when I tell you that in some houses forty and fifty people were hiding. These were not mutineers, but residents who trusted our well-known mild rule for pardon. I am glad to say they were disappointed.

Amongst those they killed were Zafar's two sons and a grandson who were shot at the Khooni Darwana, known afterwards as the 'bloody gate'. Zafar was himself captured. The Army High Command told Captain Hodson, who had authorised the royal executions: 'I hope you bag many more.' Hodson, who was later killed at Lucknow, wrote: 'With all my love for the army, I must confess, the conduct of professed Christians on this occasion, was one of the most humiliating facts connected with the siege.' A 19-year-old officer, Edward Vibart, wrote:

'Delhi after the siege: looted house within the palace walls.' (*The Illustrated London News*)

'Delhi after the siege: gate of the palace.' (*The Illustrated London News*)

It was literally murder. I have seen many bloody and awful sights lately but such a one as I witnessed yesterday I pray I never see again. The women were all spared but their screams on seeing their husbands and sons butchered, were most painful. Heaven knows I feel no pity, but when some old grey bearded man is brought and shot before your very eyes, hard must be the man's heart I think who can look on with indifference.

The victors sent a column which relieved a besieged Company force in Agra and then moved on to Cawnpore. That city, under the able command of General Sir Hugh Wheeler, who was married to a high caste Indian woman, had endured a three-week siege after sepoys had rebelled. On 25 June the sepoy commander Nana Sahib had offered safe passage to the defenders and their families, who had suffered repeated assaults with little food or water. Wheeler agreed and two days later the evacuation had begun. As the British arrived on the dock of the River Ganges they were surrounded by sepoys. The British tried to push their boats out but they became stuck. All but four of the men were hacked to death or shot, and rebel cavalry rode into the shallow waters to finish them off. Arguments still rage over whether the massacre was accidental or by design.

The surviving 206 women and children were confined in the Bibigarth, the home of the local magistrate's clerk, for two weeks. In one week 25 were brought out dead from dysentery and cholera. A British relief force was approaching from Allahabad and Nana Sahib decided that the remainder must be killed. Sepoys refused to obey that order, so two Muslim butchers, two Hindu peasants and one of Nana's bodyguards carried out the grisly work with knives and hatchets. The dead and dying were thrown down a 50-foot well, and when that was full the rest were thrown into the Ganges.

The British retook Cawnpore after a 126-mile march and what they found in the Bibigarth provoked a terrible fury. Major Octavius Anson of the 7th Lancers wrote:

The blood, hair and garments of poor unfortunate women and children are still to be seen in the assembly room and about the compound. Ouvry brought away the frock of a baby that could hardly have been more than a month old ... We saw lots of remnants of gowns, shoes and garments dyed in blood upon the walls in different places. Outside in the compound there was the skull of a woman, and hair about in the bushes. Oh, what pain...

The few sepoy prisoners not slaughtered on the spot were taken to the Bibigarth and forced to lick the dried blood from the walls and floors. They were then executed, some by hanging, others by tying them to the mouths of cannon. Nana Sahib had fled, and nothing was heard of him again.

Britain was appalled and the cry of 'Cawnpore' spurred on the British and their allies to terrible vengeance. Lieutenant Colonel James Smith Neill of the European Madras Fusiliers, and second in command of the relief column, was one of the most ruthless officers. Europeans had been killed by a mob at the town of Fatehpur and Neill ordered every village along the Great Trunk Road to be burnt and their inhabitants hanged.

> Whenever a rebel is caught he is immediately tried and unless he can prove a defence he is hanged at once; but the chief rebels or ringleaders I first make clean up a certain portion of the pool of blood, still two inches deep, in the shed where the fearful murder and mutilation of women took place. To touch blood is most abhorrent to high-class natives, they think that by doing so they doom their souls to perdition. Let them think so ... The first I caught was a subadhar, a native officer, a high-caste Brahmin, who tried to resist my order to clean up the very blood he had helped to shed; and a few lashes soon made the miscreant accomplish his task. Which done, he was taken out and immediately hanged, and after death buried in a ditch by the roadside.

Neill and his 'gallant blue caps' were feted by the British at home, but as with many such punitive actions, he may have caused the revolt to spread further than it would have otherwise. Another young officer, Thomas Lowe, recalled how his unit captured 76 prisoners who were lined up and 'swept from their earthly existence'. On another occasion he witnessed the shooting of 149 prisoners. Lieutenant C.R.H. Nicholl wrote to his sister that when out shooting deer and peacock he and his fellow officers had no qualms about shooting runaway sepoys and then hanging them

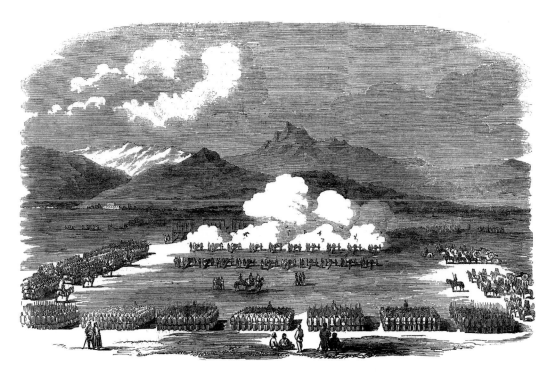

Execution of mutineers at Peshawar by hanging and blowing from cannon. (*The Illustrated London News*)

up in the trees 'for to dry'. Major William Hodson, who had written about the Sikh Wars, led irregular cavalry in a bloody swathe. He recalled: 'I never let my men take any prisoners, but shoot them at once.' The British and their allies felt justified in pursuing the semi-official policy of taking no prisoners, and sentiment at home was with them; when the Governor-General, Viscount Canning, tried to express some understanding of native sentiments he was dubbed 'Clemency Canning'.

Throughout the events at Delhi and Cawnpore, another epic siege was taking place at Lucknow in Oudh province. Sir Henry Lawrence, the British Commissioner, had had time to fortify the Residency compound. Inside were 1700 people, including around 750 British soldiers, some loyal sepoys, civilians and families, all enclosed within 37 acres under more or less constant bombardment. The rebel forces numbered around 8000.

The Residency was at the heart of the defences, connected to six smaller buildings and four entrenched batteries. It was overlooked by several mosques, palaces and administrative buildings in what was the former royal capital of Oudh. At first Lawrence refused permission to demolish them, telling his engineers to 'spare the holy places' and in the following days and weeks they gave excellent cover for rebel snipers and cannon. In one of the early bombardments, on 30 June, Corporal William Oxenham of the 32nd Foot won the Victoria Cross for rescuing a civilian trapped under fallen timbers whilst exposed to enemy fire.

The first assault by the rebels was unsuccessful, so they poured artillery and musket fire into the compound. Lawrence was one of the first to be hit, dying in agony after a shell landed in his bedroom. Colonel John Inglis of the 32nd Regiment took military command and later in the siege assumed civilian command as well when a sniper killed the incumbent.

Captain R.F. Anderson wrote after several more assaults:

We well knew what we had to expect if we were defeated, and therefore, each individual fought for his very life. Each loophole displayed a steady flash of musketry, as defeat would have meant certain death to every soul in the garrison. We dreaded that the further posts might have been further pressed than we were. At intervals I heard the cry, 'More men this way!' and off would rush two or three (all that we could spare) ... and then the same cry was repeated in an opposite direction. During this time even the poor wounded men ran out of the hospitals, and those who had wounds in the legs threw away their crutches and deliberately knelt down and fired as fast as they could; others, who could do little else, loaded the muskets.

A Calcutta merchant, L.E.R. Rees, also wrote of the wounded combatants after another rebel assault:

Pale, trembling with weakness, several of the men were bleeding from their wounds which reopened by the exertions they made. One unfortunate wretch, with only one arm, was seen hanging to the parapet of the hospital entrenchment with his musket, but the momentary strength which the fear of his being butchered in his bed, and the desire of revenge had given him, was too much for him. He died in the course of the day.

The defenders resisted all such attacks and mounted several sorties, during which Victoria Crosses were earned by Captain Samuel Hill Lawrence and Private William Dowling of the 32nd Foot and Captain Robert Hope Moncrieff Aitken of the 13th Native Infantry. But the numbers were steadily whittled away by enemy action and disease. The rebels dug tunnels beneath the walls, leading to underground combat. After 90 days the Company force was reduced to 350 British troops, 300 loyal sepoys and 550 non-combatants.

On September a relief column under Sir Henry Havelock fought its way from Cawnpore to Lucknow in a series of battles during which the 2500-strong force lost 535 men, including the vengeful James Neill. But when it arrived it was too small to break the siege, and so was forced merely to join the garrison. In October a much larger force under the new Commander-in-Chief,

The Campbells are coming!' Romanticised view of the occupants of Lucknow awaiting Sir Colin Campbell's relief column. (Engraving of a painting by F. Goodhall, included in the exhibition of the British Institute)

Sir Colin Campbell, was able to come to the rescue. He stormed the rebel positions with 4500 men and all those inside were killed as retribution for Cawnpore. But Campbell believed that a continued presence in Lucknow would serve no strategic purpose and decided to abandon it. On 18 November the women and children were evacuated first, and then the army made an orderly withdrawal to Cawnpore.

Early in 1858 Campbell again advanced towards Lucknow in force, helped by a strong Nepalese contingent under Jang Bahadur. Dr Monro, surgeon of the 93rd Highlanders, wrote of the start of one bloody engagement:

Each man stood leaning on his rifle, wrapt in his own thoughts. Suddenly there was a slight movement in the ranks, just enough to break the previous stillness. Officers moved quietly to their places, men stood erect, pressed their bonnets firmly down upon their heads, stretched their arms and then, grasping their rifles tightly, stood firm and steady. There they remained for a second or two, when the tall form of their favourite leader, Adrian Hope, appeared and his right hand waved the signal for the assault. Then a cry burst from the ranks. It was not a cheer, which has a pleasant ring to it, but a short, sharp, piercing cry which had an angry sound which almost made one tremble.

Campbell's pace was slow and methodical, although he drove the enemy steadily back with few casualties. One of those mortally wounded was Major Hodson. The rebels abandoned Lucknow but were able to spread out across Awadh. Campbell was forced to spend much of the year dealing with scattered resistance while his men perished from heat, disease and guerrilla attacks.

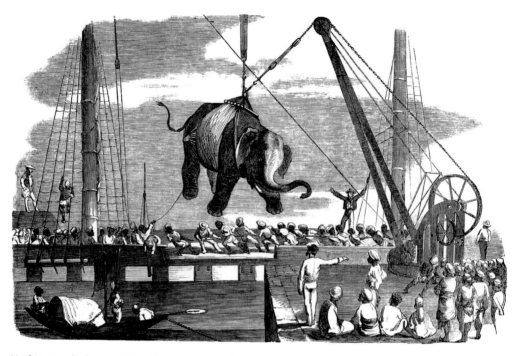

Unshipping elephants at Calcutta as British reinforcements arrived. (*The Illustrated London News*)

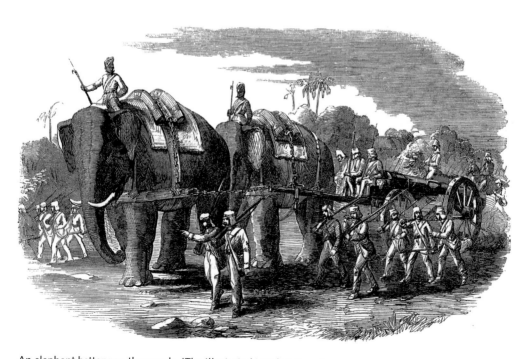

An elephant battery on the march. (*The Illustrated London News*)

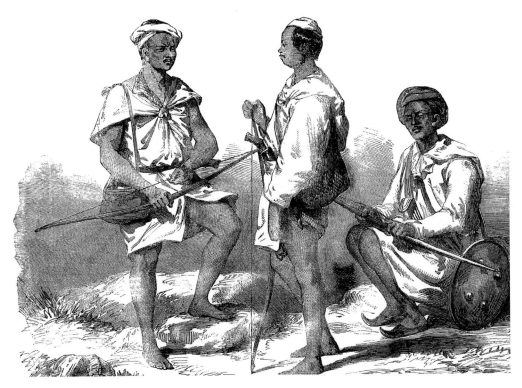

Gurkhas in their national costume. (W. Carpenter, *The Illustrated London News*)

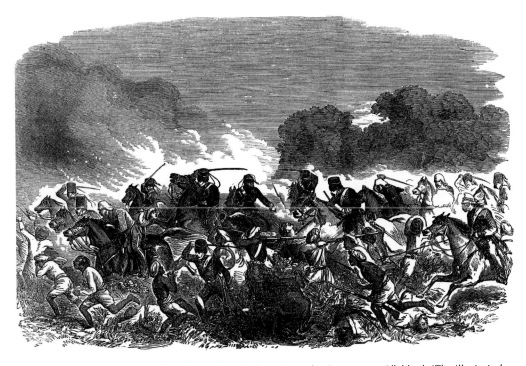

Charge of the Royal Horse Artillery during the attack on Secundra Gunge near Allahbad. (*The Illustrated London News*)

'City and fort of Allahabad: the taking of the city from the rebels.' (Captain Stace, *The Illustrated London News*)

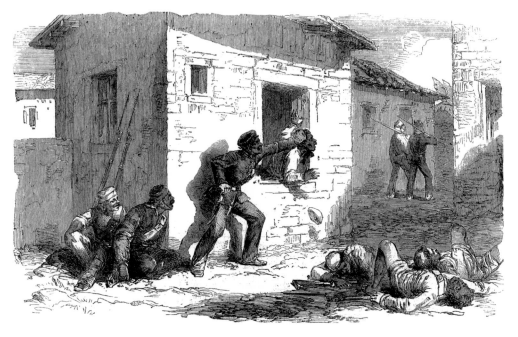

'Tragical adventure in the Subseemundee.' An alleged mutineer was spotted spying on resting soldiers and was promptly beheaded 'to the great delight of the Fusiliers, who could not for ten minutes shoulder their muskets for laughing.' (Captain G.F. Atkinson, *The Illustrated London News*)

There were more bloody clashes in Jhansi, Indore, Jaunpor and Arrah, but the British forces steadily advanced while rebels and princelings squabbled. Actions were largely the scattered pursuit of mutineers, both real and imagined. More bodies hung from trees, more villages were gutted. Garnet Wolseley wrote to his brother:

> Altogether I am thoroughly tired of this life. As long as any honour or glory was attached to it, of course I liked it, but now that the row or whatever it should be called has degenerated down into pursuing small bodies of rebels without cannon and annihilating not fighting them, I take no interest whatsoever in the work as I consider it quite derogatory to a soldier's profession.

The most talented rebel generals were either dead or had fled. The last rebels were defeated in Gwalior towards the end of June.

In July 1858 a peace treaty brought an official peace. Mass executions and reprisals continued. Some estimates put the numbers killed in the hundreds of thousands. No other event in Victorian Britain raised national hysteria heavily spiced with racism to such a high level as the Mutiny. A popular song called on the British lion to 'hang every pariah hound.' William Forbes-Mitchell of the 93rd described the Mutiny as

> a war of the most cruel and exterminating form, in which no quarter was given on either side. Asiatic campaigns have always been conducted in a more remorseless spirit than those between European nations, but the war of the Mutiny was far worse than the usual

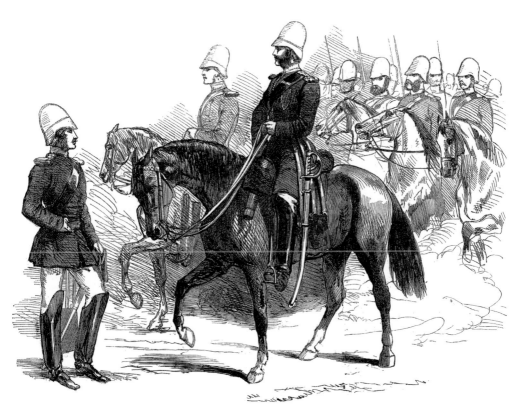

Calcutta Volunteer Guards. (*The Illustrated London News*)

type of even Asiatic fighting. It was something horrible and downright brutalising for an English army to be engaged in such a struggle, in which no quarter was ever asked or given. It was a war of downright butchery.

Bahadur Shah Zafar was tried for treason and exiled to Rangoon, where he died in 1862. The East India Company was dissolved and the India Office was created to govern the subcontinent. It embarked on numerous reforms to better integrate the Indian ruling classes. Religious tolerance was encouraged and territorial grabs were stopped. The civil service was enhanced and widened, while the Raj was based on tradition and hierarchy.

The armies of India, both native and European, were completely reorganised. The Bengal Army – most of whose infantry regiments had mutinied – disappeared and was replaced by 'martial races', most notably the Sikhs and Gurkhas. Indian artillery was replaced by British units. Officers were promoted more quickly, and on talent, reducing the number of elderly incompetents.

Historians have argued not just about the causes of conflict, but also its nature and its effect. Christopher Hibbert put the best case most succinctly:

> The Mutiny, in fact, was not so much a national revolt as the culmination of a period of unrest, a last passionate protest against the relentless penetration of the west. And it was this which gave the rising its extreme emotional content, with sepoys professing loyalty one day and shooting their officers the next. They were torn to distraction between loyalty and affection on the one hand, and the belief that their religion and way of life were threatened on the other. The Mutiny was the swan-song of the old India.

Denis Judd was more judgmental about the Raj and its reaction:

> Many bitter hatreds were left by the mutiny. Deep-seated prejudices which had already been much in evidence before 1857 were confirmed and strengthened. The gulf which had already opened between the races widened to almost unbridgeable proportions. Distrust was heightened. How could the British officer, merchant or even administrator, see Indians in the same light ever again? In a matter of moment, apparently steadfast soldiers and loyal servants had been transformed into murderous fiends. The almost universal approval in Britain of the steps taken to put down the uprising were part of a national mood of retribution and despair.

The British Empire now ruled beyond doubt. In 1877 Queen Victoria became Empress of India, although she never visited the country. Resentments stemming from the Great Revolt simmered up to and beyond independence.

THE ABYSSINIAN EXPEDITION

'The ruthless hand of war.'

The 1868 Abyssinian Expedition, also known as the Magdala Campaign, ended with a pitched battle outside a mountain stronghold which settled an affair of honour. But it is notable not for the clash of warriors and soldiers, but for the extraordinary feats of military engineering involved. The cause, familiar to modern eyes, was the principle that no-one should dare take Britons as hostages. If they did, the outcome was retribution.

Emperor Tewodros II of Abyssinia was a colourful figure – a Christian warrior who had risen from relatively humble beginnings to lead a massive but unruly kingdom. By 1862 most of his provinces had risen up against him, rebelling both against his westernised reforms and his despotism. He believed he had many friends amongst the rulers of the Great Powers and wrote to Britain, France, Russia, Prussia and Austria asking for help to crush the revolt. He was ignored.

Emperor Tewodros II of Abyssinia. (*The Illustrated London News*)

Incensed, Tewodros seized a German-born missionary from the London Society for Promoting Christianity, Henry Aaron Stern, and other Europeans, imprisoned them and had their servants slaughtered. The British consul, Charles Duncan Cameron, and other missionary groups intervened on behalf of the captives. They joined them in chains. The British ordered Hormund Rassan, an Assyrian Christian who worked for the British agency in Aden, to negotiate their release. Tewodros initially welcomed him with generosity and friendship, but the Emperor was subject to wild mood swings; eventually Rassan and all European artisans and their families at the imperial court were seized. The captives were sent to the highland fortress of Magdala, a mountain citadel deep in the heart of the rugged Abyssinian hinterland.

It was clear that the time for negotiation was at an end. On 21 August 1867 Queen Victoria authorised a military expedition to rescue the hostages. Britain had learnt the lessons of the Crimea and this expedition would spare no expense in taking a modern army across more than 400 miles of blistering desert and mountain terrain mainly devoid of roads. The task was given to the Bombay Army under Lieutenant-General Sir Robert Napier. The 58-year-old was a born soldier and military engineer. He had built roads and bridges across India, fought in the First and Second Sikh War, was wounded at Ferozeshah and had seen further action in the North-West Frontier, Oudh and China. He carefully gathered intelligence about the terrain and the size of the force expected to face him before drawing up his expeditionary plans. Hiring commissions were sent across the Near East and Mediterranean to buy horses, mules and camels for transport, and 44 trained elephants were sent from India to carry the heavy guns. Cash was spent to appease the tribes along the route who had a reputation for quickly-shifting allegiances, and Chancellor of the Exchequer Benjamin Disraeli proposed an extra penny on income tax to raise the £2 million thought necessary to finance the expedition. That sum turned out to be wishful thinking.

Lieutenant-General Sir Robert Napier. (*The Illustrated London News*)

The final force consisted of 13,000 British and Indian soldiers – infantry, sappers, artillerymen and cavalry. The British and some Indian cavalrymen were armed with the latest breech-loading Snider rifles which had proved their worth during the American Civil War. The rest of the Indians, in line with army policy since the Mutiny, carried the less efficient Enfield muzzle-loaders. In addition there were 8000 auxiliaries – cooks, teamsters, grass-cutters and animals – and up to 8000 camp followers. The livestock amounted to 36,000 animals, including the elephants. Supplies included 70,000lbs of salt beef, 30,000 gallons of rum, 3000 tins of condensed milk, 250 dozen bottles of port, 800 leeches in the medical carts, and, mainly for Sikh consumption, a quantity of opium.

It took 291 ships and three months to ferry them all from India, Aden and Europe to the Ethiopian coast, which was under Anglo-Egyptian control. The advance guard built piers, landing stages, lighthouses and warehouses on the sandy shore at Annesley Bay south of Massawa. The latest condensers and pumps were bought from the US to ensure a constant supply of fresh water, a photographic unit was created to copy maps and a railway track, complete with locomotive, was laid 20 miles inland across the coastal plain. Napier was criticised for the long and elaborate preparations; armchair generals talked of flying columns and a swift, sharp attack but Napier dismissed such talk as romantic and dangerous nonsense. He had seen much blood during his career and was determined that not a single man under his command should die because of neglect. Christmas dinner on the shore was guinea fowl shot in rows to conserve ammunition.

Tewodros had also been busy, campaigning for a year against the rebels with little success. He knew that his only hope was to beat the British invaders in a glorious war which would rally his people. On hearing that the British were preparing to advance on Magdala he said: 'I asked them for a sign of friendship which is refused to me. If they wish to come and fight let them come. By the power of God, I will meet them and call me a woman if I do not beat them.' At his base in Gondar his well-paid German and Swiss artisans forged cannon and artillery pieces. They included a 7-ton mortar capable of propelling a 1000lb ball which he named 'Sebastopol'.

Tewodros determined to beat Napier to Magdala and the hostages and set off from Gondar with an army which had been whittled down by battle and desertions. He was left with just 5000 fighting men but with more than 40,000 baggage-handlers, drivers and camp-followers. They made painstakingly slow progress across some of Abyssinia's wildest country, and 'Sebastopol' slowed them down even further. On the slopes of one plateau, thousands of men hacked a zig-zag road for the new, prized artillery and Tewodros worked with his bare hands lifting rocks alongside the labourers. In one ravine it took 18 days to reach the floor and three weeks to scale the other side. But by 20 February 1868 his entire army was on the plain approaching Magdala. Told that the British were also on the march, he said: 'We must be on the watch as I hear that some are come to steal my slaves.'

Meanwhile Napier had decided to divide his force. The larger one was to garrison and protect the supply lines along the route, while the smaller division of 5000 fighting men would be the strike force. The British marched from base to base in good order, resting at each stage until fresh troops reached them, and then moving on in turn. It took three months. At Antalo, Napier parleyed with Ras Kassai, later to become Emperor after Tewodros, and won his support, and the dense but slender column was not attacked by hostile tribes. Troops hardened in Afghanistan and India at first found the march easier than they had feared, rough going but not brutal. At the halfway point Napier halved the daily rations to lighten loads and the expeditionary force spread across 100 miles speeded up to 10 miles a day. But then the terrain began to work in the Emperor's favour. Spectacular mountain crests, deep gorges and swollen rivers stood in their path. The weather worsened and the ingenuity of the sapper trail-blazers was tested as they negotiated and improved steep tracks and hairpin bends.

Eventually the spearhead reached the relative ease of the Wadela plateau. From that vantage point Napier could see the outlying spurs of Magdala 12 miles away. He also, to his chagrin, saw the new road which had been built to drag 'Sebastopol' along. It dawned on him that Tewodros had won the race back to his seemingly-impregnable fortress.

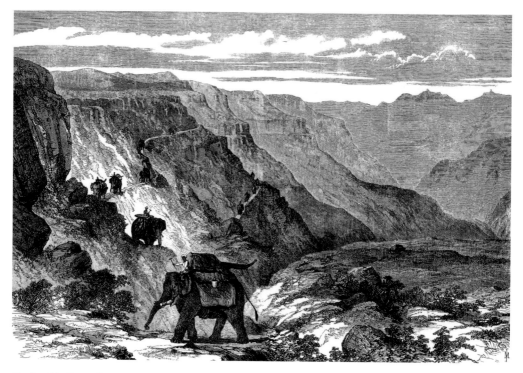

Elephant battery of Armstrong guns crossing the Tacase Valley. (*The Illustrated London News*)

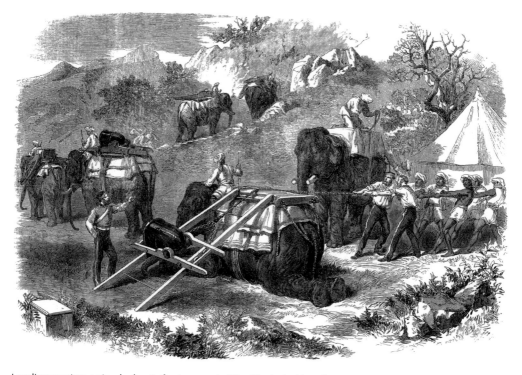

Loading mortars onto elephants for transport. (*The Illustrated London News*)

Part of the British line of march. (*The Illustrated London News*)

Tewodros had reached Magdala on 27 March and had carefully positioned his artillery overlooking its approaches. For weeks on the march he had behaved like a general, a tactician, a leader of men. Once within the fortress he again brooded and was subject to more mood swings. He ordered the release of the hostages, then rescinded the order. He unshackled hundreds of native Galla prisoners, but when they asked for food he went berserk, spearing several as they lay on the ground. His soldiers caught his bloodlust and went to work with their swords until up to 300 lay dead or wounded. All were thrown off the high cliff at Salamji.

The British force camped below the heights but on the afternoon of Good Friday, in the first error of a clockwork operation, they left the baggage train unguarded on the Aroji Plateau. The Abyssinians saw a chance of easy plunder and swarmed down the mountainside. Realising his error, Napier sent the 23rd Punjab Pioneers and the King's Own Royal Regiment to the rescue. The Sikhs were in position first and the King's Own, with some engineers and members of the Naval Brigade, formed a line across the plateau just as Tewodros's warriors reached the level ground. The attackers, clad in medieval armour with cloaks swirling behind them, formed a solid mass of horsemen and foot soldiers up to 3500. The King's Own numbered perhaps 300 men. But they were strung out across a shooting gallery as flat as a billiard table and the attackers had no chance against the Snider rifles and the rockets of the Naval Brigade.

The rockets were fired first, passing just over the heads of the King's Own, causing more discomfort to the British than to the enemy. But the British rifle line opened up at 250 yards and caused carnage. The Abyssinians, all battle-hardened troops, barely faltered as the first volleys ripped into their front ranks. Their tactic, tested successfully on many battlefields, was to soak up casualties and then rush forward as the enemy reloaded. But they had no experience of the Snider rifles and had no time to advance between volleys. Hundreds died before the remainder took cover. One group of 60 however, got as close as 100 yards before being annihilated.

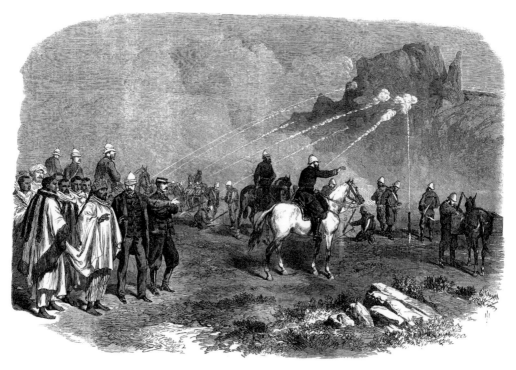

The Naval rocket brigade firing at Senafe. (*The Illustrated London News*)

Meanwhile a smaller Abyssinian force had launched a flanking attack on what they thought was the baggage train. In fact it was a light mountain battery whose guns opened up at 500 yards. The shot and shell did not stop the onrush, nor did the two volleys from the out-of-date muskets carried by the Sikh defenders, and the Sikhs had to meet the Amhari warriors head on. It was basic, brutal hand-to-hand fighting which stemmed the charge and the attackers were all but massacred. The survivors turned and fled, only to find themselves in a killing ground between the Sikhs, a detachment of the King's Own and the mountain battery. Most died.

Throughout the night the wounded lay dying and the night air was punctuated by the wails of women searching for their men. A British observer wrote: 'In ravenous packs the jackals and the hyenas had come to devour the abundant feast spread out by the ruthless hand of war.' The British found that few Abyssinians had discarded their weapons as they attempted to flee the European firepower, a sign that they had been the very bravest of opponents. The death toll was estimated at 700 dead with 1500 wounded, many of whom would have died of their wounds in the hostile environment. Napier lost two dead and 18 wounded.

Tewodros watched the slaughter from above and was driven to despair. His prized 'Sebastopol' was unused, having proved too heavy to manoeuvre into position; other artillery pieces had shattered at their first attempt to fire, and he was aware that his army had been defeated by the mere vanguard of a much larger British force. He freed Cameron and all the European hostages with their families, 187 servants, domestic animals and large quantities of baggage. The British soldiers were amazed at their sleek, well-fed appearance. The prisoners, who for most of their long captivity had been well looked after in comfortable accommodation, objected to having to sleep on the ground under canvas.

Napier had achieved his objective but he sensed that victory would not be considered his without the surrender, capture or death of the Emperor. Tewodros, for his part, gathered 2000 followers within the walls of Magdala and planned to escape via a steep southern path to regroup elsewhere.

Napier ordered the assault on Magdala for 9.00am on 13 April. The 33rd Duke of Wellington Regiment led in drill formation, its band playing 'Yankee Doodle Dandy'. They were met on the

wide approaches by a disorganised flood of refugees. As they got closer to the ramparts a dozen mounted warriors burst from the gate, led by Tewodros himself in a white tunic and lion skins, carrying a rifle, spear and sword. He challenged Napier to single combat, but was met with a salvo of artillery fire. He and his men screamed abuse before wheeling their horses and galloping back to the fortress. It was typical of the man: gallant, medieval, hopeless. It later emerged that by then he had only 250 warriors left behind the walls, but Napier did not know that.

Napier ordered the final assault that afternoon after a mortar and rocket bombardment. The Royal Engineers and the Madras Sappers led the attack, followed by ten companies of the 33rd. Napier's plan was for the infantrymen to give covering fire while the sappers blew the main gate, but a heavy downpour turned the path into a quagmire. When they reached the gate they suffered nine non-fatal casualties from defending fire. The sappers were unable to do their job because the gate had been reinforced with heavy stones and, incredibly, they had brought neither explosives nor ladders. A massive Irishman of the 33rd, Private James Bergin, used his bayonet to hack a foothold in the wall and heaved up a drummer boy, Michael Magner, who straddled the top of the wall and pulled up his comrade. Bergin poured shot after shot into the defenders behind the gate. They were joined by more men of the 33rd. Ensign Walter Wynter, who carried the regimental colours, later wrote: 'It was a tough pull up, but I was hardly ever on my feet as the men took me and the colours and passed us on to the front. I shall never forget the exhilaration of that moment.' The defenders, who included Tewodros, turned and fled. It was his final humiliation. Tewodros sat down behind a hayrick and blew the back of his head off with a silver-plated pistol inscribed as a token from Queen Victoria.

The British met no further resistance. The Abyssinians lost 20 dead and 120 wounded in the artillery bombardment, with a further 45 killed in the turkey shoot behind the main gate. The British suffered ten wounded and five scratched by rock splinters. Bergin and Magner were awarded the Victoria Cross. Magdala was plundered and then burnt. 'Sebastopol' was too heavy to move and lies there still. The column, carrying wagonloads of loot, retraced their steps, again paying tribal rulers for safe passage.

Napier returned home in triumph. Some queried the enormous cost – not the £2 million that Parliament had voted, but £8.6 million – and a Commons inquiry found that some profiteers

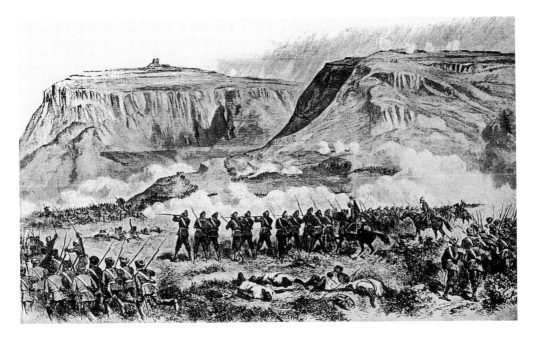

The Battle of Arogee before Magdala on Good Friday, 10 April 1868. (*The Illustrated London News*)

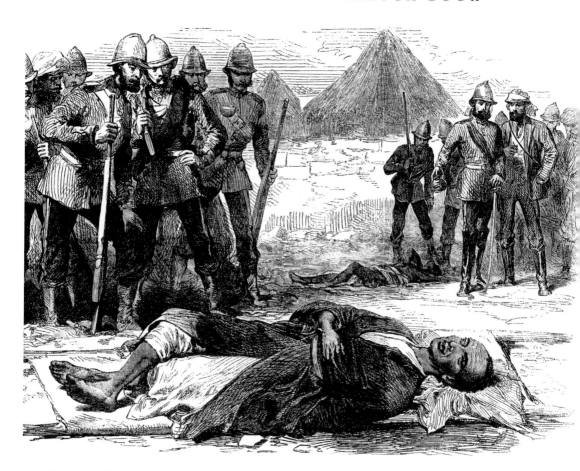

The body of Emperor Tewodros. (*The Illustrated London News*)

had made a fortune from the supply of mules. The P&O Steamship Company was also accused of levying excessive transport charges. But Disraeli responded: 'Money is not to be considered in such matters – success alone is to be thought of.' And that success had been gained at an astonishingly light cost in terms of lives. Just 35 Europeans had died, mainly through illness and exhaustion along the long march, with the Indian contingents suffering similar losses. The low rate of death by disease was due to Napier's preparations and showed that at least some of the lessons of the Crimea had been learnt.

Napier asked for and was given a peerage, becoming Lord Napier of Magdala. He saw no more action but continued to serve as an army commander-in-chief in India, reaching the rank of Field Marshal, before being appointed Governor of Gibraltar. He died, aged 80, of influenza in 1890. His final address to his troops in Abyssinia could eloquently stand for many of those who served the Queen in far-off places:

> You have traversed, often under a tropical sun, or amidst storms of rain and sleet, 400 miles of mountainous and very difficult country. You have crossed many steep and precipitous ranges of mountains, more than 10,000 feet in altitude, where your supplies could not keep up with you ... A host of many thousands have laid down their arms at your feet ... Indian soldiers have forgotten the prejudices of race and creed to keep pace with their European comrades ... You have been only eager for the moment when you could close with your enemy. The remembrance of your privations will pass very quickly but your gallant exploits will live in history.

The burning of Magdala. (*The Illustrated London News*)

The British Army mountain train returning from Magdala. (*The Illustrated London News*)

THE ASHANTI WARS

'An able tactician and a gallant soldier.'

THE FIRST ASHANTI WAR

The Ashanti Empire was a union of warrior tribes who prospered from the slave trade; they raided weaker tribes on the Gold Coast for plunder and captives who they either sacrificed or, in much larger numbers, sold to European slavers. The abolition of the slave trade by Britain led to tensions between the former trading partners. In 1823 Governor Sir Charles McCarthy rejected Ashanti claims to coastal regions and led an invasion from Cape Coast Castle. He was defeated when his columns failed to join up to deliver the expected hammer blow. He shot himself rather than be captured. His head, and that of a young ensign, were kept as trophies by the Ashanti. Their warriors swept down the coast but were forced back by disease.

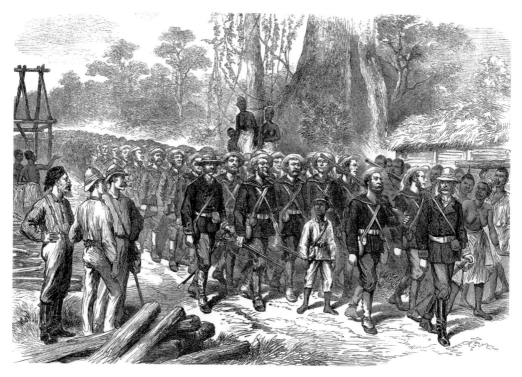

'Arrival of the Naval Brigade in camp at Prahsu.' (*The Illustrated London News*)

In 1826 the Ashanti again invaded and came close to again defeating the British and their native allies in battle. But they were so surprised and shocked by the use of Congreve rockets that they withdrew. In 1831 the Pra River was accepted as the border with the Gold Coast.

THE SECOND ASHANTI WAR

Apart from some minor skirmishes in 1853 and 1853, relations remained peaceful between the Ashantis and Britons for nearly 30 years. Even when the peace was broken, the conflict is often not deemed worthy of being classed as a 'war' by many historians. It came about when a group of Ashantis crossed the Pra in pursuit of a fugitive prisoner, and were met by British troops. Both sides took casualties but the British could not achieve a resounding victory. The refusal of a request for reinforcements from Britain and sickness amongst the men forced the governor to withdraw.

THE THIRD ASHANTI WAR

Britain set up a Protectorate in the coastal regions of the Gold Coast, including areas bought from the Dutch in 1871. The Ashanti were content to keep their power in the north and central uplands of what is now Ghana, trading in palm oil, gold, hardwood and farm produce. But their warlike nature, built out of necessity in a turbulent region, erupted when King Kofi Karikari sent 12,000 warriors south across the Pra. The Protectorate tribes were reduced, according to one British report, to 'a heap of scattered fugitives at the mercy of a pitiless and bloody foe, whose delight is to torture and who will drive them by thousands into slavery, and slaughter all the weak and sick.'

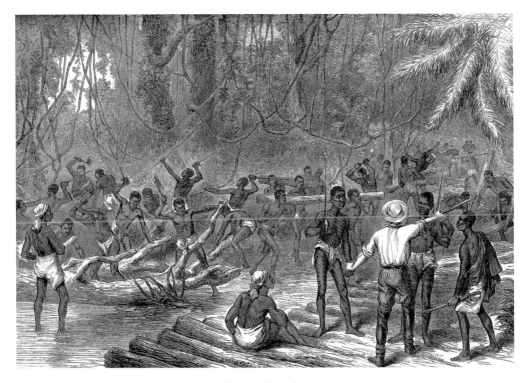

Cutting and making a road to Kumasi. (*The Illustrated London News*)

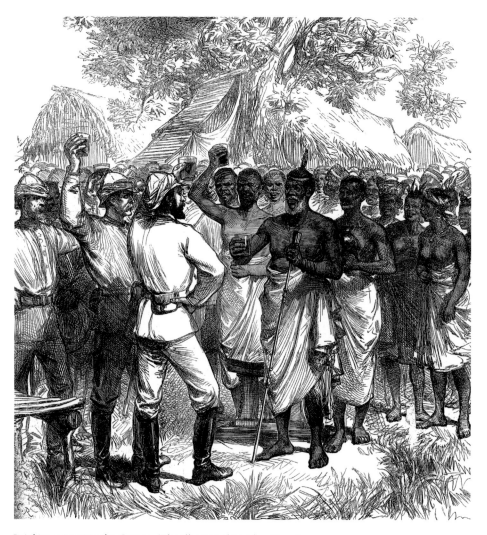

Drinking a toast to the Queen. (*The Illustrated London News*)

British sailors and marines garrisoning the coastal forts – former slave castles – held back the invaders as an expedition force was sent from Liverpool under the command of Major-General Sir Garnet Wolseley. A popular hero and veteran of the wars in Canada, China, Burma and the Crimea, he had been chosen from a list of 400 generals and had laid his plans carefully before arriving in January 1874. He had 2500 British troops and several thousand West Indian and African soldiers, including numerous Fante, deadly rivals to the Ashanti. War correspondents Henry Morton Stanley, Wiliam Reade and G.A. Henty accompanied the expedition.

Wolseley directed his forces from a hammock carried by four soldier-porters, puffing on a cigar while bullets whistled around him. At the Battle of Amoaful on 31 January he pushed back the Ashanti who fielded up to 12,000 warriors. Henty wrote much later:

The roar of the fire was tremendous, so heavy indeed that all sound of individual reports was lost, and the noise was one hoarse hissing roar ... For two hours the fight went on. Then the column to the left found that the Ashantis in front of them had fallen back; they had, however, altogether lost touch of the 42nd. They were accordingly ordered to cut a

Fixing telegraph wires on the road to the Pra River. (*The Illustrated London News*)

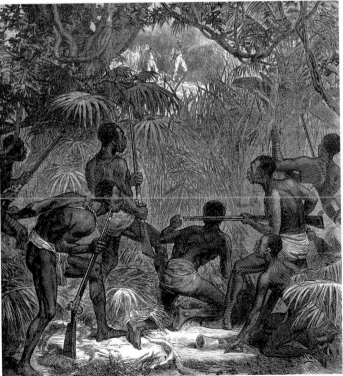

Ashanti warriors wait in ambush. (*The Illustrated London News*)

road to the northeast until they came in contact with them. In doing so they came upon a partial clearing, where a sharp opposition was experienced. The Houssas carried the open ground in a rush, but the enemy, as usual, opened a heavy fire from the edge of the brush. The Houssas were recalled and fire was opened with rockets, which soon drove the Ashantis back, and the cutting of the path was proceeded with ... In the meantime the 42nd was having a hard time of it. They had fought their way to the edge of the swamp, beyond which lay a massive Ashanti camp, and here the fire was so tremendously heavy that the advance was again completely arrested. Not an enemy was to be seen, but from every bush of the opposite side puffs of smoke came thick and fast, and a perfect rain of slugs swept over the ground upon which they were lying.

After five days of hard fighting, Wolseley defeated the Ashanti at Ordahsu. Mark Sever Bell, a 30-year-old Australian-born Royal Engineer won a Victoria Cross for his role in that battle. Part of his citation read:

This Officer's fearless and resolute bearing, being always in the front, urging on and encouraging an unarmed working party of Fantee labourers, who were exposed not only to the fire of the Enemy, but to the wild and irregular fire of the Native Troops in the rear, contributed very materially to the success of the day. By his example, he made these men do what no European party was ever required to do in warfare, namely to work under fire in the face of the enemy without a covering party.

Wolseley and his army took the abandoned capital of Kumasi at dawn on 4 February 1874. Reade of *The Times* wrote of the riches they found: 'The King's Palace consists of many courtyards, each surrounded with alcoves and verandahs having two gates or doors secured by padlocks. The rooms upstairs reminded me of Wardour Street.' Inside were sumptuously-bound

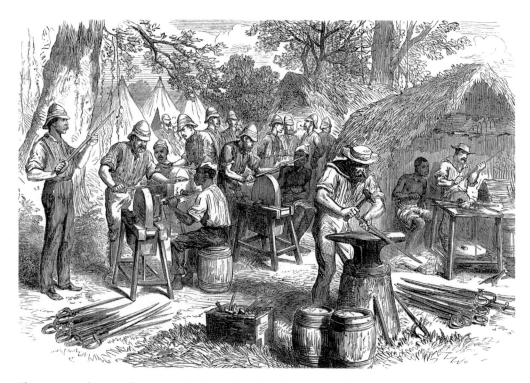

Sharpening cutlasses in the camp at Prah-su. (*The Illustrated London News*)

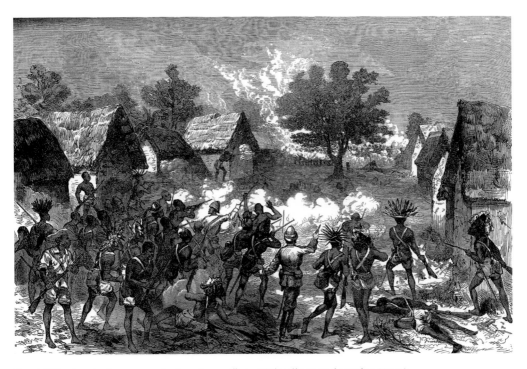

'Lord Gifford and advance scouts storming a village.' (*The Illustrated London News*)

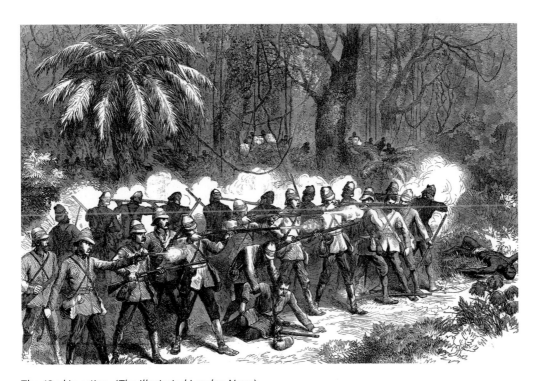

The 42nd in action. (*The Illustrated London News*)

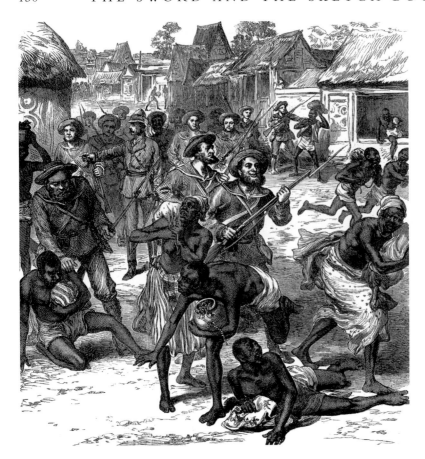

The Naval Brigade clearing the streets of Kumasi. (*The Illustrated London News*)

books in many languages, a sword inscribed from Queen Victoria, Kidderminster carpets, gold-studded sandals with Arabic on the soles, caps of beaten gold covered with leopard skin, velvet umbrellas and many other treasures. It was all looted before British sappers blew up the deserted palace with dynamite. Total British losses were 18 killed, 55 dead of disease and 185 wounded. The campaign had been a success – although an Ashanti army remained at large – because of Wolseley's meticulous preparations, particularly concerning supplies and the health of his men.

Wolseley left after two days. In the Treaty of Fomena, King Karikari's envoys agreed to keep the road from Kumasi to Cape Coast Castle clear and open for trade and peaceful travel. The British agreed to withdraw in return for 50,000 ounces of pure gold as reparations for the £200,000 cost of the expedition. There was peace for another 20 years.

For Wolseley, victory over the Ashanti allowed him to bring together a 'ring' of like-minded senior officers who had distinguished themselves in battle. His idea was to establish cohesion and continuity amongst his staff, but the situation led to bitterness, envy and accusations of elitism. Later, as Adjutant-General he modernised the infantry drill book, championed the switch from red coats to khaki, improved military diet and established mounted infantry schools. He was never to return to West Africa, but tensions with the Ashanti were again stretched.

THE FOURTH ASHANTI WAR

In 1895 the British, fearful of German and French empire-building in West Africa, asked permission to build a fort at Kumasi; King Prempeh turned them down. A British column under Colonel Sir Francis Scott marched into the Ashanti capital the following year without firing

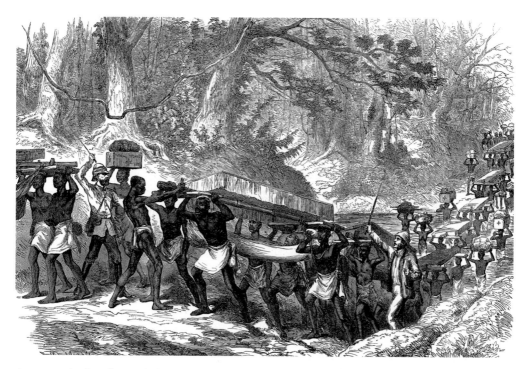

A convoy of sick and wounded crossing a river on the road from Kumasi. (*The Illustrated London News*)

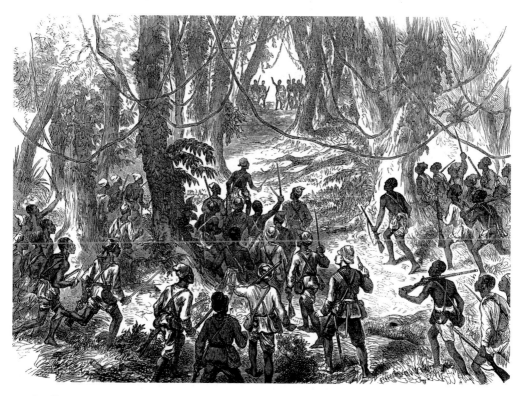

'Lord Gifford and advance scouts on the Adansi Hills warned by an Ashanti priest not to go forward.' (*The Illustrated London News*)

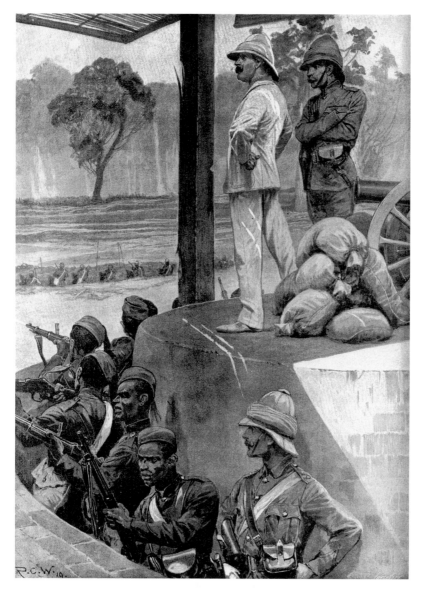

'The siege of Kumasi: The Governor, Sir Frederick Hodgson, directing the defence of the fort.' (F. Caton Woodville, from a sketch by an officer with the expedition, *The Illustrated London News*)

a shot. They found numerous skulls and traces of human sacrifice, adding to the Ashanti's fearsome reputation. The King and 30 of his close relatives were arrested and detained for the alleged crime of not paying the 1874 reparations in gold. They were exiled, first to Sierra Leone and then to the Seychelles, a continent and half an ocean away.

THE WAR OF THE GOLDEN STOOL

The Gold Coast Protectorate's Governor, Sir Frederick Hodgson, travelled to Kumasi with his wife and a mixed bag of soldiers, arriving on 25 March 1900. They were greeted by a surly population apparently on the brink of revolt. Hodgson, a bureaucrat rather than a soldier, pushed them over it. He rightly observed that the key to power in the Ashanti lands was possession of the Golden Stool. Its importance cannot be underestimated – it represented power, unity, and communion

with the tribe's ancestors. Hodgson demanded that it be brought to him so that he could sit on it as the representative of the Queen. The Ashanti leaders, sophisticated power-brokers, had expected Hodgson to demand possession of the stool, but to sit on it was sacrilege. No Ashanti king had ever done so as a mark of respect for ancient forebears, and it was incomprehensible that a foreigner should do so. The outrage of the tribal leaders was compounded when Hodgson sent troops into the bush to search for the Golden Stool.

The search party was quickly surrounded and its leader, Captain Cecil Armitage, decided that a display of British stiff upper lip was called for. He called for afternoon tea and his orderlies set up a spread on folding tables. It was a bad mistake. After five minutes Ashanti snipers opened fire, shattering the cosy affair. A sudden downpour halted the Ashanti rifles, giving the British time to haul their wounded back to Kumasi.

Hodgson withdrew into Kumasi's small, newly-built fort with his wife, 16 European civilians and servants. The garrison consisted of 300 Hausas from Nigeria led by British officers, with six 7-pounders and four Maxim guns. The Ashanti forces made one serious assault on the fort but were repulsed with heavy losses by the rapid fire of the Maxims. The Ashanti and the defenders settled in for a long siege. Ashanti snipers kept up a continuous bee-sting barrage of potshots rather than lethal attacks. For a month the defenders were crammed together, keeping up their spirits with patriotic songs.

A relief column was sent the 170 miles from the coast, but it was a poorly organised, feeble affair. Around 250 men arrived but half were either sick or wounded from ambushes along the trail. They brought no more food or ammunition, and were simply more mouths to feed. As the weeks dragged by, with 600 people now packed into an area designed to hold 60, malnutrition and disease took their toll. Dozens died daily, mainly natives.

Early in June a second column of 700 native troops under Major Morris arrived, but they were already suffering malnutrition themselves. By then the fort had been swelled by refugees to nearly 1000 occupants. It was decided that the Governor and Lady Hodgson, together with several hundred Hausas and a large number of baggage-carriers, should break out of the fort and make a dash for the coast. The sick were to be left behind with a doctor and some fit soldiers with orders to hold out for a further three weeks. At dawn on 23 June Hodgson's party moved out, treading softly as the Ashanti pickets slept.

A small advance party under Captains Armitage and Leggett attacked an Ashanti stockade guarding the main escape route. In a short, fierce fight the Ashanti were driven off, but Leggett and another officer were mortally wounded. It took the Ashanti two days to organise an effective pursuit with up to 15,000 warriors. By then the escape column was well on its way, although harried by villagers who hastily threw up barriers. Sir Frederick and Lady Hodgson were carried in hammocks, although Her Ladyship later complained that she sometimes had to walk like everyone else.

The escape column moved through dense forest hills, down primeval tracks darkened by mammoth mahogany trees, across swamps tangled with bamboos. Food and fresh water was scarce and sickness spread. Reuters later reported: 'Eventually the carriers became so weakened by hunger that everything they carried was thrown away. The Governor and the whole party lived on plantains and endured great hardship.'

They finally crossed the Pra and into the safety of the colony. During the break-out and march the column had lost two officers and 39 loyal Hausas, with twice that number wounded or missing. Hodgson told reporters that the escape was 'one of the most marvellous on record.'

By then a proper relief column under Major James Wilcocks was approaching Kumasi with 1000 British and native troops and police units, six pieces of artillery and six Maxims. During their march the column had been repulsed in attacks on stockades manned by Ashanti and their allied tribes, suffering heavy casualties. It had also suffered almost constant skirmishing and guerrilla attacks by an enemy in its natural element. Willcocks launched his final assault on Kumasi on 15 July 1900 with his force led by Yoroba warriors from Nigeria. They took four heavily-guarded stockades and relieved the fort the following day, just two days before the garrison was due to surrender. Most of those in the fort were too weak to stand.

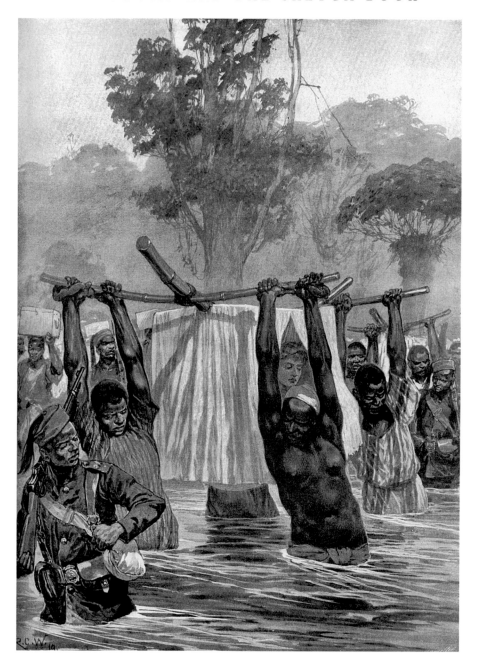

'The escape of Sir Frederick and Lady Hodgson from Kumasi: crossing the Prah.' (F. Caton Woodville, from a sketch by an officer with the expedition, *The Illustrated London News*)

Willcocks spent the rest of the summer tending the sick and wounded in Kumasi, but in September he despatched flying columns into neighbouring regions which had supported the uprising. It was now the rainy season and most roads had turned into muddy torrents. Despite such handicaps, Willcocks's troops routed an Ashanti force at Obassa and destroyed the stockade and town of Kokofu, which had previously beaten off his column during the advance march. Captain Charles John Mellis won a Victoria Cross for his valour in the attack. The Yorobas pursued Ashanti fugitives into the forest, taking few, if any, prisoners.

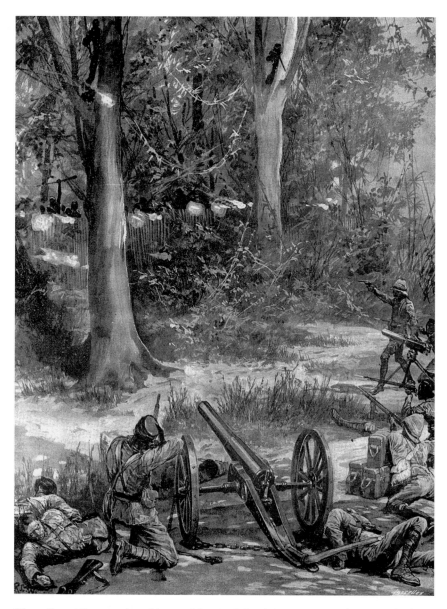

'The action at Dompoasi on 6 June: mishap to Colonel Carter's Force. The enemy had stockaded inside the bush twenty yards from the road, and were driven from their trenches, but owing to lack of ammunition and number of casualties, the British had to retire to Kwisa. The density of the forest-growth made it imperative for the column to advance in Indian file. The seven-pounder gun, with which it was intended to blow down the stockade, was carried in pieces.' (*The Illustrated London News*)

The British annexed Kumasi and took over Ashanti state-owned gold mines. The Ashanti still nominally ran their own affairs but missionaries and Western school teachers undermined the tribal leaders. The Ashanti lands became part of the Gold Coast colony on New Year's Day 1902, the last imperial acquisition of Victoria's reign.

The Golden Stool was hidden in the forests until 1920 when it was discovered by labourers who stole its gold ornaments. Its power was broken.

The Zulu War

'Eat up the red soldiers.'

The Zulu War of 1879 is best remembered for the British Army's worst single massacre at the hands of 'natives' and a heroic defence which inspired an epic film. But it was also a story of oppression and illegal invasion.

Cetshwayo became absolute ruler of the Zulus in 1873 and immediately began rebuilding the military prowess with which his uncle Shaka had forged a nation north of Natal, a British possession in southern Africa. Cross-border disputes with the neighbouring Boer Republic and the persistence of missionaries added to the tensions. Bishop Schreuder of the Norwegian Missionary Society described Cetshwayo as 'an able man, but for cold, selfish pride, cruelty and untruthfulness, worse than any of his predecessors.' The British would soon match his alleged vices.

A British commission into the border dispute over a strip of land in the Utrecht district along Rorke's Drift in 1878 found largely in favour of the Zulus, but the decision was rejected by High Commissioner Sir Henry Bartle Frere; he was determined to form a South African federation which would include both the Boer Republic and Zululand, and was desperate for an excuse to invade the latter. Three incidents, none of them political, gave him that rather flimsy excuse: the wife of a Zulu chief was murdered by relatives after she fled her husband and escaped into Natal; a week later another errant wife suffered a similar fate, in accordance with Zulu law, but this time on British-controlled territory; and two whites, an engineer and a trader, were roughly handled by Zulus when they strayed across a ford on the Tugela River. An ultimatum was sent to Cetshwayo – hand over the perpetrators to British justice, or else. Cetshwayo treated such demands with levity.

Frere's demands were unauthorised in London where the government's official policy was one of non-aggression. Frere, however, was hell bent on humbling the Zulus and their king. His 13-point ultimatum was ignored by Cetshwayo and when it ran out, on 11 January 1879, Britain was deemed to be at war. Cetshwayo sent his main 24,000-strong army from Ulundi with the orders: 'March slowly, attack at dawn and eat up the red soldiers.'

Frere had a willing ally in Lieutenant-General Frederick Augustus Thesiger, the Second Baron Chelmsford, who led the invasion of Zululand without official authorisation. Under his command were 5000 British and 8200 African troops. He decided to split his force into three columns, crossing the border at Lower Tugela, Rorke's Drift and Utrecht, aiming to converge on the Zulu capital of Ulundi. Cetshwayo's army totalled 40,000 men but they did not oppose any of the three crossings. They were biding their time, allowing Chelmsford to drive deeper into their territory.

Chelmsford's main column consisted of twelve companies of the 2nd Warwickshires, experienced and reliable troops. There were also around 2500 Natal Native Contingent auxiliaries, led by European officers, whom the British regarded as poor-quality and unreliable in battle. In addition there were some irregular cavalry units, two field guns, several Congreve rockets and their operators, and several hundred camp followers and servants. It was the rainy season and each column repeatedly became bogged down, slowing the advance to a crawl.

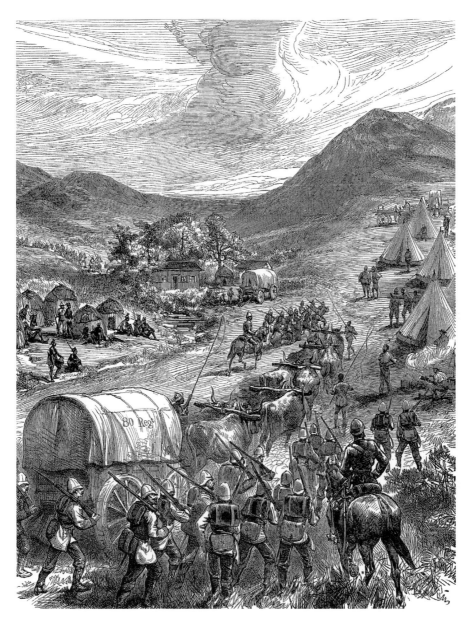

'Camp of the 80th Regiment on the Zulu border.' (Lieutenant Beverley Ussher, 80th Regiment, *The Illustrated London News*)

Facing them was Cetshwayo's army, warriors called out at a time of national danger but who normally only operated for short periods until returning to tend the cattle and crops needed to support their families. The British had timed the invasion to coincide with the harvest, but unfortunately for them the army had already formed in Ulundi for an annual ceremony which all warriors were duty-bound to attend. The Zulus were armed with short assegai thrusting spears, cowhide shields and clubs. They were regularly drilled to use such weapons most effectively, and were trained to form – at a run – the feared mass charges and flanking movements to envelope an enemy.

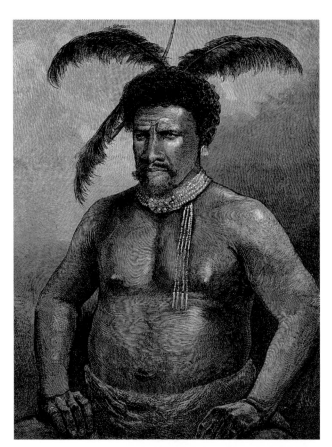

Cetshwayo, the Zulu king, drawn from life in June 1877. (Edward Tilt, *The Illustrated London News*)

'Troops crossing the Tugela under the inspection of Lord Chelmsford. (Melton Prior, *The Illustrated London News*)

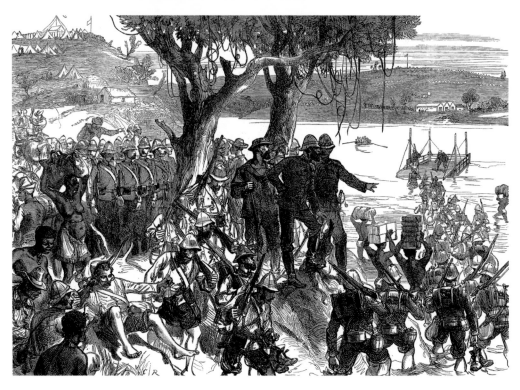

By 22 January the centre column of 1600 British and 2500 Africans, which had crossed at Rorke's Drift, had established a camp close to the distinctive mountain rock known as Isandlwana. Ignoring reports that a large body of Zulus were near by, Chelmsford split his force, leading half his troops to support a reconnoitring party and leaving the camp in the charge of Lieutenant-Colonel Henry Pulleine and Colonel Anthony Durnford. Around noon 20,000 Zulus erupted from the grasslands in their traditional formation resembling the horns and chest of a buffalo. Durnford's rocket battery was swiftly isolated and eradicated. The redcoats were taken by surprise, with no defensive perimeter established. It was a slaughter. The British tried to maintain a slender firing line around the camp – and for an hour or so volleys succeeded in halting and pinning down the Zulu centre – but when ammunition began to run out volunteer irregulars and African troops fell back in panic. The regulars tried to mount a stand in the camp itself and around a *donga*, or dry watercourse, but were overwhelmed by sheer weight of numbers. Assegais at close quarters wreaked terrible havoc. The *Annual Register* recorded:

> We hear of an indiscriminate flight through the tents, and of the slaughter of our soldiers as they fled. We hear, too, of our men forming themselves into squares and little groups, and resisting desperately till their ammunition failed, or they were overwhelmed by repeated charges and showers of assegais. We hear of one wounded officer who, from a waggon, kept crowds of Zulus at bay. And we hear of others who threw down their arms and begged for mercy.

Official reports showed that 858 whites and 471 Africans were killed. More died in ones and twos in gullies and on river banks as they tried to flee or hide. Only five officers survived. The Zulus lost perhaps 1000 men to British and African volleys. Such losses were outweighed by the scale of their victory and by battlefield plunder amounting to 1000 Martini-Henry rifles, up to 2000 draft animals and supplies of tinned food, beer and biscuits.

An officer in Chelmsford's column witnessed the final stages of the battle through a telescope:

> We distinctly saw the guns fired, one after the other, sharp ... a pause, and then a flash! The sun was shining on the camp at the time, and then the camp looked dark, just as if a shadow was passing over it. The guns did not fire after that, and in a few minutes all the tents had disappeared.

One of the few officers to survive, Transport Major Horace Smith-Dorrien, described the massacre and his flight from it:

> Before we knew where we were, they came right into camp, assegaing everyone right and left. Everybody then who had a horse turned to fly. The enemy were going at a kind of very fast half-walk and half-run ... Everybody went pell-mell over ground covered with huge boulders and rocks until we got into a deep spruit or gully. How the horses got over I have no idea. I was riding a broken-kneed old crock which did not belong to me. We had to go bang through them at the spruit. Lots of our men were killed there. I had lots of marvellous escapes, and was firing away at them with my revolver as I galloped along. The ground there down to the river was so broken that the Zulus went as fast as the horses, and kept killing all the way. There were very few white men; they were nearly all mounted niggers of ours flying. This lasted until we came to a kind of precipice down to the River Buffalo. I jumped off and led my horse down ... the horse went with a bound to the bottom, being struck by an assegai. I gave up all hope, as the Zulus were all around me, finishing off the wounded ... I rushed off on foot and plunged into the river, which was little better than a roaring torrent. I was being carried down the stream at a tremendous pace, when a loose horse came by and I got hold of his tail and he landed me safely on the other bank.

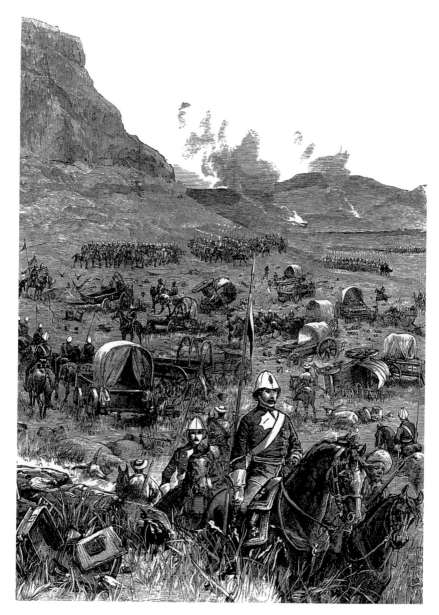

Fetching the wagons from the Isandlwana battlefield. (Melton Prior)

The military post mortem of the catastrophe was mixed. Some blamed ammunition shortages and over-officious quartermasters. Others blamed the length of the perimeter lines which spread the most seasoned regular soldiers too thinly. But the main blame must lie with Chelmsford himself. He under-estimated the Zulus and split his force at a crucial time. He also failed to secure a decent defensive position, and ignored or derided intelligence that there was a large Zulu army in the area. In contrast the Zulus, under the command of princes Ntshingwayo and Mavumengwana, responded swiftly to their surprise discovery of the British camp and launched an immediate, well-disciplined advance. The *impis* (groups of warriors) were well-led, highly-motivated, confident and fearless.

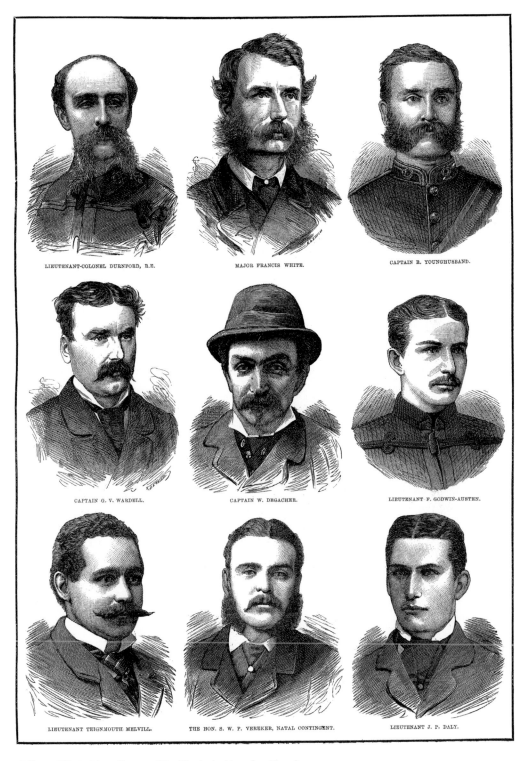

Officers killed at Isandlwana. (*The Illustrated London News*)

After the battle 4000 Zulu reserves, disobeying orders not to attack fortified positions, raided the British post at Rorke's Drift. They were driven off by the disciplined rifle fire of 139 men, some of whom left their hospital beds to fight, behind hastily-improvised ramparts of mealie bags, biscuit tins and upturned wagons. Part of the 13-hour action involved patients cutting holes through the walls, room by room, and bayoneting Zulu pursuers as they squeezed through behind them, while the hospital's straw roof blazed above them.

One of those defenders, Private Robert Jones of the 24th, said afterwards:

I had three assegai wounds, two in the right side and one in the left of my body ... Just as I got outside, the roof fell in – a complete mass of flames and fire ... As to my feelings at the time, they were that I was certain that if we did not kill them they would kill us, and after a

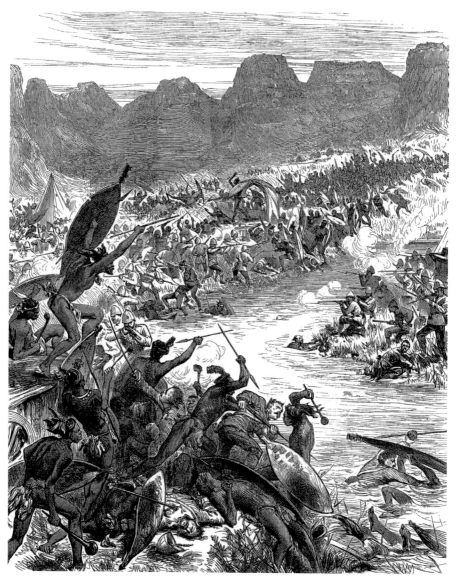

'Attack on an escort of the 80th Regiment at the Intombi River.' (Lieutenant Ussher, *The Illustrated London News*)

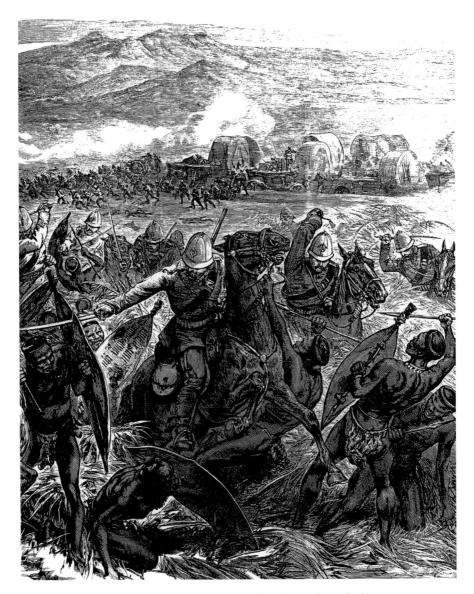

Repulse of the Zulus at Ginghilovo. (Lieutenant-Colonel J. North Crealock)

few minutes' fighting I did not mind it more than at the present time; my thought was only to fight as an English soldier ought to for his most gracious Sovereign, Queen Victoria, and for the benefit of Old England.

Six times the Zulus got inside the perimeter, only to be beaten back, and eventually they withdrew, leaving behind 351 bodies. The Zulu wounded were bayoneted. Eleven Victoria Crosses were awarded to the defenders, including the joint commanders, Lieutenants John Chard and Gonville Bromhead, and the newly promoted Corporal Robert Jones. The all-night defence of the tiny outpost was seized upon at home as a glorious episode which went some

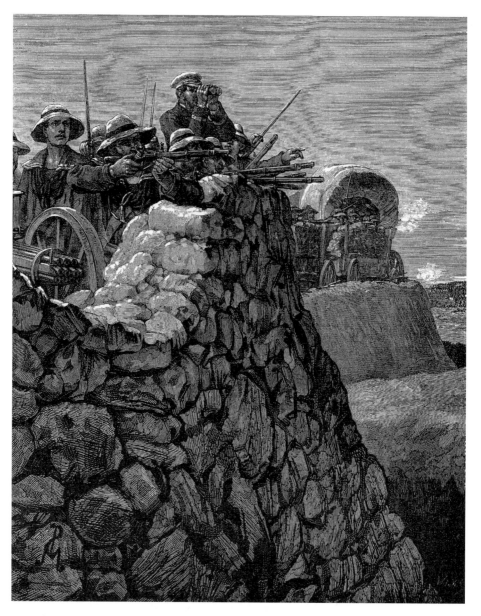

Men of HMS *Shah* at Ginghilovo. (Lieutenant Smith-Dorrien RN, *The Illustrated London News*)

way towards mitigating the humiliation of Isandlwana. The British press lapped up first-person accounts from Rorke's Drift, partly because there were few from Isandlwana. The Zulus saw it as an unimportant side show.

Meanwhile the right flank column under Colonel Charles Pearson crossed the Tugela and advanced to a deserted missionary station at Eshowe. The Zulus cut his supply lines and besieged the mission which held 1300 troops and seamen, and 400 wagoners. The left flank column under Colonel Evelyn Wood occupied tribal lands to the northwest but, hearing of the disaster at Isandlwana, withdrew back to the border.

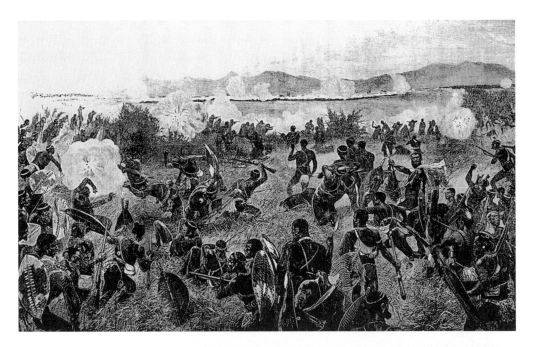

The Battle of Ulundi –
final rush of the Zulus.
The British square in
the distance.' (R. Caton
Woodville)

'Death of Lieutenant
Frith in a skirmish
at Erzungayan Hill.'
(Melton Prior, *The
Illustrated London News*)

The investiture of Major Chard – one of the heroes of Rorke's Drift – with the Victoria Cross.
(*The Illustrated London News*)

 For the next two months Chelmsford built a fresh invasion force to relieve Eshowe. The British government, seething at being bounced into a war they had not sanctioned, nevertheless sent seven regiments of reinforcements and two artillery batteries to Natal. The public demanded that the bloodbath of Isandlwana be avenged. The first troops arrived at Durham on 7 March and at the end of that month Chelmsford led another column into Zululand. It consisted of 3400 British and 2300 Africans who were careful to entrench their camps each night. One lesson of Isandlwana had been learnt.
 A separate contingent of Woods' troops, mainly Staffordshire Volunteers, was ordered to attack the Zulu stronghold of Hiobane. But the main Zulu army of 26,000 men sped to the scene and

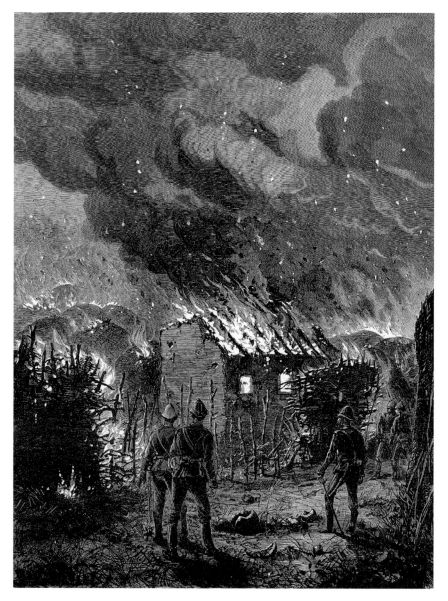

'Ulundi in flames – burning of Cetawayo's house.' (Melton Prior, *The Illustrated London News*)

the attackers – under Lieutenant-Colonel Redvers Buller – were scattered. A quarter of the 600 Britons engaged were killed or wounded. The following day, however, the Zulus lost around 2000 men when their army attacked Woods' fortified encampment at Kambula. Chelmsford's main column also shattered a Zulu attack at Gingindlovu and on 3 April Pearson and his men were relieved. Three days later they evacuated the station, after which the Zulus burnt it to the ground. Chelmsford could feel that at least some of the humiliation of Isandlwana had been alleviated but, despite the latest successes, he was right back where he started from in January.

Chelmsford was determined to inflict a total victory on the Zulus before he was relieved by Sir Garnet Wolseley whom London had despatched to replace him. He built up more reinforcements,

reorganised his forces and mounted another invasion in June. One of the first casualties was Imperial Prince Louise Napoleon Eugene, exiled heir to the French crown, who was killed while reconnoitring with an unsupported patrol on 1 June. He had volunteered to serve on Chelmsford's staff to gain experience of warfare, and his death caused Queen Victoria much grief.

Cetshwayo, who had never tried to invade Natal and wanted only to secure his own country, tried to open peace negotiations but was rebuffed. Chelmsford rushed his army towards the royal *kraal* at Ulundi. Outside the town Chelmsford's advance guard of mounted infantry skirmished, before the main body moved forward in square formation on 4 July with 4165 whites and 1150 Africans. 'The white soldiers made a wall with their bodies,' said a native trooper. Cetshwayo's army of 20,000 men attacked the square in two traditional horns but were bloodily repulsed. The square then opened up to release the cavalry who fell on the remaining Zulus, turning a defeat into a rout. Chelmsford lost 10 men dead and 87 wounded, while the Zulu dead topped 6000.

Cetshwayo went on the run but was captured on 28 August and sent to Cape Town. Wolseley, now in charge, split Zululand amongst various competing chiefs, but it quickly became clear that that was a recipe for more bloodshed and the British government decided that Cetshwayo should be reinstated as the supreme ruler. That strategy also failed as a rival king, Usibepu, had grown too powerful and ambitious. In July 1883 Cetshwayo was defeated and Usibepu's victorious force, led by mounted Boer mercenaries, descended on the royal *kraal* at Ulundi. Cetshwayo escaped the massacre but was wounded and disheartened. Ironically, he died at Eshowe soon after. The independence of the Zulu nation was finally over.

Bartle Frere, more than anyone the instigator of a bloody and unnecessary war, was demoted to a minor clerical post in Cape Town.



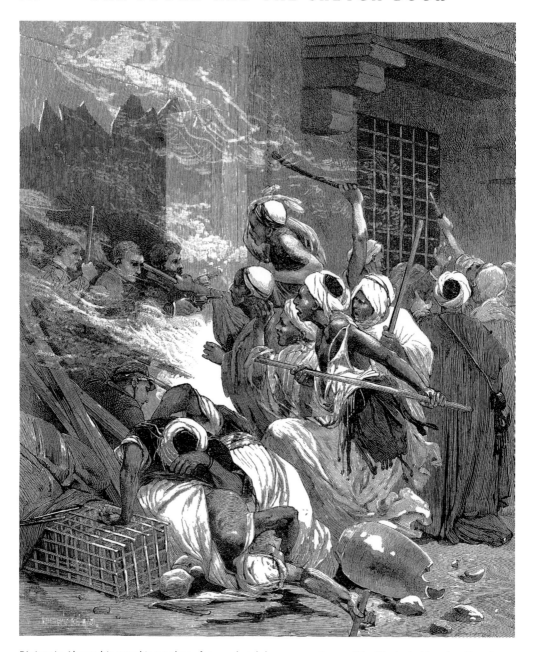

Rioters in Alexandria wrecking a shop, from a sketch by an eyewitness. (*The Illustrated London News*)

directed and ineffective and no British vessel was sunk, while the bombardment reduced much of Alexandria to rubble. Urabi's men, anxious to deny the invaders shelter, set fire to many of those properties left. Urabi withdrew his forces, determined to defend Cairo, and left Alexandria in the hands of the mob.

British marines occupied the ruins, restored order with bullet and bayonet, and installed Ismail's nephew Tawfig as the new Kheldive. Tawfig declared Urabi a rebel and the colonel responded by calling a *fatwa* on the grounds that Tawfig had brought an invasion by a foreign power, in breach of both state and religious rules. Urabi ordered conscription of civilian men and declared war on Britain.

'British and American Marines in Alexandria.' (E. Kremer, *The Illustrated London News*)

The British Expeditionary Force disembarked at Alexandria giving the impression that their aim was to march straight to Cairo. Commanded by Lieutenant-General Sir Garnet Wolseley, the force was 40,650-strong. Its two divisions under Lieutenant Generals G.H.S. Willis and Sir Edward Hamley, consisted of infantry, artillery, engineers and cavalry, several Indian units including the 13th Bengal Lancers, several field hospitals and a naval brigade.

A correspondent for the German newspaper *Kolnische Zeitung* wrote of the British Army:

The private soldiers are very much more than ours. There are among them old and young, weak and strong. In general the strong predominate. Many of them are splendid men, with

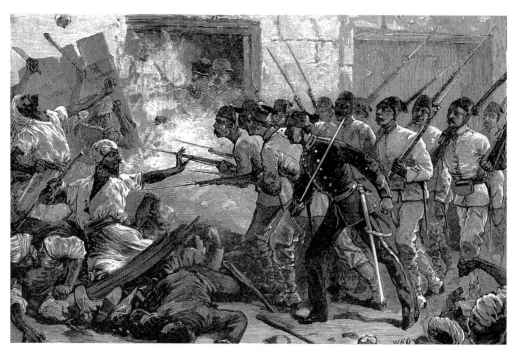

'The military clearing the streets of Alexandria, Sunday, 11 June.' ('WHO', *The Illustrated London News*)

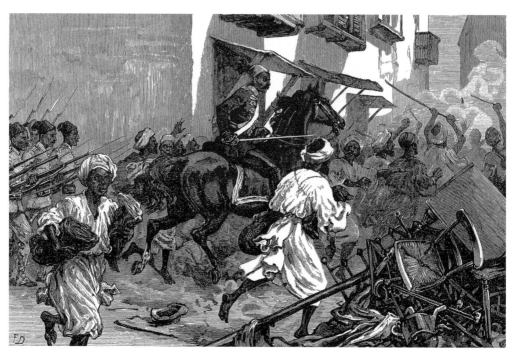

'Flight of pillagers at Alexandria on approach of military: soldier with telegrams for Governor, forcing his way through.' ('F.D.', *The Illustrated London News*)

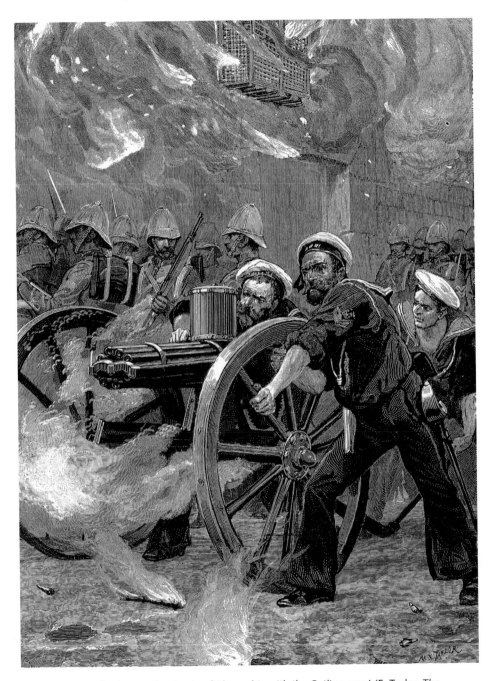

'The Naval Brigade clearing the streets of Alexandria with the Gatling gun.' (E. Taylor, *The Illustrated London News*)

muscles like those of the 'dying gladiator.' The uniform is the red tunic and Indian mud-coloured helmet. The Household Cavalry, Rifles, Marines and Artillery do not wear red tunics. All, however, wear the sun helmet, which is of a beautiful shape, but an ugly colour. They also wear a flannel shirt and needlessly warm woollen trousers. The little wooden water-bottle that each soldier carries at his belt appears very practical, as the water keeps cooler than in flasks of tin. The Hussars and Dragoons are to be distinguished only by their leggings, as they

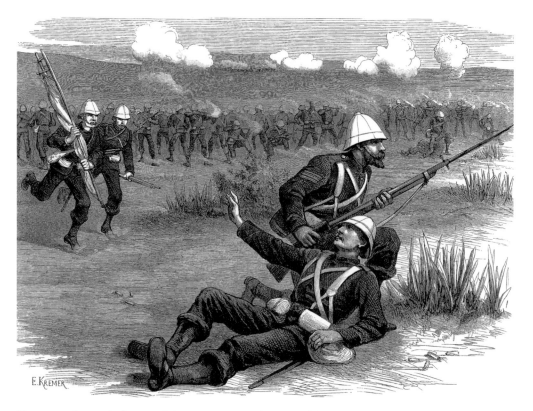

The reconnaissance in force on 5 August 1882. Royal Marines falling back at the close of day under heavy fire. (E. Kremer, *The Illustrated London News*)

also wear red tunics. The Indian cavalry look well in their uniforms which resembles that of the Cossacks. They carry lances, their pointed shoes are in the style of the fifteenth century. All these men have gipsy faces with beautiful fiery eyes. They move with a cat-like softness, peculiar to all southern Asiatics. These Indians know better than anyone how to forage and steal. Among the British officers, especially the Guards, are crowds of lords with £10,000 a year or more ... British officers when not on duty wear the half military, half civilian costume. They appear in yellow leather lace-boots and gaiters, fancy coats, broad belts, gigantic revolver-pockets, scarfs, etc. As far as I can judge they do not trouble themselves much about their men.

But the Alexandria landing was a feint. Wolseley's first objective was to secure the Suez Canal and use Ismailia, its mid-point, as a base from which to attack Cairo. He re-embarked part of his force to capture Port Said, where the canal meets the Mediterranean. Landing parties from the India contingent also secured Suez at the canal's southern end, and Kantara and Ismailia along its length. The canal was now a waterway for full-scale invasion.

Wolseley pushed west towards Urabi's main army and fought engagements at Magfar and Kassassin to secure water supplies and rail routes. The Kassassin action was notable for the night time 'moonlight charge' by the Household Cavalry and the 7th Dragoon Guards: late on 24 August an Egyptian infantry force threatened General Graham's positions. Graham ordered Major-General Drury-Lowe to assault the enemy's exposed flank with his cavalry, which he did, guided by the gun flashes in the darkness. The cavalry swept the Egyptian lines and captured their guns.

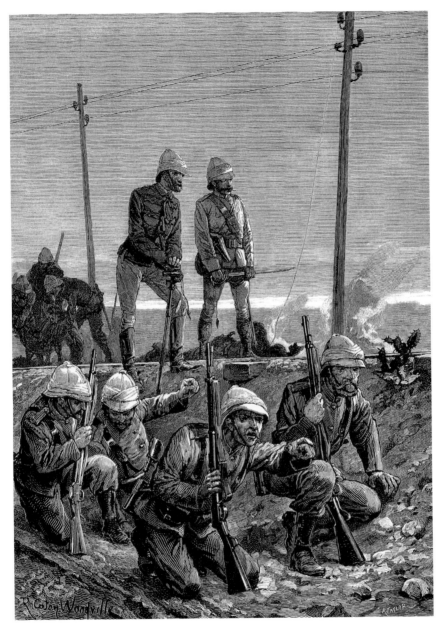

'A skirmishing party along the railway embankment.' (R. Caton Woodville from a sketch by E. Taylor, *The Illustrated London News*)

Colonel Urabi deployed to defend the approaches to Cairo. He dug his main force into trenches at Tel el-Kebir, north of the Sweetwater irrigation canal and the railway line which linked the capital city to the Suez Canal. The Sweetwater was damned to deny Wolseley's force water. The defences were hastily made, with no obstacles placed in front of the line, but included 59 artillery guns, some of them modern pieces made by the German firm Krupp. The defenders numbered 20,000 regular troops and 2000 tribesmen.

Wolseley made a personal reconnaissance of the defences and found that the Egyptians did not man their outposts at night. He sent his 17,000-strong force in under cover of darkness,

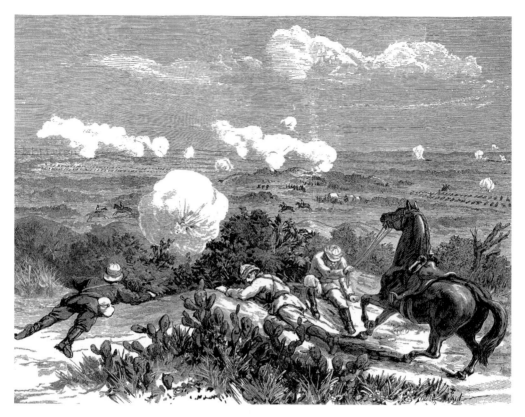

'General view of the action of August 24 at Mahuta.' (*The Illustrated London News*)

supervised by naval officers who navigated by the stars. It was an audacious plan, given the difficulties of deploying large numbers at night, but it worked. The army gathered for a two-pronged assault, the 1st Division on the right, the 2nd on the left. After initial confusion in lining up, they attacked at dawn from close positions along a 7-kilometre front. Each man had been issued with 100 rounds for their Martini-Henry rifles. The Highland Brigade were within 150 yards of the trenches before the Egyptians realised what was about to hit them; bagpipes blaring, the Highlanders shattered the Egyptian centre. Other units had longer to charge under fire, but the result was the same along the front. The British swarmed over a deep ditch and the ramparts of the entrenched positions. After the first volleys, the British mainly used their bayonets to brutal effect, including the Guards Brigade commanded by Victoria's son, Prince Arthur, the Duke of Connaught. The Egyptians, taken by surprise, were routed and those units which stood and fought bravely, notably the Sudanese in front of the Highland Brigade, were overwhelmed. It was over barely an hour after the first shot. Urabi lost up to 2000 men, while the British lost just 57 dead and around 280 wounded. The survivors fled towards Cairo but were pursued by Drury-Lowe's cavalry.

South of the canal the Seaforth Highlanders attacked the Egyptian redoubt and stormed a village, supported by the 7th Bengal Native Infantry and the 29th Bombay Native Infantry. The Indian brigade then marched into the town of Tel el-Kabir. The cavalry brigade trotted into an undefended Cairo on 14 September and accepted Urabi's surrender.

The shattering defeat broke the morale of Urabi's men and the rebellion petered out. The Kheldive was restored to power with a British donation of £2.3 million to clear his debts. The British Consul-General to Egypt, Sir Edward Malet, wrote to a Cabinet minister in London: 'You

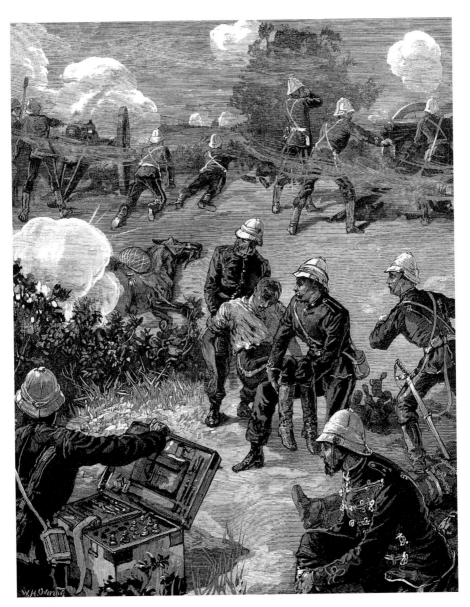

Two nine-pounders of the Royal Horse Artillery at Mahuta. (W.H. Overend, *The Illustrated London News*)

have fought the battle of all Christendom and history will acknowledge it. May I also venture to say that it has given the Liberal party a new lease of popularity and power.' It was certainly a textbook operation which added to Wolseley's already considerable reputation. Superior, although admittedly badly organised, forces had been neutralised or destroyed in almost exactly a month.

Gladstone was determined that the captured Urabi be tried and executed. The Prime Minister described his captive as 'a self-seeking tyrant whose oppression of the Egyptian people still left him enough time, in his capacity as a latter-day Saladin, to massacre Christians.' But studies of Urabi's orders and diaries failed to support that view. The charges against him were reduced; he

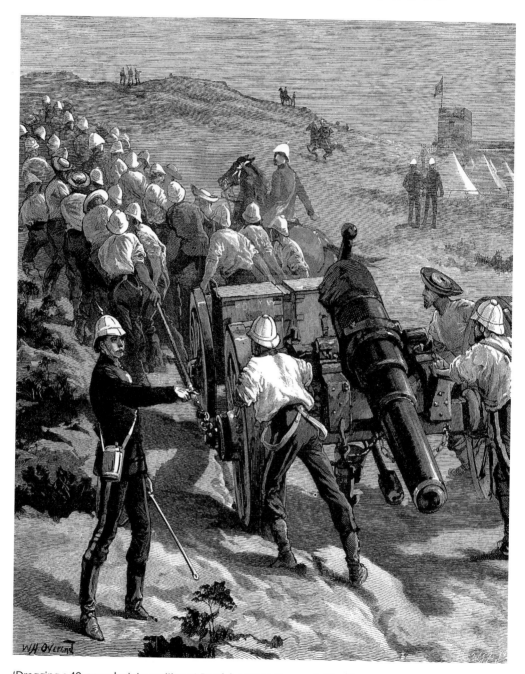

'Dragging a 40-pounder into position at Ramleh.' (W.H. Overend, *The Illustrated London News*)

admitted rebellion and went into exile in Ceylon, although he was allowed to return nineteen years later in 1901. The grateful Kheldive ordered the creation of a new Egyptian Army, to be trained by Britain's Major-General Evelyn Wood.

The British stayed in Egypt and their commercial interests enjoyed the benefits of reduced inflation, increased investment and higher bond prices. The occupation continued until the Anglo-Egyptian Treaty of 1922.

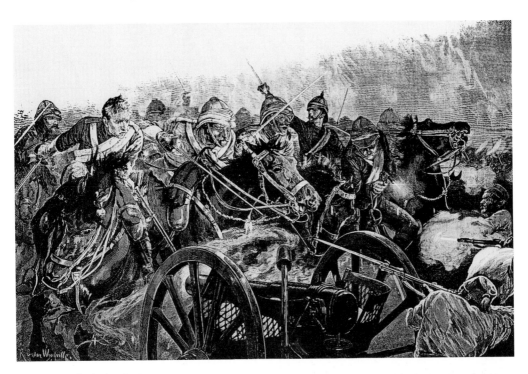

'The Battle of Tel-el-Kebir.'
(R. Caton Woodville, *The Illustrated London News*)

'The Highland Brigade bore the brunt of the action' – the telegram announcing the capture of Tel-el-Kabir. (W.H. Overend, *The Illustrated London News*)

Khartoum and the Sudan

'An indelible disgrace.'

The Sudan had long been conquered, occupied, exploited and abused by Egypt and by the ruthless trade in slaves. In the late 1870s a religious teacher called Mohammed Ahmed Ibn Seyyid Abdullah travelled through Kordofan province denouncing Egyptian rule and preaching revolt. As the devout and the angry flocked to hear him, he declared himself to be the Islamic messiah, the Mahdi. He declared that he and his followers would defeat the infidel and unite the whole Muslim world under Sharia Law. After the Anglo-Egyptian War the British treated Egypt as a protectorate, but the administration of the vast arid land of Sudan to the south was regarded as an administrative problem for the Cairo authorities, and London was content to leave it to the Kheldive's government. The suppression of the Mahdi's revolt was a local matter.

However, in November 1883 the Egyptian Army under Pasha Hicks suffered a catastrophic defeat and the Mahdists overran the provinces of Darfur and Kordofa, as well as capturing huge stocks of weapons and supplies. That woke Britain up to the threat to British interests in Egypt and the wider region. Prime Minister William Gladstone wanted to stay well out of another desert war but had considerable sympathy for the Sudanese, who had suffered under Egyptian repression. The British representative in Egypt, Sir Evelyn Baring, persuaded the Egyptian administration that their garrisons in the Sudan should be evacuated. General Charles Gordon, a former governor-general in Sudan and a national hero at home, was given the task.

Gordon had governed Sudan on behalf of the Kheldive with Christian zeal and concentrated on stamping out slavery. Born in 1833, the son of a general, he had served in the Crimea. But it was the war in China which had made him a household name. Philip Haythornthwaite summed up his appeal: 'From the outset [he] demonstrated his ability to engender loyalty, even adoration, among unenthusiastic and even untrained followers, and his affinity with non-European troops.'

Gordon had no intention of evacuating the garrisons in the Sudan. Unlike Gladstone, he believed that the rebellion had to be decisively crushed to prevent the Mahdi taking the whole country and then Egypt; he was well aware of the Mahdi's claim to the domination of the whole Islamic world. Gordon was an aggressive imperialist and, along with General Sir Garnet Wolseley, made his views known in a letter to *The Times*. He promised to complete the evacuation, however, and was given a £100,000 Treasury credit to oversee the task. In January 1884 he took the Dover ferry to Calais and travelled on to Cairo. Once there he became convinced that Al-Zubayr Rahma Mansur, a slave trader who had once ruled a minor Sudanese province, was the right man to guarantee the loyalty of local tribes who backed Egypt against the Mahdi. On his way to Khartoum with his aide, Colonel Stewart, Gordon stopped at Berber to address the tribes. During his speech he made the mistake of telling them of the evacuation plan. The tribal leaders saw this as retreat, and their loyalties wavered.

'A toilsome march.' The desert column skirting the Nile. (*The Illustrated London News*)

Gordon entered Khartoum on 18 February 1884 and was greeted by cheering crowds. He delayed the planned evacuation of troops, and instead set about administering the city. He released prisoners detained without trial by the Egyptians, abolished torture and remitted outstanding taxes. To further appease the Sudanese population he also legalised slavery, even though he had himself abolished it several years earlier. That caused an outcry at home led by the Anti-Slavery Society, which turned into outrage when Gordon demanded that the notorious slaver Zubayr should be sent to help him. The request was rejected, as was his call for a regiment of Turkish soldiers as Egypt was still nominally part of the Ottoman Empire. Gladstone also rejected Gordon's appeals for

'Waiting for the departure of the train at Boulak-el-Dakrur railway station, Cairo.' (*The Illustrated London News*)

200 British soldiers and a unit of Muslim Indian troops. The British Cabinet remained determined to press ahead with the evacuation and avoid military intervention. Gordon, on the other hand, remained determined to 'smash up the Mahdi'. He mounted a propaganda campaign through telegrams and letters saying that abandoning the garrisons would be an 'indelible disgrace'. The Conservatives, seeing a chance to topple Gladstone, moved a vote of censure which the government only narrowly won. Gordon, an insubordinate hero, was on his own.

Gordon set about strengthening Khartoum's defences. He created a flotilla of armoured gunboats – nine paddle-steamers used for communication – to patrol the Blue Nile and the White Nile which protected Khartoum to the north and west. To the south, facing open desert, he laid out complex trenchworks, homemade land mines and barbed wire. He also ensured that the nearest tribe, the Shagia, remained hostile to the Mahdi. But in early April those tribes to the north sided with the Mahdi, blocked river traffic to Cairo and cut the telegraph links. The siege had begun.

The Mahdist forces grew by the day, swelling to over 30,000 men. Inside the city, food stores dwindled and both the Egyptian soldiers and the civilian population began to starve. A sortie from Khartoum was decimated with the death of 200 Egyptian soldiers. Some communications remained possible through runners but the situation was increasingly desperate. The intense summer heat added to the ordeal inside the city. In September another force was sent from Khartoum to Sennar but was defeated with the loss of 800 garrison troops. By then the Mahdi had switched his main army's attention to Khartoum, up to 60,000 men, almost double the city's civilian population.

Gordon's plight ignited the British public and Queen Victoria intervened in a bid to save him. Gladstone's government ordered him to return to Britain, but the general refused point blank. He said that the defence of the city was a matter of duty and personal honour. By July Gladstone

reluctantly gave in to pressure and authorised a relief column under General Wolseley. But it took months to organise and the expedition did not reach the Sudan until January 1885.

Wolseley decided to use the Nile route to Khartoum as the alternative from the east coast would have required the building of a railway and the route would have taken him through hostile desert territory. He had 6000 troops from Egypt and a camel corps made up of 1600 volunteers from elite units; 800 whale boats were built to negotiate the Nile cataracts, crewed by seamen from as far away as Canada. Progress was slow. Thomas Pakenham wrote:

> Here was the flower of the British Army led by the flower of London society – including eleven peers or peers' sons – precariously mounted on camels. By mid-November they were plodding along the banks of the Nile, strung out in groups of 150, all the 240 miles from Aswan to Wadi Halfa.

Wolseley received a 13-day-old letter from Gordon saying that he could only expect to hold out for 40 days more. The relief force was then at Korti, close to a large bend in the Nile which turned away from Khartoum before turning south again. Wolseley decided to send a desert column, made up mainly of the camel corps, in a dash 176 miles directly across the loop while his main force continued by the river route. The desert force of around 1400 men including a small naval brigade manning a Gardner machine gun was under the command of Major-General Herbert Stewart. It advanced towards Metemmeh and on 17 January 1885 it was attacked by around 10,000 of the Mahdi's men as it approached the vital wells at Abu Klea.

'Arrival of the post-boat at Assouan.' (Melton Prior, *The Illustrated London News*)

'Dangers and difficulties of the River Nile Passage. 1 The wrecked steamer *Ghizeh* lying aground; the house built by the crew above. 2. Upper part of the Tangour Catraract where the steamer *Ghizeh* was lost. 3. The steamer sinking fast. 4. Between the reaches at Ambigol: a bad place for the boats. 5. Some of the crew after the wreck.' (W.H. Overend from sketches by Lieutenant R. de Lisle RN, *The Illustrated London News*)

The attack briefly broke the British square, a gap opening up at the left corner. Then the Gardner gun, untested in desert conditions, was run out to provide covering fire but jammed after 70 rounds. Two companies of the camel corps rallied in support but many of the animals were cut down. Gunner Alfred Smith was awarded a Victoria Cross for saving an officer in the melee. The square reformed thanks to such efforts, sealing many of the enemy within it. Pakenham wrote:

'On the desert march: lower well at the wells of Gakdul.' (Melton Prior, *The Illustrated London News*)

It was another of those 'soldiers' battles': hand against hand, spear against bayonet, each man hacking and cutting like a butcher. For five minutes there was pandemonium. But the outer ranks of the broken square had closed, sealing in the attackers, and the wall of dead camels prevented them from advancing beyond the centre. The bloody business was soon over. It only remained to try to help the British casualties and finish off the Arab wounded.

The Mahdists were beaten off with 1100 casualties to Stewart's losses of 74 killed and 94 wounded in an action which lasted just 15 minutes. The dead included several officers and men of HMS *Alexandra*, and national hero Colonel F.G. Burnaby, who died from a spear thrust to the throat. Stewart was wounded two days after recklessly exposing himself to fire during a similar attack at Abu Kru, dying a week later. He was replaced by the inexperienced intelligence officer Sir Charles Wilson who dithered over reorganising his force. However, both attacks on the desert column had failed, with heavy losses, and the main British column was still steadily progressing along the banks of the Nile.

The Mahdi, hearing of the defeats and the British advance, decided to launch his all-out attack on Khartoum after 317 days of siege. On the evening of 5 January his whole army attacked the city walls just before midnight, taking advantage of the low level of the Nile. The bulk crossed the riverbeds on foot and swarmed around the shore wall and into the city. Another force led by Al Nujumi took casualties in the minefields and barbed wire barriers, but broke through the Massalamieh Gate. The garrison, weakened and disheartened, put up only a token resistance before running and hiding in panic. By dawn they had all been slaughtered, as had 4000 civilians. Mahdi ordered that Gordon be taken alive, but he was slain in the turmoil. One account has him speared to death in full dress uniform after disdaining to defend himself, while

The Gakdul
Wells. (Lord St
Vincent, Captain,
16th Lancers,
*The Illustrated
London News*)

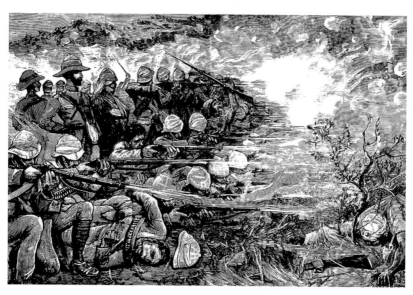

Defending
the square at
Abu Klea. (*The
Graphic*)

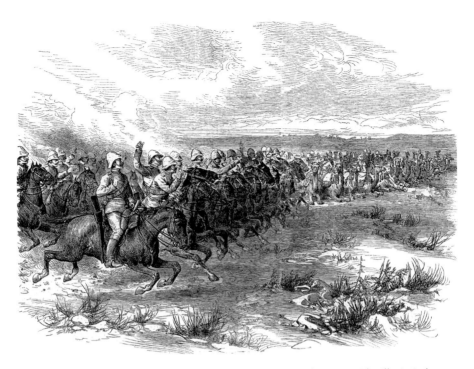

The 19th Hussars charging by a corner of a camel square. (Melton Prior, *The Illustrated London News*)

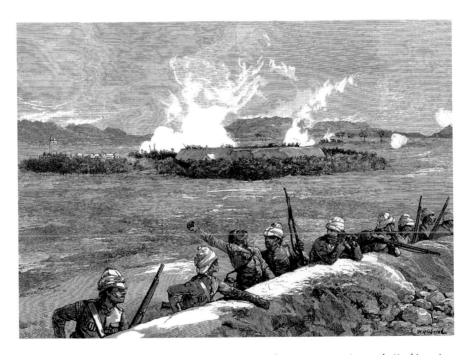

'Sir Redvers Buller's retreat from Metammeh to Korti: the enemy pursuing and attacking at Abu Klea Wells.' To the left can be seen the hospital, and in the centre is the fortification defended by the Naval Brigade. The 18th (Royal Irish) Regiment are defending the earthwork in the foreground. (Melton Prior, from a sketch by Lieutenant Walter H. Ingram, *The Illustrated London News*)

'Royal Engineers building a fort at Korti.' (Melton Prior, *The Illustrated London News*)

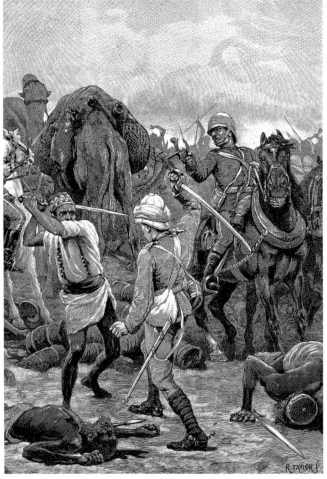

Attack on Sir John McNeill's zereba at Tofrik. (R. Taylor)

another has him recognised in the street as he tried to make his way to the Austrian consulate. His head was put on a pike and presented to the Mahdi.

The advance of the British relief force reached sight of Khartoum two days later. They quickly realised they were too late. The British and Egyptian troops withdrew from almost all of the Sudan, leaving the country to the Mahdi.

Gladstone was blamed by the British press for his tardiness in sending a relief expedition, and Queen Victoria rebuked him in similar terms by telegram. He and his government fell in June 1885, but the following year he was back in power. Public sentiment for Gordon had waned, particularly when it was announced that the abortive expedition had cost £11.5 million.

Muhammad Ahmad ruled much of what is now Sudan for only a few months, dying in June 1885, but the religious state built on Sharia Law which he created lived on. And so did Gordon's legend. As the years passed, the image of Gordon as a hero cruelly treated by both enemy and superiors again gripped popular imagination. An opportunity to avenge his murder arose in 1898 when a new crisis swept the Sudan.

The Mahdi's self-proclaimed successor, Abdullah al-Taashi, announced a holy war against the infidel. His army of fanatics, known as Dervishes, and Ansar troops numbered 50,000, including around 3000 cavalry. General Horatio Kitchener was sent to crush the threat, re-conquer the Sudan and punish Gordon's killers. His army numbered 8000 British regulars and 17,000 Egyptian and Sudanese soldiers. However, the two-to-one Dervish advantage in numbers was no match for a disciplined force armed with modern rifles and artillery.

Abdullah chose the town of Omdurman – the previous Mahdi's capital after the fall of Khartoum – as his operational base. That was Kitchener's target and the two armies met at Kerreri, 11 kilometres to the north. Kitchener deployed his force in a shallow arc close to the bank of the Nile, supported by gunboats on the river. His men faced a flat plain between modest

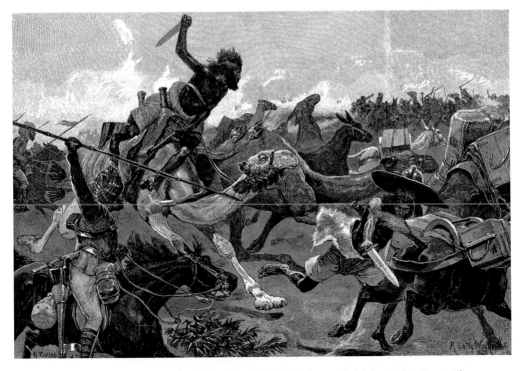

'Destruction of transport near Souakim.' (R. Caton Woodville, from a sketch by Walter Paget, *The Illustrated London News*)

British officers killed in the Sudan: Commander Alfred Pigott RN; Major W.H. Atherton, 5th Dragoon Guards; Lieutenant Rudolph de Lisle RN. (*The Illustrated London News*)

The death of General Gordon. (J.L.G. Ferris)

Major-General Sir Herbert Stewart, commander of the advance relief column. (R. Taylor, *The Illustrated London News*)

hills, and Kitchener placed his cavalry on both flanks. They waited for the attack, and initially there was little to see. Abdullah and 17,000 men were out of sight behind the Surgham Hills under Osman Azrak, while 20,000 more men were behind the Kerreri Hills. A further force of 8000 were on a slope to Azrak's flank.

The attack came at around 6.00am on 2 September 1898. Azrak's men advanced with spears and some rifles straight at the British lines and were quickly followed by other massed formations. The British artillery opened fire when they were 2750 metres away and sliced through the Dervishes. Those that got through the hailstorm of shot and shell were cut down by the entrenched Maxim guns and rifle volleys. Around 4000 died in the assault and not one got closer than 50 metres to the trenches. The cavalry on both flanks saw action but the first stage of the battle was effectively over when the central infantry charge collapsed.

Kitchener was determined to prevent the untested Ansar forces from retreating to Omdurman to regroup, and he ordered his forces to advance on the town in columns. The 21st Lancers were sent ahead to clear the ground. The 400 light cavalrymen, including Winston Churchill, charged

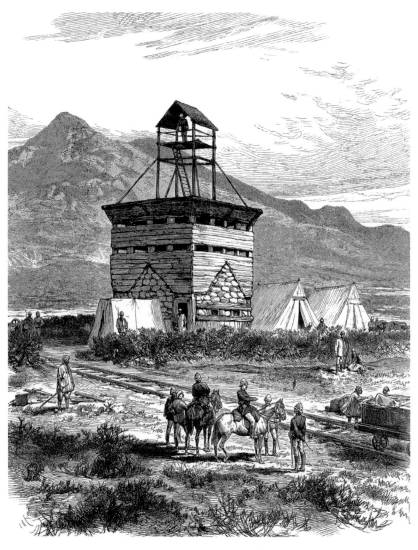

Zerebra and advanced redoubt of the relief force near Souakim. (*The Illustrated London News*)

'Sir Charles Wilson and his party on the island of Meruat after the wreck of their steamer.'
(Melton Prior, from a sketch by Sir Charles Wilson, *The Illustrated London News*)

what they thought were a few hundred Dervishes. When they reached the line, 2500 enemy infantry rose from a slight depression which had hidden them. After hand-to-hand fighting in which three Victoria Crosses were won, the British drove them back. Winston Churchill wrote of both the exhilaration and disgust at the British Army's last massed cavalry charge:

> The whole scene flickered exactly like a cinematograph picture; and, besides, I remember no sound. The event seemed to pass in absolute silence. The yells of the enemy, the shouts of the soldiers, the firing of many shots, the clashing of sword and spear, were unnoticed by the senses, unregistered by the brain ... Men, clinging to their saddles, lurched helplessly about, covered with blood from perhaps a dozen wounds. Horses, streaming from tremendous gashes, limped and staggered with their riders. In 120 seconds five officers, 65 men and 119 horses out of less than 400 had been killed or wounded.

'The Seaforth Highlanders forcing Mahmud's zareba in the Battle of Atbara.' (Captain Sir Henry S. Rawlinson, *The Illustrated London News*)

'Death of a gallant officer in the Soudan.' (*The Illustrated London News*)

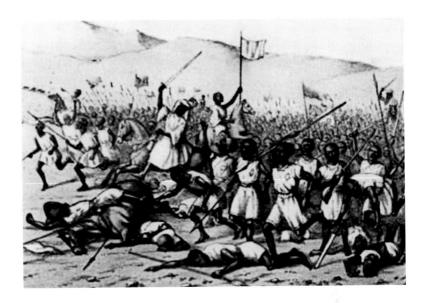

The Battle of Omdurman – medieval warriors against Maxims. (*The Illustrated London News*)

War was, he declared, 'a dirty shoddy business which only a fool would undertake.'

Khalifa Abdullah still had around 30,000 men, most of whom had seen no action. He ordered them to attack from the Kerreri Hills while his main reserves swept in from the west. Kitchener's force wheeled to advance up Surgham Ridge before heading southwards for Omdurman. To protect his rear he deployed 3000 mainly Sudanese troops under General Hector 'Fighting Mac' MacDonald, reinforced with Maxims and some field guns. MacDonald's force turned to face a charge by about 15,000 enemy troops in two prongs, and kept up a ferocious fire. Kitchener, alerted to the danger, sent back reinforcements. The Ansar attackers were halted and then pushed back, many of them dying where they stood. A second Ansar force, which had regrouped late, reached the valley after their allies had been routed. They nevertheless pressed hard at MacDonald's Sudanese before sustained volleys from the Lincolnshire Regiment drove them back. A final charge by around 500 Dervish cavalry was wiped out.

Kitchener took Omdurman; he had lost 47 men dead and 382 wounded, most of them from MacDonald's command. Colonel Frank Rhodes, the brother of Cecil Rhodes and war correspondent for *The Times*, was severely wounded in the right arm. The Khalifa escaped, leaving behind 10,000 dead, 13,000 wounded and 5000 prisoners. The wounded were left on the battlefield for several cold nights and parched days. Churchill criticised Kitchener's ruthless neglect of them.

On 4 September a parade and service were held in the ruins of Gordon's residence. Two days after that Kitchener ordered that the Mahdi's tomb at Omdurman be blown up. He intended to send the Mahdi's skull to London as both a trophy and a reprisal for the beheading of Gordon, but public disgust and concern from Victoria stopped him doing so.

Kitchener was diverted by a small French expedition which had arrived at Fashoda in southern Sudan to gain a French foothold on the Nile. When he arrived he discovered that the French had been attacked by Dervishes. His mission was to deal decisively with the French – he ended up saving them.

Operations continued to subdue the remnants of the Dervish army and crush the Mahdists once and for all; it was not an easy task. In late September British forces occupied Gedaref and beat off two counterattacks. Small units and columns criss-crossed the arid land, but it was not until November 1899 that final victory came. First a flying column under Colonel Sir Francis Wingate repulsed an attack at Abu Aadel. Days later the Khalifa's main forced launched another onslaught near Om Debreikat. They were beaten off and Wingate's counterattack overran the Dervish camp, killing Abdullah and his top generals.

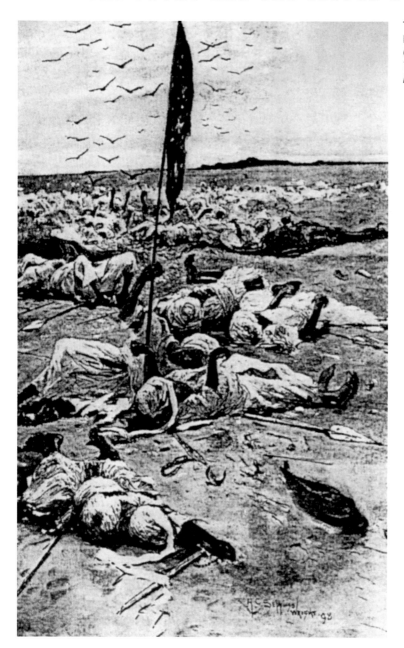

The aftermath of the Battle of Omdurman. (H.C.S. Eppings Wright, *The Illustrated London News*)

The reconquest of the Sudan was complete and as Britain had shared the cost it was agreed that Britain and Egypt should hold joint sovereignty. Kitchener was appointed Governor-General until he was sent south to fight the Boers. He was replaced as *Sirdar* by Wingate. Mahdism was not entirely eradicated, however. In 1903 a Tunisian called Mohammed-al-Amin appeared in Kordofan and proclaimed himself the new Mahdi. He was captured and executed. In 1908 a former Dervish warrior, Abd-el-Kader claimed to be Jesus to raise rebellion in the Blue Nile district. He murdered a British official but was later hanged.

THE NORTH-WEST FRONTIER AND TIRAH

'The skirling of the pipes ... the wild excitement and romance.'

The Afghan and Sikh Wars and the Indian Mutiny had been fought on India's borders, but one region never took much notice of formal hostilities or ceasefires. This was the North-West Frontier, spilling across the mountain passes and over the borders into Afghanistan. It sucked in army columns and spat out casualties. Its importance, as with much of the region, was to act as a buffer zone between the territorial ambitions of Russia and the burgeoning prosperity of British India. Most of the campaigns do not deserve to be called wars, but were punitive expeditions designed to punish tribal incursions, keep the Raj's frontiers secure and pursue the 'forward policy' which kept British rule as close to the Afghan border as possible. Winston Churchill spelt out the dilemma which led to incessant, if small-scale, campaigning: 'We hold the Malakand Pass to keep the Chitral road open. We keep the Chitral road open because we have retained Chitral. We retain Chitral in accordance with the Forward Policy.' But they involved, like all military operations in Victoria's far-flung Empire, extraordinary feats of courage and determination as well as incompetence and cruelty. Churchill, campaigning with Major-General Sir Bindon Blood in 1897, wrote of the strange fascination of the frontier:

> In the clear light of the morning, when the mountain side is dotted with smoke puffs, and every ridge sparkles with bright sword blades, the spectator may observe and accurately appreciate all grades of human courage – the wild fanaticism of the *Ghazi*, the composed fatalism of the Sikh, the steadiness of the British soldier, and the jaunty daring of his officers.

The new Indian Army which had replaced the British East India Company's military organisation were confronted with numerous independent tribes who collectively might have fielded 100,000 warriors. The British were lucky that they never unified and spent more time fighting and raiding each other than attacking the British. But their incursions were numerous, raiding India's northern plains and taking their plunder back into the mountains a day's ride away. In that border country even the most gallant British soldier spent restless nights fearing a slit throat while sleeping or a bullet when going about his routine duties. The province was known in army encampments simply as 'The Grim'. Obscure names still adorn regimental honours and medal clasps, such as Sittana, Shabkadr, Tochi, Jowaki and Utman Khel.

In March 1860 a troop of the 5th Punjab Cavalry fought off an attack on the town of Tanks by Mahsud Waziris, killing up to 300 tribesmen in a short battle. The following month a punitive column repulsed with bayonets an attack on the British camp at Palosin. In October 1863 Brigadier-General Sir Neville Chamberlain led two brigades totalling 5000 men against the Hinmost 'Fanatics'. Taking a circuitous route through the Ambela Pass, Chamberlain upset the

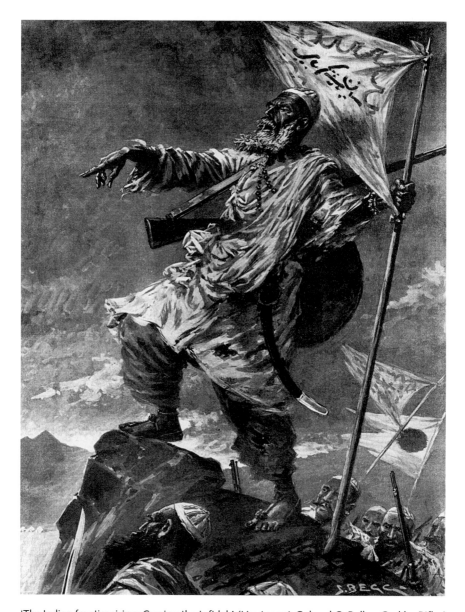

'The Indian frontier rising: Cursing the Infidel.' (Lieutenant-Colonel C. Pulley, Gurkha Rifles)

Bunerwal tribes. He decided to hold the Pass and await reinforcements. British positions on craggy tops, including the famous 'Eagle's Nest', were repeatedly lost and retaken in ferocious close-quarter fighting. When the British reinforcements arrived, the Bunerwal leaders agreed to pull back and crush the Fanatics themselves. The campaign was costly for the British, with 238 dead and 670 wounded, but three times as lethal for the tribes.

There were more border wars and expeditions in Bhutan, the Tochi Valley and Sikkim throughout the 1860s and 1870s, and actions against the Bizoti Orakzais, the Jowaki Afridis and the Utman Khel tribes, all of them dwarfed by the Second Afghan War (see chapter one). There were several campaigns against the Black Mountain tribes; the first in 1861 followed an attack on a police post and saw skirmishing and the destruction of many villages in a 'scorched earth' action. The second, in 1888, followed an ambush in which two British officers were killed. Five columns were formed

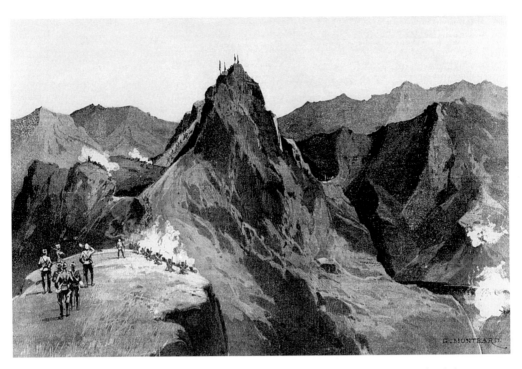

'Attack on Tangi Pass by the First and Second Brigades, Malakand Field Force.' (G. Montbard, from a sketch by H.H. Maclean, *The Illustrated London News*)

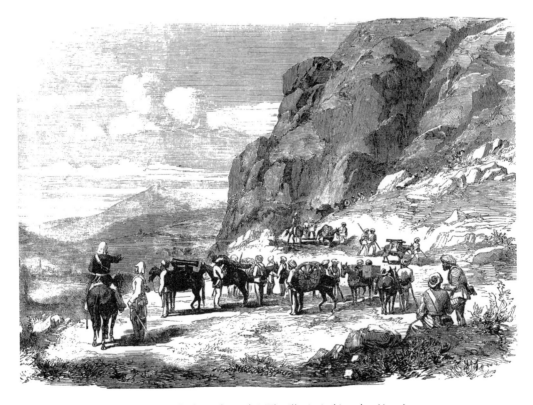

'The Peshawar mountain train in the line of march.' (*The Illustrated London News*)

into the Hazara Field Force and, with strong support from allied Kashmiris, the British destroyed the main enemy settlement at Maidan. The third in 1891–92 was to enforce the terms imposed on the Hassanzais and Akazais in the previous operations. Sporadic fighting continued in Hunza, Nagar and Waziristan.

In 1893 the Amir of Afghanistan agreed to a fixed border with British India called the Durand Line, named for the chief British negotiator, Sir Mortimer Durand. The frontier state of Chitral was on the British side. Following the murder of its ruler, the state was thrown into anarchy and the British agent at Gilgit, Surgeon-Major George Robertson, installed a child as puppet ruler. This was unacceptable to the followers of allied Pathan chiefs Sher Afzal and Umra Khan. From early March Robertson was besieged in Chitral fort in an epic six-week action. With him were a handful of British officers, 99 men of the 14th Sikhs, 300 Kashmiri infantry and around 100 non-combatants. The defenders, though short of ammunition and food, held out until relieved by a party of pioneers and Kashmiri troops under Colonel James Kelly.

From 1897 the British faced a wave of uprisings by tribes unhappy over the Durand Line and by British attempts to civilise their terrain and even levy taxes. The fiercest opponents were the Afridis, a confederation of tribes born for battle and eager to avenge any slur. Colonel Sir Robert Warburton, who spent 18 years on the frontier, wrote:

> The Afridi lad from his earliest childhood is taught by the circumstances of his existence and life to distrust all mankind; and very often his nearest relations, heirs to his small plot of land by right of inheritance, are his deadliest enemies. Distrust of all mankind and readiness to strike the first blow for the safety of his own life have therefore become the maxim of the Afridi.

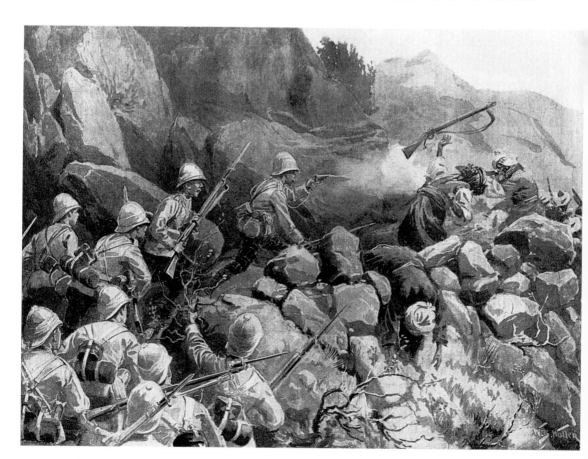

The King's Scottish Borderers storming Afridi positions. (*The Illustrated London News*)

Winston Churchill described the Afridis as 'amongst the most miserable and brutal creatures of the earth. Their intelligence only enables them to be more cruel, more dangerous, more destructive than wild beasts.'

Although uncoordinated, various insurrections became known collectively as the Pathan revolt. Mullahs were blamed for inciting a jihad. British-led forces occupied the Tochi Valley, while an outbreak at Malakand led to a battle in which 60 11th Bengal Lancers and 180 45th Sikhs were said to have killed 2000 tribesmen at Chakdara.

In August 1897 a British post on the Samana Ridge was attacked and its garrison, 21 men of the 36th Sikhs, were all killed after refusing to surrender. A cleric, Dr Theodore Pennell, watched the attack from a distant ridge and wrote: 'The Sikhs knew that the Pathans would give them no quarter, so they prepared to sell their lives dearly. The Afridis worked nearer and nearerso the noble garrison fell at their posts to a man.' One Sikh, whose identity was never known, killed 20 attackers while defending the guardroom before it was burnt around him. Two other border forts successfully held out until relieved. Such actions were the prelude to a much larger enterprise.

The largest field force ever assembled by the British set out to punish the Afridis and the Orakzais in their homelands on the Tirah plateau, an expedition known to history as the Tirah Campaign. A fertile valley covering some 900 square miles, hidden by the Samana Ridge, it was closed to all foreigners save for prisoners. It was from there that the Afridis levied extortionate tolls on the Khyber Pass and sent out raiding parties. Commanded by Lieutenant-General Sir William Lockhart – a veteran of the Mutiny and Magdala– it comprised two divisions with two brigades in each, totalling 35,000 men and 20,000 followers. Against them were 50,000 tribal warriors desperate to defend their homes. It advanced in early October 1897; Gunner subaltern George MacMunn described the spectacle:

> The roads in every direction were full with gathering troops. Highland regiments, Gurkhas, Sikh corps, long lines of Indian cavalry, their lances standing high above the acrid dust that they stirred. By the side of the roads strings of laden camels padded on besides the troops, the jinkety-jink of the mountain guns, the skirling of the pipes, all contributed to the wild excitement and romance of the scene.

As the British force approached they realised that the road to the plateau led up the precipitous Dargai Heights; these were captured relatively easily on 18 October. But the troops were then withdrawn because of water shortages and the Afridi marksmen took position in force at the brow. There were 19 Afridi standards on the ridge-top, representing 8000 men. The Heights were stormed under intense fire by the 1st Battalion Gordon Highlanders and the 1/2nd

General Sir William Lockhart.
(National Army Museum)

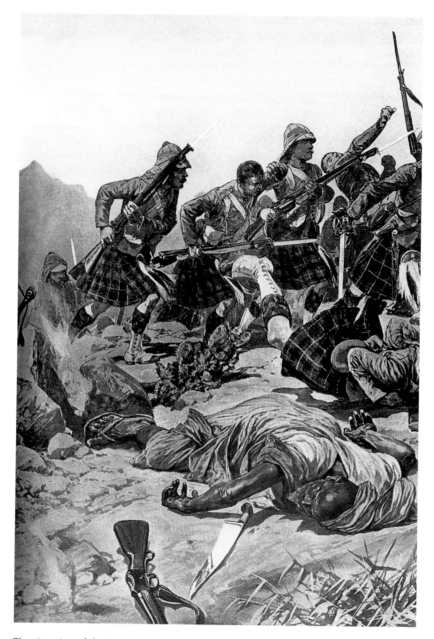

The storming of the Dargai Heights. (*The Illustrated London News*)

Gurkhas. The pipers played 'Cock of the North' as the Scots roared up the exposed neck of rock. Piper Milne was shot in the lungs and fell unconscious. Piper George Findlater won the Victoria Cross for continuing to play for his comrades after being shot in both legs. The Gurkhas, Sikhs and the Dorset and Devonshires quickly followed. Higher ground offered them better protection from the marksmen above. The combined force scaled a near-vertical goat path weaving between outcrops and crevices, and three more Victoria Crosses were won. The Highlanders reached the top first and fixed bayonets, but the enemy melted away. The British and Gurkhas lost 200 men dead or wounded.

Queen Victoria telegraphed from Balmoral:

Please express my congratulations to all ranks, British and Native troops, on their gallant conduct in actions. Deeply deplore loss of precious lives among officers and men in my army. Pray report conditions of the wounded and assure them of my true sympathy.

That message was greatly appreciated. Less so, perhaps, was a work by Britain's most self-deluded poet, William Topaz McGonagall. Verses included:

'Twas on the 20th of November, and in the year of 1897,
That the cheers of the Gordon Highlanders ascended to heaven,
As they stormed the Dargai heights without delay,
And made the Indian rebels fly in great dismay.
The Gordon Highlanders have gained a lasting fame,
Which for ages to come will long remain:
The daring gallantry they displayed at the storming of Dargai,
Will be handed down to posterity.

'The Dorsets: hand to hand fighting in a nullar.' (Melton Prior, *The Illustrated London News*)

The camp at Bagh, showing low stone walls to protect those sleeping in tents from snipers. (Melton Prior, *The Illustrated London News*)

The British ranged across the plateau, burning fortified villages and crops and killing stock. The fertile land was stripped bare. The *Times* correspondent reported:

> Strings of mules go out every day, with sufficient escorts, and return in the evening laden with forage, which abounds ... The foragers not infrequently find odds and end of booty, which they annex for themselves, old *jezails*, swords, daggers and Korans. They are retained by the finders as mementoes of the campaign. Of Korans there are two kinds – one printed in Peshwar or Lahore, and of no particular interest or value, the other hand-written and generally illustrated and illuminated. These are rare and very precious finds indeed.

There was almost constant skirmishing. Lockhart split his force and sent it in all directions. One column of about 3200 men under Brigadier-General Sir Richard Westmacott easily took the stronghold of Saran Sar but lost 64 men during the withdrawal, hard-pressed on all sides by sharp-shooters. On 11 November Saran Sar was taken again with only light casualties. Meanwhile a column under Brigadier Kempster advanced to the Waran Valley where it destroyed several villages. But on the return march the rearguard was under constant fire and stragglers were picked off. It was a method of warfare at which the Afridis excelled, and similar casualties were inflicted when another British column returned from the Rajgul Valley.

Guerrilla hit-and-run tactics and worsening weather also picked away at Lockhart's army. One officer wrote:

> During the last two nights the firing into camp by prowling marauders has been very bad, but no casualties have been incurred. Last night the 5th Gurkha scouts stalked a firing

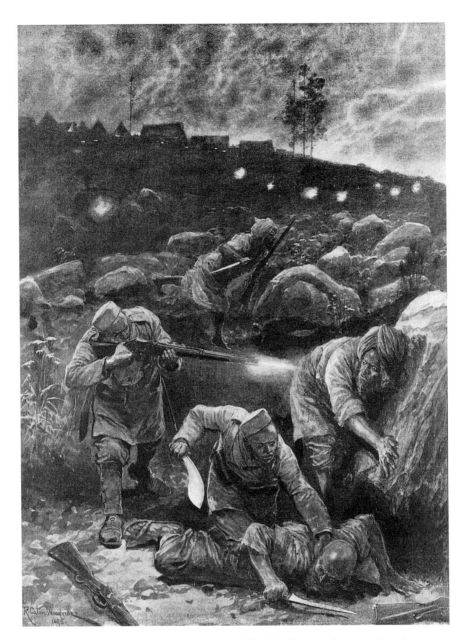

'A sniping affair by the camp.' (R. Caton Woodville, *The Illustrated London News*)

party and a *melee* ensued, with the result that eight Afridias and one Gurkha killed. It was a very plucky and creditable performance of the Scouts who have done excellent service. The nights are extremely cold now, with hard frosts, but the sun is hot in the day time.

Lockhart, commending his men for their heroism and stamina, told them:

We must remember that we are opposed to perhaps the best skirmishers and best natural rifle shots in the world, and the country which they inhabit is the most difficult on the face of the globe. Their strength lies principally in their intimate knowledge of the ground,

which enables them to watch over our movements unperceived and to take advantage of every height and every ravine. Our strength lies in our discipline, controlled fire and mutual support, and our weakness in our ignorance of the ground and the consequent tendency of small parties to straggle and get detached. The moral, therefore, is that careful touch must be maintained; and if small bodies do from any cause get separated from their regiment they should, as far as possible, stick to the open and not enter ravines or broken ground where, with such an enemy, they at once place themselves at a terrible disadvantage.

Colonel Hutchinson wrote to *The Times* that the Afridis

have absolutely nothing to learn from us. Contrariwise, their dashing and bold attack, the skill with which they take advantage of the ground, the patience with which they watch for a favourable moment, and their perfect marksmanship – all these qualities have again and again won our admiration.

By early December all Lockhart's objectives had been achieved, with sub-tribes punished and subdued. He drew up plans to evacuate Tirah. He sent one division under Major-General W. Penn Symons to return via the Masura Valley, and the other under Major-General Yeatman Biggs along the Bara Valley. The march began on 9 December in frosty conditions. The first division was barely opposed, but the second was attacked throughout its 40-mile march through narrow passes in biting cold. The road along the Bara river criss-crossed the icy torrent. On the 12th there were 20 casualties, the next day up to 60, and those were just the soldiers; many camp followers trailed behind and were never seen again. The rearguard was constantly harried and

Bengal Lancers escorting the bodies of dead officers being taken down country for burial. (Melton Prior, from a sketch by S. Begg, *The Illustrated London News*)

Queen Victoria conferring the Victoria Cross on Piper Findlater and Private Vickery at Netley Hospital. (*The Illustrated London News*)

supplies had to be abandoned. Lieutenant Thomas Dowdall and several others were killed by snipers after clearing the enemy from an overlooking ridge. His commanding officer wrote to the young man's mother: 'There was nothing of the drawing room or carpet soldier about him, only a plucky desire to be in the thick of the fight and share the dangers with his men by whom his loss will be deeply regretted.'

The most determined Afridi attack came on the night of 13 December; its target was the baggage train at the rear of the column. The men of the 4th Brigade were packing up camp equipment when heavy Afridi fire killed ten pack animals in seconds. The native drivers panicked and ran between the lines, where many fell in a confused crossfire. British and Indian troops fought back as they carried the wounded to cover. A stand was made near a river ford and the defenders were only saved by a mountain gun and Peshawar pickets who turned back to hammer the attackers. Casualties among the troops topped 40 but the official history recorded that upwards of 100 camp followers and 150 pack animals were lost that night.

Eventually the force got through the valley and, on the 14th, joined up with the other column. Together they occupied the Khyber Pass forts with no opposition.

The final British toll was 287 dead, 853 wounded and 10 missing. Peace negotiations resulted in the tribes, under threat of another scorched earth operation, agreeing to pay fines and hand over a quantity of rifles.

The costly campaign was controversial from the start. Churchill, who arrived late and saw no action – although that did not stop him pleading with his mother to use her influence to get him a campaign medal – was more scathing in private correspondence than in his public reportage:

> The troops have done all that was asked of them. They have marched freely into all parts of Tirah and have burnt and destroyed everything that came to hand. The tribesmen have been powerless to stop them but they have been able to make them pay heavily in men and officers. The whole expedition was a mistake because its success depended on the tribesmen giving in when their country was invaded and their property destroyed. This they have not done. We have done them all the harm possible and many of them are still defiant. Had they cannon we could have captured them. Had they towns we could have destroyed them. Had they any points of strategic or political importance, we could have occupied them. But regular troops cannot catch or kill an impalpable cloud of skirmishers. It is because we have no real means – except by prolonged occupation – of putting the screw on these tribesmen and making them give in – that it is a great mistake to make the attempt.

Nevertheless, the Tirah Field Force had beaten, for the first time, frontier guerrillas fighting in their own homeland, and had, by example, curbed the warlike tendencies of other tribes. General Sir George White said that no campaign in India had been fought in such arduous circumstances.

> The country was physically most difficult, and the enemy were well-armed and expert in guerrilla warfare. Severe punishment was, however, inflicted on them. The officers and men conducted themselves in a manner thoroughly befitting the traditions of the Queen's Army.

No fewer than seven Victoria Crosses were awarded, one of them to Piper Findlater who received his personally from the Queen. He tried to hobble to his feet but was waved down by Victoria. As she left the hospital corridor he played 'Haughs of Cromdale'. He was promoted to Piper-Major and feted across Britain. He died in Turriff, near his birthplace, in 1942.

THE BOER WARS

'…choked with dead and wounded.'

The struggle for the southern regions of Africa was an epic fight between the Great Powers themselves, and its indigenous populations, both black and white. From the imperial perspective it was fuelled by the wish to control trade routes to India and the treasures of the Orient, the race between colonial powers to carve up the continent, the discovery of diamonds around Kimberley in 1868 and, 18 years later, of gold in the Transvaal. Competitors included Portugal, Germany and Belgium. Natives had no say in the matter but the Boers, Dutch-descended settlers who had carved out two republics from land taken from the blacks, certainly did.

Britain obtained the Cape Colony of Good Hope from the Dutch in 1815 as a prize from the Napoleonic wars. The Boers resented British rule and many trekked north to create Natal, the Transvaal Republic and the Orange Free State. The British were happy with the migration as it pushed forward the boundaries of 'civilisation' but they followed behind, annexing Natal in 1845. Skirmishing with Boer farmers, together with almost incessant warfare with beleaguered African tribes, increased tension. In 1868 the British annexed Basutoland, modern-day Lesotho, after an appeal by a mixed tribe of refugees from the Zulu Wars who wanted protection from both the Zulus and the Boers. The Boers were isolated in the African interior and most were content to accept that situation – until the discovery of diamonds.

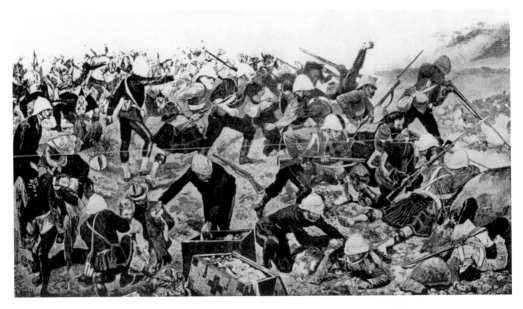

The Battle of Majuba Hill, from notes supplied by officers present. (R. Caton Woodville)

THE FIRST BOER WAR

The diamond rush attracted tens of thousands from across the globe and reawakened British imperial interests. In 1875, Colonial Secretary Lord Canaervon approached the Transvaal Republic and the Orange Free State with the aim of establishing a federation of British and Boer territories in South Africa. He was turned down and for a while the British focus switched to the destruction of the Zulus. That conflict, however, gave Britain the excuse to annex Transvaal under special warrant as long as the Zulu threat remained. Transvaal Boer leader and later President Paul Kruger decided to ensure that the threat was vanquished before voicing the deep resentment over annexation. But such rectitude evaporated when the Zulus were defeated in 1879. The Boers revolted on 16 December 1880, declared independence and attacked a column of the 94th Foot at Bronkhorstspruit.

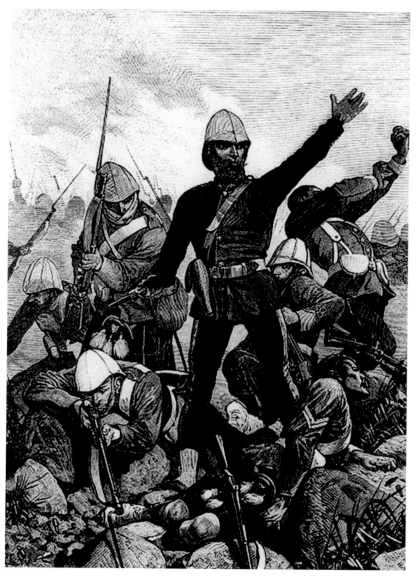

General Sir George Colley just before he was killed at Majuba Hill. (Melton Prior)

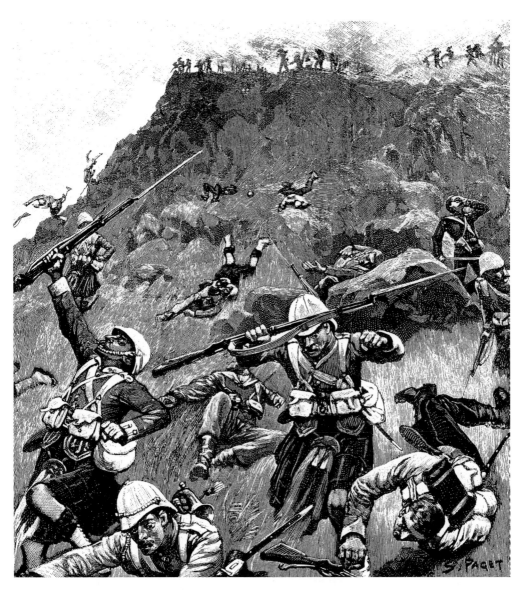

The rout at Majuba Hill. (*Cassell's History of the Boer War*)

The convoy, which had been on its way to support Pretoria, was destroyed. Lieutenant-Colonel Ansthruther and 120 of his men were dead or wounded within minutes – each suffering an average of five gunshot wounds – for the loss of two Boers dead and five wounded. From 22 December British garrisons were under siege. The Boer tactics of ambush and hit-and-run were at odds with the British Army's strategy of forcing open battle; the British generals rated the bayonet charge highly, a tactic which was useless in this type of warfare. In contrast the Boers formed themselves into militia 'commandos' with elected officers. These farmers, used to a lifetime in the saddle, were crack shots and superb horsemen, knew the terrain well, and wore clothing that camouflaged them. The British did not know the country and their scarlet tunics made them easy targets.

The British were also hampered, in the early stages at least, by sensitivities towards their white brethren. The Governor of Natal and High Commissioner of South Africa, Major-General Sir George Pomeroy Colley, said in an address to his troops:

The task now forced upon us by this unprovoked action is a painful one, and the General calls on all ranks to assist him in his endeavours to mitigate the sufferings it must entail. We must be careful to avoid punishing the innocent for the guilty, and we must remember that, though misled and deluded, the Boers are in the main a brave and high-spirited people, and are actuated by feelings which are entitled to our respect.

The British had six small forts scattered across the Transvaal with around 2000 troops between them, spaced no less than five miles apart. The three main battles of the war were centred on an area no more than 16 miles across and were the consequence of Colley's attempts to relieve the forts. At Newcastle near the Transvaal border he mustered 1200 men into the Natal Field Force and set out, convinced that the forts would not hold out long enough if he waited for much-needed reinforcements of both men and horses. Few of the force were mounted at Lang's Neck on 28 January 1881 but Colley ordered it to attack Boer positions lined along the Drakensbery mountain range under the command of Piet Joubert, the victor of Bronkhorspruit. Around 480 of the British troops who charged were repulsed with the loss of 150 men, many of them officers.

Colley retreated three miles to Mount Prospect to await reinforcements. Determined to keep his communications lines open, he accompanied a large escort to protect a mail convey carrying wages. At the Ingogo river crossing it was ambushed by a stronger Boer force of about 300 men. The Battle of Schuinshootge continued for several hours, but the Boer marksmen dominated. Only a night storm allowed Colley and about half his men to retreat back to Mount Prospect, leaving behind 139 corpses, wounded and prisoners. The engagements so far had been setbacks, but the next was a disaster.

On 14 February 1881 hostilities were suspended after Kruger offered a peace settlement. Colley, fearing that it was just a ruse and bolstered by long-awaited reinforcements, decided to attack to allow the British to negotiate from a position of strength. He led a night march of 360 men to the top of Majuba Hill overlooking the main Boer positions at Lang's Neck. The men were fully loaded with equipment, including 70 rounds of ammunition apiece, and were either exhausted or elated, according to conflicting reports. They consisted of 171 men of the 58th,

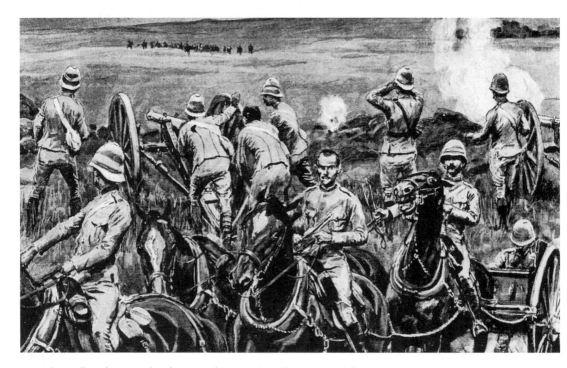

'The artillery threatened with a Boer charge.' (*Cassell's History of the Boer War*)

Lord Roberts: The commander-in-chief writing despatches in his wagon tent at Paardeberg.
(*The Graphic*)

141 of the Gordon Highlanders and a small naval brigade. Colley fatally took no artillery with him and failed to order his men to dig in. Early on the morning of 27 February around 450 Boers under Nicolas Struit crawled up the slopes, using every scrap of natural cover and sniping with terrible accuracy as they went. Colley's position of strength had become a death trap. Fire poured into the British ranks. Panicky troops, unable to see the enemy, fled down the mountain and were picked off as they did so, or tumbled into crevices. Colley was killed in a fierce scrap on the summit after trying to organise a fighting retreat. Only fire from the big guns in the main British camp prevented a full-blown Boer pursuit and massacre. But it was bad enough. In total 285 British troops were killed, wounded or captured. The Boers lost two dead and four wounded.

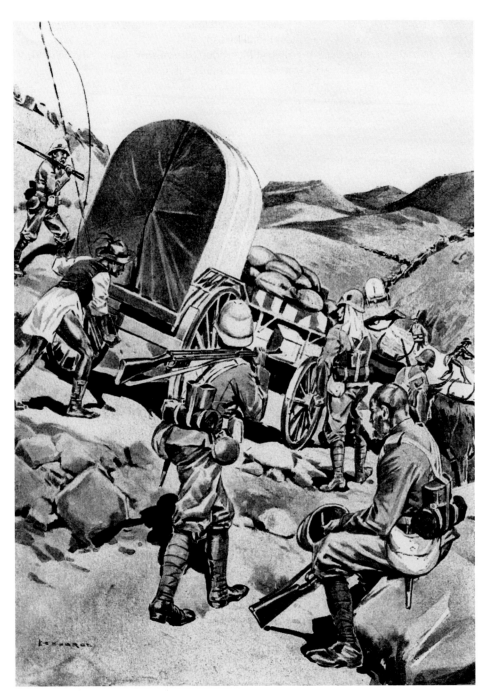

A convoy guard. (*Cassell's History of the Boer War*)

Hostilities continued until 6 March, with few casualties on either side. The forts held out, but the Boers made only sporadic, half-hearted forays on them. British Prime Minister William Gladstone, shocked by the earlier British losses and realising that victory could only come with massive reinforcements and the attendant cost, ordered an armistice. At the final peace treaty on 23 March the British agreed to Boer self-government under merely notional imperial oversight

and allegiance to the Queen. In 1884 even those strictures were removed and the Transvaal achieved full independence under President Paul Kruger.

The Boers had exploited British vulnerability, poor generalship and outdated methods of warfare. But the British had learnt valuable lessons about marksmanship, terrain, camouflage and attrition tactics. They had been momentarily humbled, but less than a generation later the cry would go up: 'Remember Majuba Hill!'

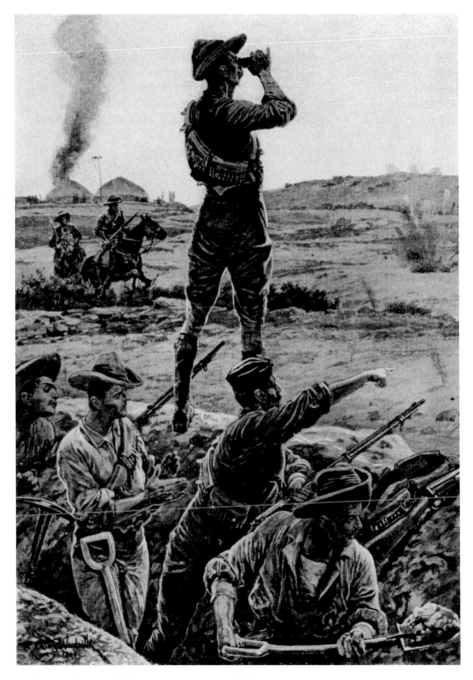

'In the trenches at Makeking.' (R. Caton Woodville)

THE SECOND BOER WAR

The discovery of gold in 1886 boosted the Transvaal and again made it an attractive prize. Tens of thousands of foreigners flocked to the minefields, many of them British, and almost overnight Johannesburg turned from a tented camp into a bustling frontier city. The new settlers were dubbed 'Uitlanders' (Afrikaans for 'foreigner', literally 'outlander') and refused political rights. British imperialists led by Cecil Rhodes, who had made his fortune from mining before becoming Prime Minister of the Cape Colony in 1890, exploited such grievances. His dream, shared by many, was to bring all of southern Africa into the Empire before expanding across the whole continent 'from Cape to Cairo'. Rhodes conceived a planned Uitlander insurrection supported by an invasion led by his friend Dr Leander Starr Jameson. It proved to be a fiasco. Jameson took 500 volunteers across the border but the Uitlanders failed to rise up. The force was surrounded at Doornkop on 2 January 1896; it suffered around 100 casualties and was forced into a humiliating surrender. Jameson was tried in Britain and served one years' imprisonment, but was nevertheless regarded as a hero. Rhodes, however, was forced out of office.

The issue of Uitlander rights remained thorny and the Boers hardened their attitude. In 1897 a treaty of mutual assistance was signed by the Transvaal and the Orange Free State which until then had avoided conflict with the British. Britain responded by appointing Sir Alfred Milner, a hard-line Imperialist, as High Commissioner in the Cape. He backed up negotiations with President Kruger with a show of force in May 1899 and sent for reinforcements – 10,000 men from the Mediterranean and India to be deployed in the Cape and Natal. In October Kruger demanded that the troops be withdrawn from the Transvaal border. Such demands were unacceptable and war with the two Boer republics started on 11 October 1899.

In Britain the war was initially popular, with newspapers providing stories of alleged Boer atrocities which in turn fed outrage at a bunch of Dutch farmers daring to take on the might of the Empire. Justin McCarthy, writing a few years after the event, saw a pattern which had marked domestic attitudes to foreign wars throughout the century:

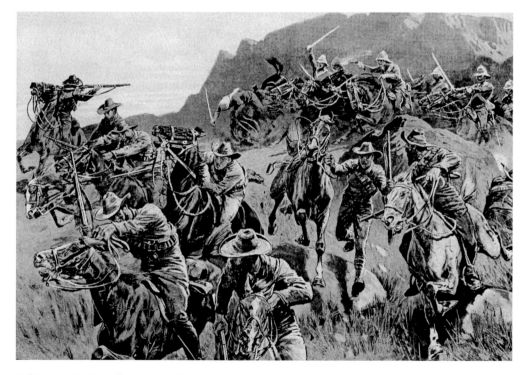

'A hot corner'. (*Cassell's History of the Boer War*)

An Empire like Great Britain, with territory in all parts of the world, is not likely to have prolonged intervals of peace throughout the whole of her various and widely-spread dominions ... It may be said with confidence that to the British public at home little or nothing is known about one of these far-off wars until the struggle has gone on for some time and forced itself on the notice of London and the provinces. The English people

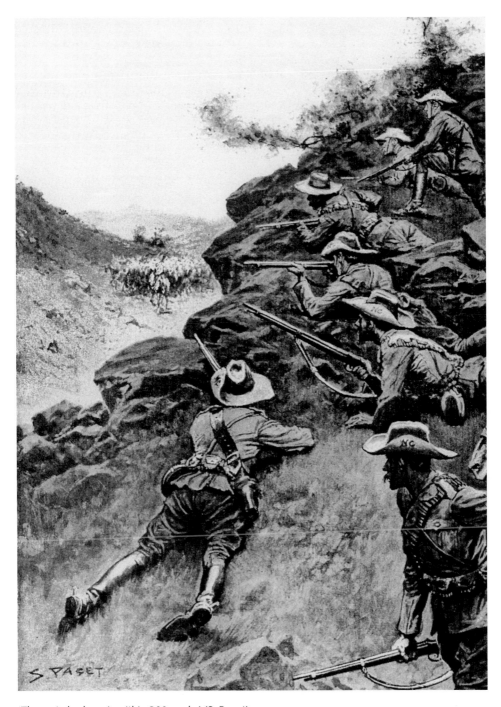

'The main body ... is within 300 yards.' (S. Paget)

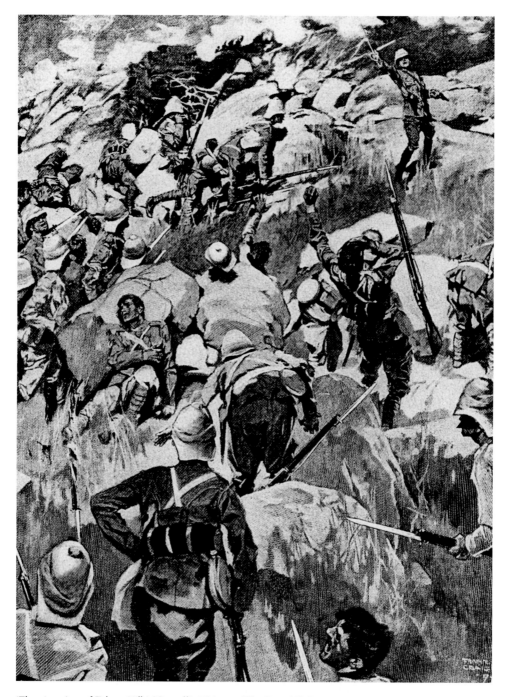

'The storming of Talana Hill.' (*Cassell's History of the Boer War*)

suddenly wake up to the knowledge that a war is going on in some far-off Asiatic or African region where British troops are fighting against heavy odds and displaying splendid courage and discipline. Then a national sympathy is instantly aroused, and the Englishman at home rushes for his newspaper every morning and every evening in the hope of hearing that the soldiers of his country have succeeded in driving back some new attack of their opponents.

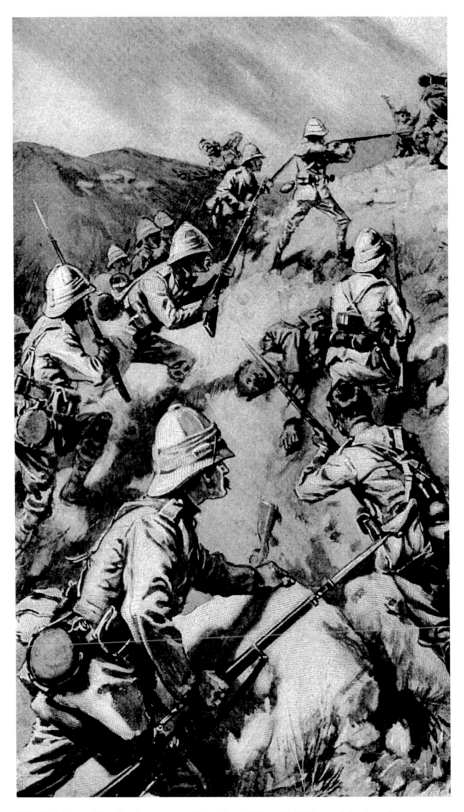

'The Dublins rushing the trenches on Spion Kop.' (*Cassell's History of the Boer War*)

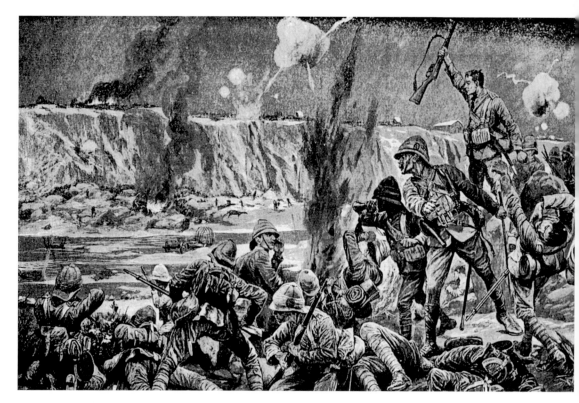

'Paardeberg: The assault on Cronje's position.' (*Cassell's History of the Boer War*)

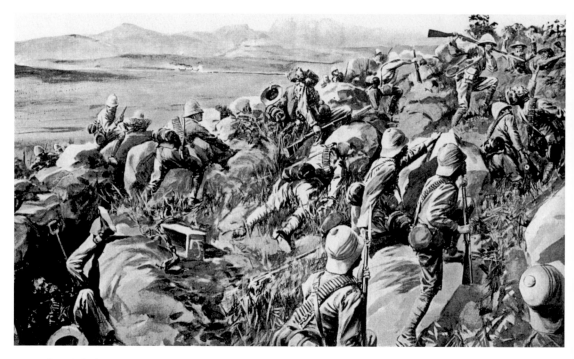

'The relief of Ladysmith – the last rush at Hlangwane Hill.' (René Bull)

In the early stage of the war the Boers had a numerical advantage with a combined strength of around 50,000 combatants, who were armed with modern, smokeless, magazine Mauser rifles and Krupp field artillery, and who enjoyed all the advantages seen in the previous conflict in terms of mobility and knowledge of the terrain. Reinforcements gave the British rough parity in terms of numbers. They were well supplied and communications were vastly improved by the new wireless telegraphy and observation balloons. Their main problem was inexperience in this type of warfare. Ian McDonald wrote:

> Officers trained on Salisbury Plain, were impatient for a stand-up battle; infantry, drilled to shoot in concert, had to learn to become marksmen – and then found that many of their rifles had to be re-sighted. The generals soon realised that they needed mounted troops like the Boers, but the cavalry and lancers weren't trained for that type of action.

The first phase of the war reflected the British Army's inexperience, but eventually two small republics – the Transvaal and the Orange Free State – found themselves facing the mighty war machine of the British Empire.

The British public were led to expect, not for the last time, that it would be all over by Christmas. But that year saw a series of setbacks which shook the nerves of politicians and some generals. The Boers launched pre-emptive strikes into Cape Colony and Natal, laying siege to the British garrison towns of Ladysmith, Mafeking and Kimberley. The British commander, General Sir George White VC, was himself isolated at Ladysmith and ordered a disastrous sortie against Boer artillery positions, leaving 140 men dead and over 1000 captured. In the besieged towns food and supplies grew low, but morale held under repeated bombardment. Strategically the Boer sieges can, with hindsight, be seen as a major mistake. They tied down their forces, achieved little and gave the British the time, and equally importantly the will, to regroup and build up reinforcements. But at the time the news from the front appeared all bad. During Black Week – 10–15 December 1899 – several British counter-offensives designed to break the sieges all failed.

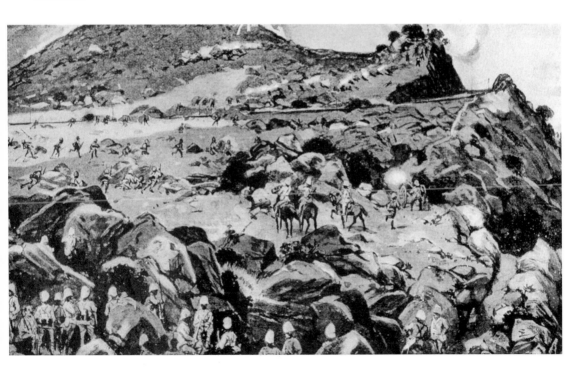

'The last charge at Railway Hill.' (*Cassell's History of the Boer War*)

On the last day of the year the *Evening Standard*'s special correspondent in Ladysmith reported:

> There is no change to record in the general situation beyond the fact that, since the return of General Joubert, the enemy have thrown greater energy into the bombardment. Their two six-inch guns, aided by the howitzers and quick-firers, persist in the ineffectual attempts to reduce the town. The rains have come at last, and, though they may tend to delay the advance of the Relief Column, they are more than welcome, if only because they may check the outbreak among the garrison of dysentery and enteric fever. On Christmas-day the enemy fired a shell into camp containing a plum-pudding, and bearing the legend, 'The Compliments of the Season.' On Boxing-day fully a hundred of the women in the Boer camp made the ascent of Bulwana Hill to watch the furious bombardment. Last night there was a repeated and heavy fusillade along the enemy's lines. It was impossible for us to tell whether they intended to assault, or were merely suffering from a bad attack of nerves, but not a shot was fired in return.

At the Battle of Stormberg on 10 December 1899, Major-General William Gatacre's attempt to recapture a vital railway junction was beaten back with the loss of 135 men killed and wounded and 600 captured. At Magersfontein on 11 December, Lieutenant General Lord Methuen with 14,000 troops launched a raid at dawn in his bid to relieve Kimberley. This turned into a rout when the Highland Brigade was pinned down by, as always, effective Boer sharp-shooting. After six hours in the intense heat they finally broke and ran. The British lost 120 killed and 690 wounded. Worse was to come.

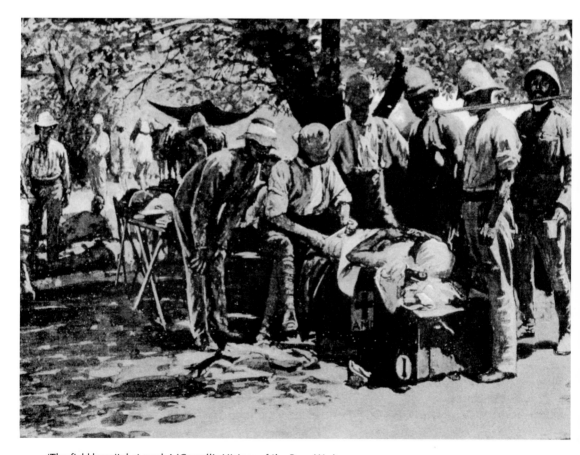

'The field hospital at work.' (*Cassell's History of the Boer War*)

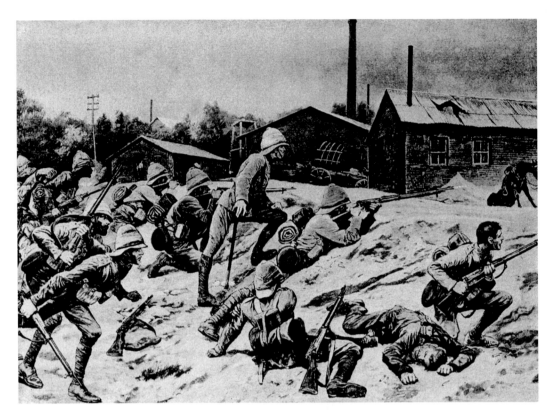

'The street-fighting outside Johannesburg.' (*Cassell's History of the Boer War*)

At Colenso on 15 December, 21,000 British troops under General Sir Redvers Buller, a brave but outdated commander, tried to cross the river Tugela to relieve Ladysmith. Around 8000 Transvaal Boers under Louis Botha halted them with accurate rifle and artillery fire and better use of the ground. A major blunder was made by the brave and experienced Major-General Fitzroy Hart who led his Irish Brigade into a salient made by a loop in the river, in which his men came under fire from three sides. They lay down to return fire but Hart, walking calmly up and down amongst bullets and shrapnel, urged them forward. It was another mistake, as 4000 men crammed into a loop 1000 yards wide. Buller ordered a retreat, leaving behind 145 men killed and 1200 missing or wounded.

Another *Evening Standard* correspondent with Methuen's column at the Modder River offered sanguine advice:

The problem confronting the general is how to attack the Boers by forcing them to attack us. The main lesson to be derived from the campaign so far as it has proceeded, is that a comparatively small number of determined men, armed with modern rifles, and however little entrenched, can then beat off a force greatly superior in strength and equipped with heavy guns.

The anonymous correspondent offered, with much foresight, his solution: 'The best way to solve the difficulty seems to be to get between him and his supplies – seizing, if possible, a strong line of country commanding his communications, and fortifying it in the same manner as the Boers are now doing.'

Rattled by such defeats, the British government sent two more divisions plus large numbers of colonial volunteers under the command of Lord Roberts. By January 1900 British forces would

Lord Kitchener, in a lithograph from a photographic portrait by Bassano Studios, London.

'Colonials burning a
Dutch rebel's farm.'
(R. Caton Woodville)

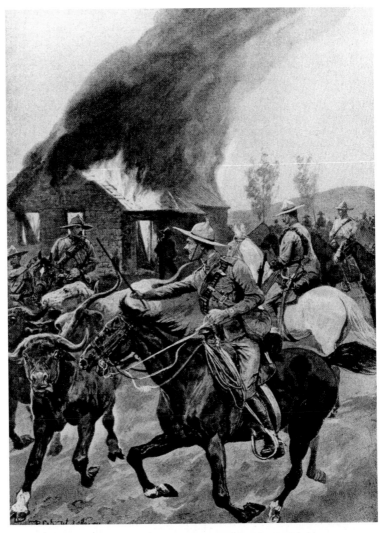

'The British
prisoners' enclosure
at Nooitgedacht.'
(*Cassell's History of the
Boer War*)

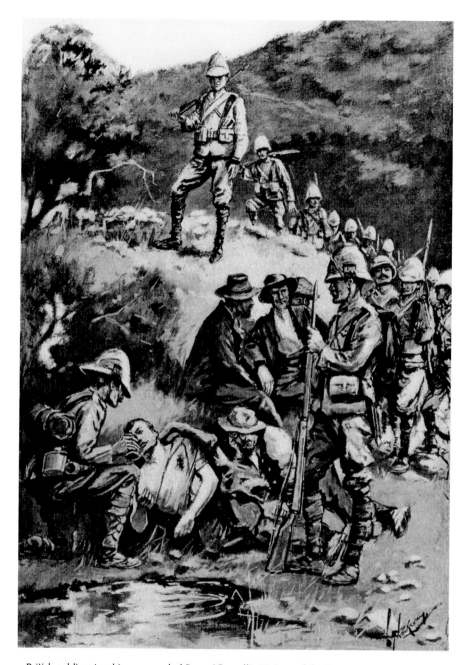

British soldiers tend to a wounded Boer. (*Cassell's History of the Boer War*)

amount to 180,000 men, the largest force the nation had ever sent overseas. But while he was waiting for the reinforcement to arrive at the front line, Buller suffered another humiliating defeat when he sent Major-General Charles Warren to attempt another Tugela crossing. Warren was successful and captured a Boer position at the top of a prominent hill known as Spion Kop early on 24 January, but when the morning fog lifted the British realised that they were overlooked by Boer guns on the surrounding highlands. The day was marked by confusion and contradictory orders. John Atkins, correspondent for the *Manchester Guardian*, watched the carnage from three miles away:

I shall always have it in my memory – that acre of massacre, that complete shambles, at the top of a rich green gully with cool granite walls which reached up the western flank of the mountain. To me it seemed that our men were all in a small square patch; there were brown men and browner trenches, the whole like an over-ripe barley field. I saw three shells strike a certain trench within a minute; each struck it full in the face, and the brown dust rose and drifted away with the white smoke. The trench was toothed against the sky like a saw – made, I supposed, of sharp rocks built into a rampart. Another shell struck

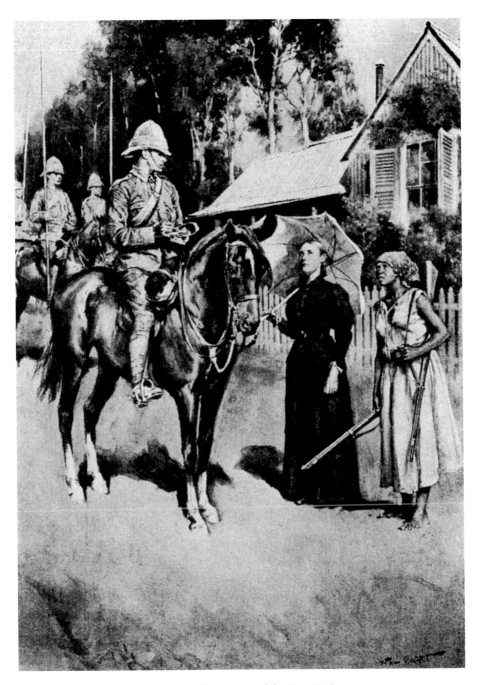

'Boer widow surrendering rifles.' (*Cassell's History of the Boer War*)

it and then – heavens! – the trench rose up and moved forward. The trench was men; the teeth against the sky were men. They ran forward bending their bodies into a curve – they looked like a cornfield with a heavy wind sweeping over it from behind.

Winston Churchill, commissioned as a Lieutenant in the South African Light Horse after having escaped from Boer captivity, was a courier between Spion Kop and Buller's HQ. He wrote: 'Corpses lay here and there. Many of the wounds were of a horrible nature. The splinters and fragments

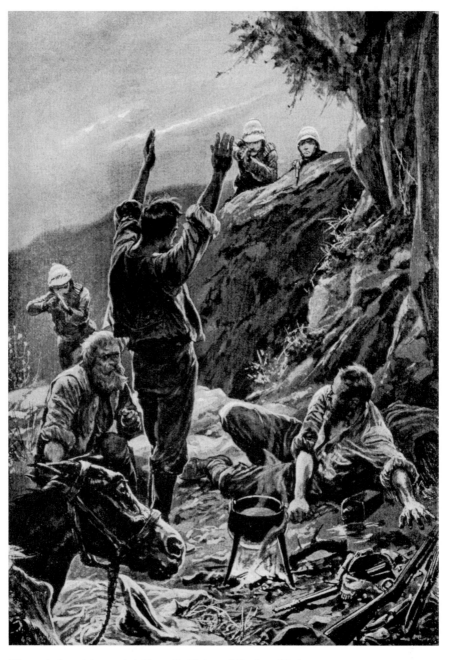

'The end of a sniping party.' (*Cassell's History of the Boer War*)

The victory celebration in London. (*Cassell's History of the Boer War*)

of the shells had torn and mutilated them. The shallow trenches were choked with dead and wounded.' The British lost 350 men killed and nearly 1000 wounded before the remnants made it back down the hill and across the river.

Roberts waited, built up his forces and this time the British were successful. Boer strategy stagnated as their horses struggled to survive on the parched veldt, allowing Roberts to take the initiative, this time backed by military might. He massed his forces along the Western Railway near the Orange River and pressed forward. A massed cavalry charge split the Boer forces

'Native grooms crouching over the camp fire.' (*Cassell's History of the Boer War*)

around Kimberley, allowing Major-General John French to relieve the town after a 124-day siege. Buller, ignoring Roberts' suggestion that he do nothing without reinforcements, picked off Boer strongholds south of the Tugula River and, after four days of hard fighting in which the Irish Brigade suffered many casualties, won control of the railway that linked Colenso to Ladysmith. Boer General Piet Cronje's retreating army was cornered at Paardeberg Drift on the banks of the Modder in a week-long battle. But it was no walkover.

Cronje, after his convoy of heavy wagons had been ambushed by cavalry under Sir John French, had unwisely decided to form a two-mile long laager (a fortified enclosure made of wagons) and dig in. He was by now heavily outnumbered and the British enjoyed an overwhelming artillery advantage. Lieutenant-General Kelly-Kenny, commanding the 6th Division, proposed to lay siege to Cronje and bombard his force into surrender, a tactic which would have caused few British casualties. However, Roberts was sick and his chief of staff, Herbert Kitchener, was now in overall command. He overruled his cannier subordinate.

Kitchener ordered infantry and mounted troops to launch a series of uncoordinated frontal attacks against the entrenched Boer laager. They were shot down in waves. By nightfall 24 officers and 279 men were dead and 59 officers and 847 men were wounded. It was the highest British casualty rate of the war and became known as 'Bloody Sunday'. Kitchener had also left a dominating height – afterwards known as Kitchener's Kop – almost undefended and it was taken by a Boer counterattack. As darkness fell, Kitchener ordered his troops to dig in where they were. Few claimed to have heard the order and, desperately thirsty and exhausted, the surviving British trickled back into camp.

But the Boers were also exhausted. The soft riverbank had swallowed up shells and shrapnel, keeping human casualties low, but their horses, oxen and wagons were cruelly exposed; many wagons were destroyed, ammunition exploded and stores were ruined. The morale in Cronje's laager plummeted.

As the sun rose on Monday 19 February, General Roberts arrived on the scene. At first he urged a resumption of the costly attacks, but Cronje asked for a ceasefire to bury the dead. Roberts refused and Cronje said defiantly: 'If you are so uncharitable as to refuse me a truce as requested, then you may do as you will. I shall not surrender alive. Bombard as you will.'

Roberts did as he was told, with increasing effect. Almost every Boer horse, mule and ox was killed in the relentless bombardment. Finally the Royal Canadian Regiment, having already lost 70 soldiers in an earlier charge, were ordered forward. Instead of another blood-curdling charge they moved at night and, with the help of the Royal Engineers, silently dug trenches on high ground just 65 yards from the Boer lines. On 27 February 1900 the Boers woke up to stare into the muzzles of Canadian rifles. Cronje surrendered with 4019 men and 50 women. It was the nineteenth anniversary of Majuba Hill.

Two days later Buller finally relieved Ladysmith after 118 days. Winston Churchill observed the gaunt and ragged appearance of the defenders and the despondency of Boer captives. 'We didn't believe it possible,' one told him.

Roberts paused for a week to tend to the wounded and await supplies but then marched onwards to strike at the Boer capital of Bloemfontein. Six thousand Boers prepared defences but, on seeing the advance of three British columns, rode away. On 18 May 1900 the defenders of Mafeking, under Baden-Powell, were also relieved, sparking hysterical jubilation in Britain. Once Cape Colony and Natal were secure, Britain was free to invade the Transvaal, capturing towns and railway junctions with relative ease.

By mid-May Roberts had covered half the 300 miles between Bloemfontein and Pretoria and the last stretch saw heavy-duty foot-slogging as the Boers fought consecutive delaying actions, destroying bridges and railway tracks. A particularly tough struggle took place at Doornkop, but the Boers were encircled.

Prevost Battersby of *The Morning Post* described the taking of a railway station east of Johannesburg:

It was all very quaint and much more like melodrama than an event of life and death, but that is the charm of street fighting – its extraordinary air of unreality. The reality was there. A man lay on the platform pushed up against the wall, with a great patch of cloth blown out of his thigh, where some foul bullet had passed out through the leg; and a boer was lying back against the white slope of cyanide ash (cyanide is used in refining gold ore) with his throat visible through the gap which had held his eye. And below were the women, peering and screaming, and staring hysterically at each fresh phase of the fight.

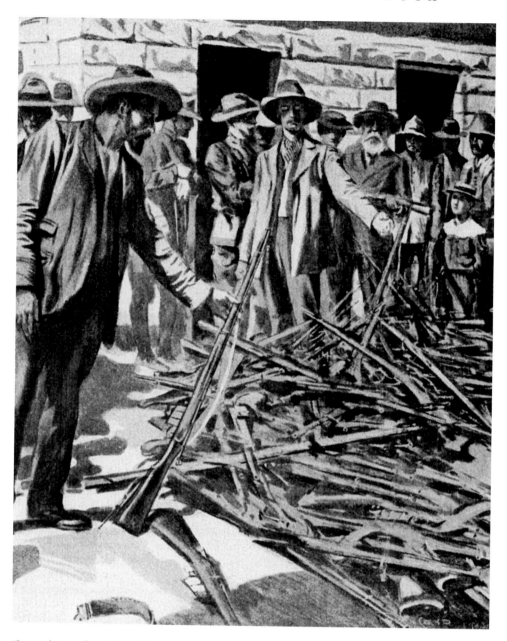

'Surrendering rifles.' (*Cassell's History of the Boer War*)

On 30 May Roberts allowed the Boers to evacuate Johannesburg to avoid damage to the gold mines.

The Transvaal capital, Pretoria, was taken in June 1900. For correspondents at the scene, it was a disappointment as there were no pitched battles, no crushing of Boer resistance, no reprisals taken against the city. The Boer forces simply melted away after an inconclusive battle in what they called '*vlug in vol moed*' ('flight in good spirits'). Their commander, Jan Smuts, launched a guerrilla war for which the Boers were eminently suited: hit and run raids on troop columns, storage depots, railways and telegraph centres.

In November Roberts was succeeded as commander-in-chief by Field-Marshal Horatio Herbert Kitchener. The 50-year-old was as tough as nails, a veteran of the Nile Expedition to relieve

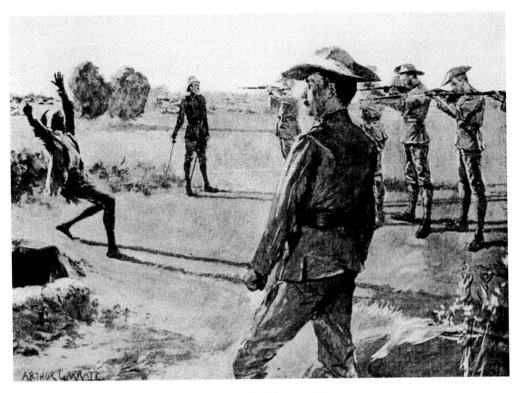

'Shooting a native spy, Mafeking.' (*Cassell's History of the Boer War*

Khartoum, a Sirdar in the Egyptian Army and the victor of Omdurman. A popular hero at home – as was seen in the use of his instantly-recognisable face on First World War recruiting posters – in southern Africa his name stood for scorched earth.

During this long, bloody final stage, each Boer commando was fighting on its own local territory, where the men could melt into a landscape they knew intimately. At its peak the British commanded 250,000 men but, given the vast distances and length of supply lines, they were initially limited to columns. Once a column had passed through a town or district, British control disappeared. Boer tactics were at first successful, playing on the complacency of British commanders who had assumed the war would finish with the capture of the Boer capitals. But equally, the guerrilla tactics were disorganised and uncoordinated in the face of occupying power. And in Kitchener the British had a commander capable of extreme ruthlessness. As he advanced Kitchener built a chain of blockhouses linked by barbed wire to restrict Boer movements. At first the blockhouses were used primarily to guard the railways, allowing small numbers of soldiers a strong defensive network against guerrilla attack. But by 1901 Kitchener developed a scorched earth policy of burning farms to deny the enemy food and supplies, and more blockhouses linked by barbed wire and trenches were used in conjunction with the clearances, limiting the Boers' mobility, their greatest strength. He authorised the creation of fast-moving, mounted raiding columns to sweep the countryside, poisoning wells and killing mercilessly. And, most notoriously of all, he herded men, women and children into unsanitary 'concentration camps' in which families were wiped out by disease. The death rate was a staggering 34.4 per cent.

Emily Hobhouse, writing for the *Manchester Guardian*, wrote of her visit to one camp:

The nurse, underfed and overworked, just sinking on to her bed, barely able to hold herself up, after coping with some 30 typhoid and other patients, with only the untrained help of two Boer girls. Next I was called to see a woman panting in the heat, just sickening for

her confinement. Fortunately I had a nightdress in my bundle for her and two tiny baby gowns. Next tent, a six months' baby gasping its life out on its mother's knee. Next, child recovering from measles, sent back from hospital before it could walk, stretched on the ground, white and wan; three or four others lying about. I can't describe what it is to see these children lying about in a state of collapse. It's just exactly like faded flowers thrown away. And one has to stand and look on at such misery and be able to do almost nothing.

Such reports caused a furore in Britain.

Kitchener insisted that the camps were necessary to control families whose farms had been destroyed in the war of attrition. His defenders pointed out that both the camps and the wider scorched earth policy had been conceived by Roberts – their man had simply implemented the strategy effectively. But Thomas Pakenham summed up Kitchener's plan as:

Flush out guerrillas in a series of systematic drives, organised like a sporting shoot, with success defined in a weekly 'bag' of killed, captured or wounded, and to sweep the country bare of everything that could give sustenance to the guerrillas, including women and children. It was the clearance of civilians – uprooting a whole nation – that would come to dominate the last phase of the war.

Ian McDonald wrote:

It was a miserable type of warfare: the land cleared of people, animals and crops; the Tommies penned in their lonely posts, watching the wire; the restless bands of guerrillas, always on the move – men not doing battle but hunting each other. It was a time of frustrations, taut nerves and reports of atrocities on both sides.

Such brutal methods, combined with increasingly sophisticated intelligence-gathering and infiltration, eventually broke the Boer resolve. The last of them surrendered in May 1902 and the war officially ended on the last day of that month with the Treaty of Vereeniging. That placed the two former Boer republics firmly in the British Empire but gave the Boers an increasing degree of self-government at the expense of the non-white populations of South Africa.

The butcher's bill was, for late Victorian times, immense. The British lost 7792 men through battle and around 14,000 from disease. Up to 7000 Boer combatants were killed and between 20,000 and 28,000 civilians died in the camps or due to scorched earth operations. The number of blacks who died on the battlefield and in the camps was never officially counted but is reckoned to have been at least 20,000. Both sides later painted it as a 'white man's war' but in reality up to 100,000 blacks were enrolled by both the British and the Boers as ditch-diggers, labourers, drivers and guides. As ever on that continent at that time, they paid the heaviest price not just of the war, but also of its consequence.

EPILOGUE

By the end of the Second Boer War Queen Victoria was in her grave, having died at Osborne House, her home on the Isle of Wight, on 22 January 1901. She had been born during the victorious aftermath of the Napoleonic Wars and had inherited a nation growing rich from the Industrial Revolution. But her Golden Jubilee in 1897 had in retrospect been not just a celebration of her reign but also a recognition that her Empire had reached its peak and that changes in the modern world would have an impact on her legacy. Gladstone had died in 1898 and with him had gone the golden age of imperialism. The Labour Party was emerging as a strong force, as were trade unions and the Suffragettes. Victoria's Germanic relatives were planning military expansions which would lead to the Somme. It is somehow fitting that Victoria died halfway through a war which besmirched Britain's reputation abroad, most particularly in Europe where Boer ties of blood were strongest.

Among her last acts was to send a donation to the survivors of a fishing fleet disaster in Shetland and a message of sympathy to the widow of the Bishop of London, who died eight days before her. On her last day she was reported to be at peace, aware of her fate and resigned to it. A nation mourned. For 63 glorious, bloody years she had ruled a nation and an Empire.

Veterans of her wars lined the route of her funeral procession. Many of their comrades lay in barely-marked graves.

BIBLIOGRAPHY

Agyermang, Fred, *Accused in the Gold Coast* (Presbyterian Press, 1972)

Alison, Philip, *Life in the White Man's Grave* (Viking, 1988)

Allen, Charles, *Soldier Sahibs* (Abacus, 2000)

Asher, Michael, *Khartoum: The Ultimate Imperial Adventure* (Penguin Books, 2005)

Bambart, Winfreid, *The Crimean War 1853–56* (Arnold Publishers, 2002)

Barthorpe, Michael, *Afghan Wars and the North-West Frontier* (Cassell, 2002)

Bates, Darrell, *The Abyssinian Difficulty* (Oxford University Press, 1979)

Blanc, Dr Henry, *A Narrative of Captivity in Abyssinia* (Kessinger Publishing, 1868)

Bond, Brian, *Victorian Military Campaigns* (Hutchinson, 1967)

Bruce, George, *Six Battles for India* (Arthur Barker, 1969)

Chandler, David (editor), *The Oxford History of the British Army* (Oxford University Press, 1994)

Churchill, Winston S., *My Early Life* (Simon and Schuster, 1930)

_____ *The River War: An Account of the Reconquest of the Sudan* (Eyre and Spottiswoode, 1952)

Danes, Richard, *Cassell's History of the Boer War* Volumes 1 and 2 (Cassell, 1904)

David, Saul, *Victoria's Wars: The Rise of Empire* (Penguin Books, 2006)

Fairbank, John K., *Trade and Diplomacy on the China Coast: The Opening of the Treaty Ports* (Harvard University Press, 1953)

Farwell, Byron, *Queen Victoria's Little Wars* (Wordsworth, 1973)

_____ *The Great Anglo-Boer War* (Harper and Row, 1976)

Fay, Peter Ward, *The Opium War 1840–42* (University of Carolina Press, 1975)

Featherstone, Donald, *At Them with the Bayonet: The First Anglo-Sikh War 1845–46* (Leonnaur Books, 2007)

Figes, Orlando, *Crimea: The Last Crusade* (Allen Lane, 2010)

Furness, Rupert, *The Zulu War: Isandlwana and Rorke's Drift* (Great Battles of History series, 1963)

Gray, Jack, *Rebellions and Revolution: China from the 1800s to 2000* (Oxford University Press, 2002)

Greaves, Adrian, *Isandlwana* (Cassell, London 2001)

_____ *Rorke's Drift* (Cassell, 2003)

Haswell, Jock, *The British Army: A Concise History* (Thames and Hudson, 1975)

Haythornthwaite, Philip J., *The Colonial Wars Source Book* (Arms and Armour Press, 1995)

Harrington, Peter, *British Artists and War: The Face of Battle in Paintings and Prints, 1700–1914* (Greenhill, 1993)

Harris, John, *The Indian Mutiny* (Ware, London 2001)

Henty, G.A., *By Sheer Pluck: A Tale of the Ashanti War* (Blackie, 1884)

Hernon, Ian, *Britain's Forgotten Wars* (The History Press, 2007)

Hibbert, Christopher, *The Great Mutiny: India 1857* (Allen Lane, 1980)

Holmes, Richard, *Redcoat: The British Soldier in the Age of Horse and Musket* (HarperCollins, 2001)

_____ *Sahib: The British Soldier in India* (HarperCollins, 2005)

Hopkins, A.G., 'The Victorians and Africa: A Reconstruction of the Occupation of Egypt, 1882' *Journal of African History*, 27, No 2:372

Hopkirk, Peter, *The Great Game* (Globe, 1992)

Hutchinson, Colonel H.D., *The Campaign in the Tirah 1897–98* (Macmillan, 1898)

James Laurence, *Raj: The Making and Unmaking of British India* (Little, Brown, 1997)

James, Lawrence, *Warrior Race: A History of the British At War* (Little, Brown, 2001)

James, Colonel Lionel, *The Indian Frontier War: Being an Account of the Mohammud & Tirah Expeditions* (Heinemann, 1898)

Judd, Denis, *Empire: The British Imperial Experience from 1765 to the Present* (HarperCollins, London 1996)

_____ *The Great Mutiny: India 1857* (Allen Lane, 1980)

_____ *The Boer War* (MacMillan, 2003)

Kaye, Sir John, *History of the First Afghan War* (London 1860)

Keay, John, *The Gilgit Game* (Murray, London 1979)

Keene, Henry George, *Fifty-Seven: Some Account of the Administration of Indian Districts During the Revolt of the Bengal Army* (W.H. Allen, 1883)

Khushwant, Singh, *A History of the Sikhs* (OUP and Princeton University Press, 1966)

McCarthy, Justin, *A History of Our Own Times* (Caxton Publishing, 1908)

Mcarthy, Mary, *Social Change and the Growth of British Power in the Gold Coast: The Fante States 1807–1874* (University Press of America, 1983)

Macrory, Patrick, *Retreat from Kabul: The Catastrophic British Defeat in Afghanistan, 1842* (Lyons Press, 2002)

Macdonald, Ian, *The Boer War in Postcards* (Alan Sutton, 1990)

Mcfarland, Daniel Miles, *Historical Dictionary of Ghana* (Scarecrow Press, 1985)

Monck, S., 'The Political Martyr: General Gordon and the Fall of Khartoum' *Military History Journal* 6, No 6

Morris, Jan, *Farewell the Trumpets: An Imperial Retreat* (Penguin Books, 1978)

Myatt, Major F., *The March to Magdala* (Pen and Sword Books, 1970)

_____ *The Golden Stool: An Account of the Ashanti War of 1900* (Kimber, 1966)

Naylor, John, 'Balaclava 1854' from *Great Military Battles* (Spring Books, 1969)

Nicolaides, Angelo, *Military History Journal* 12 No 5 (The South African Military History Society, June 2003)

Pakenham, Thomas, *The Scramble for Africa* (Abacus, 1991)

_____ *The Boer War* (Weidenfeld and Nicolson, 1979)

Ponting, Clive, *The Crimean War* (Chatto and Windus, London 2004)

Richards, D.S., *The Savage Frontier: A History of the Anglo-Afghan Wars* (Macmillan, 1990)

Royle, Trevor, *Crimea: The Great Crimean War 1854–56* (Palgrave Macmillan, 2000)

Russell, William Howard, *The Crimean War: As Seen by Those Who Reported It* (Louisiana State University Press, 2009)

Saul David, *The Indian Mutiny 1857* (Penguin Books, 2003)

_____ *Zulu: The Heroism and Tragedy of the Zulu War of 1879* (Penguin Books, 2005)

Schofield, Victoria, *Every Rock, Every Hill: The Plain Tale of the North-West Frontier and Afghanistan* (Buchan & Enright, 1984)

Shadwell, Captain L.J., *Lockhart's Advance through Tirah* (Calcutta, 1898)

Spence, Jonathan D., *The Search for Modern China* (Hutchinson, 1990)

Spiers, Edward M., *The Victorian Soldier in Africa* (Manchester University Press, 2004)

Ullendorff, Edward, *The Ethiopians* (Oxford University Press, 1961)

Waley, Arthur, *The Opium War Through Chinese Eyes* (Allen & Unwin, 1958)

Wilkinson-Latham, Robert, *North-West Frontier 1837–1947* (Osprey, 1977)

Wolpert, Stanley, *A New History of India* (Oxford University Press, 2004)

Annual Registers
Cassell's Histories
Daily Graphic
Daily Mail
Daily Telegraph

Evening Standard
Illustrated London News
Manchester Guardian
Morning Post
Penny Illustrated Paper

INDEX